MY TAKE ON ALL
FIFTY STATES

MY TAKE ON ALL
FIFTY STATES

JIM FORD

atmosphere press

CONTENTS

Introduction 3

Massachusetts 6

New England 10

Rhode Island 13

Cape Cod 15

College in Connecticut 19

Stunt School 23

Seattle, Washington 26

Semester Abroad 37

England 39

New Countries 47

Back to the States 57

New York City 66

Sex in the City 74

Pride & Glory 77

North Carolina, Come and Raise Up 82

The Buckeye State 87

John Adams in Virginia 93

Aruba 98

Leaves of Grass in Louisiana 104

Texas 109

Heading West 114

Cross Country Road Trip 119

Four Corners, USA 128

Lamborghinis in Las Vegas 134

California 141

Second Road Trip 150

Quick Break from the States 157

Mississippi 161

Puerto Rico 165

Montana, Here I Come 171

America's Funniest Home Video 177

What the Heck is West Virginia? 183

Gettin' Dirty in Kentucky 187

The Volunteer State 190

Arkansas and All Forty-Eight 194

I Bought a Boat! 202

The Dirty Jerz 207

Vancouver 214

Alaska 228

One More (Love) Story for the Road 239

Hawaii 245

Postscript 255

I dedicate this book to my parents,
even though they never bought me a dirt bike.

INTRODUCTION

Dude, how the heck did you see all fifty states so quickly?

Well, it wasn't easy. You need more than just time and money. You have to have that weird desire to see the odd states like North Dakota or Arkansas. Everyone goes to Miami. Your friends will eventually invite you to Vegas. But will you make the effort to see Minnesota for the weekend? You kinda have to be a goofball. You have to get excited about going to Boise, Idaho.

As a kid, I was more into sports and making home videos. I didn't think much about traveling or seeing every state. Occasionally I'd take a casual glance at a map, joking about going to faraway areas like Oregon and Montana. That's probably what planted the seed, but I never thought I'd actually do it. The only folks I'd heard of touching 'em all was a retired couple and a kooky contestant on Jeopardy.

Eventually, I began to find the new engaging. I moved a lot, more times than you would believe. If I moved to a new neighborhood, I immediately got a ravenous appetite to try every restaurant or establishment in town once. Have you ever seen that Seinfeld episode? You know, the one where Jerry and Bania are talking about going to a new restaurant versus going to the same restaurant. "The new place is exciting, but it's a risk. If you stay with the restaurant you know, you're guaranteed an amazing meal."

That was a great scene in my opinion. It sort of defines a good part of me. I'm 100% with going to the new

restaurant every single time. It's stimulating. I don't care if the meal stinks. If I go out for drinks with my buds, I'd rather have one drink in five different bars then five drinks in the same one. It's not a chemical imbalance; it's a choice. It's fun to see new spots. Even if the place sucks, you can talk about what you did or didn't like about it. Kinda like going to the movies.

I also took three separate cross-country road trips, and still had dozens of states to visit. This country is massive. You can't sit around on the couch all day and be lazy. It takes energy. You have to get aggressive and plan some expeditions. If you're thinking about taking a trip—do it!

It was a bit of a hustle to see so many states so quickly. People talk about taking that dream road trip or special vacation, but only when they retire. I never wanted to be that guy who waits until he is older to start traveling and doing what he loves. Sometimes, it meant going to West Virginia last minute by myself, or turning down work to drive to Kentucky. Still, some things are far more fulfilling than saving money or planning for retirement.

Taking a trip is like opening a present, a wonderful present filled with memories and stories that can last forever. I have picked up so many awesome stories from a colorful childhood. I've run on major league baseball fields during play, jumped off highway bridges so high the passing cars thought it was a suicide, been arrested, dated many models with foreign tongues, dined on a 100-foot, private yacht in Central America, been lit on fire, scuba dived reefs in exotic lands and once saw a dirty show in Bangkok. Heck, I even got to open the Panama Canal. But some of my favorite stories simply come from buzzing around the United States. So sit down, buckle up and

prime yourself for the tale of a young man from Massachusetts who saw all 50 states swiftly and somehow became an actor and a stuntman in the process.

CHAPTER ONE: MASSACHUSETTS

There I was, burning gas from Memphis, Tennessee, across the Mississippi River, and only seconds away from the Arkansas state line—my forty-seventh state. I could see the state sign in the distance, slowly coming into focus. My heart was racing. The hairs on my arms stood tall. Wait...don't you hate movies that start out with a weird flashback or flash-forward, and then go back and try to be all artsy...yeah, I hate those too. Let's start from the beginning.

I grew up in central Massachusetts, a sleepy town outside Worcester. It's pronounced "Wusta" or "Wistah" with a nice accent if you're scratching your head while looking at that word.

It was a great childhood. I had a bunch of friends who were all unique individuals. We had a nice house on a safe street; dense woods surrounded our huge backyard. Some friends were into traditional sports, others into extreme ones; my dad and I played golf. The best part about having a diverse group of friends is that I had many options. If I wanted baseball, basketball or football, then I'd dial up trusty ol' Jimmy Lindberg and he'd come over from across the street. We both had backyards perfect for home run derbies or Hail Mary passes. If I wanted B.M.X. or skateboarding, I'd run around the corner to Dave Agurkis. He had a ton of ramps in his yard and driveway. My parents had a humongous garden in addition to my backyard. They loved growing pumpkins and other odd

plants, but we were always taking it over to make dirt jumps. I had friends who liked video games too, so we were covered when it rained. Behind the garden were thick woods—a haven for exploration. Some days we'd make mountain bike tracks or hiking trails. We'd take turns timing each other to see who could race around one lap the fastest. I loved cutting down stuff and making paths. As I got a bit older, my dad let me use his tools. We'd build half-pipes and ramps the size of small homes. The options were endless, and no day was wasted. As much as I loved watching TV, my parents were like hawks. I could never have binge-watched trash like the youth of today. Anything more than thirty minutes and one of them would say, "Go outside."

I'd try to plea, "It's the season finale." It rarely worked, and when it did, it was for another ten minutes max.

I had a natural yearning to seek out new activities. If my friends were busy or grounded, I'd entertain myself by learning a new skill. My dad built a small, but decent, basketball court on the corner of the property. I didn't just see this court as a place to practice basketball, I'd also teach myself advanced jump rope tricks, practice limbo, flatland BMX and flip-tricks on the skateboard. I probably could've joined the circus or gone pro at any number of sports if I'd have concentrated on one. Yet, I was a bona fide "really good at everything, best at nothing" type of guy and wouldn't have it any other way.

Many of my friends had world maps on their bedroom walls. I didn't, but I had a couple globes I'd spin occasionally. Whenever my cousins visited, I would jokingly say I planned to go there while pointing to Katmandu. Truth is that, while growing up, I never had a

burning desire to see the world. I loved playing sports and building jumps. When it snowed, all I could think about was gearing up and going to the gradient golf course or the restaurant down the street with the steep hill. We'd grab our snowboards, a couple shovels, and sprint to the nearest incline, where we'd build a jump and see who could get the most height or do the best trick. I had no desire to go to China or Africa. All I wanted to do was build jumps.

I didn't have a map of the world, but I did have a placemat of the USA. My dad was a firefighter and worked forty-four hours a week—two twelve-hour nights and two ten-hour days. My mom worked Monday through Friday as a nurse. Five nights a week we sat down like the classic American family, having dinner and talking. For most of my childhood, I had this placemat of the United States at my spot at the table. This loyal placemat was a simple, colorful map of the fifty states with their capitals. I loved that placemat. I was constantly quizzing my parents and they'd quiz me back. I learned to love state capitals because I memorized all fifty without fail. Some of my older, smarter friends were enamored that I knew Salem was the capital of Oregon and not Portland, or that I couldn't be fooled with Columbia vs. Columbus. I'd stump people with the Dakotas or Mississippi vs. Missouri. Still, the state that fascinated me most was Montana and its capital Helena. No one knew that capital. If I asked a thousand people, I can't recall two who got it right. Even when I revealed the answer, they'd admit they never heard of it or question my response. Neither my parents, friends, nor my teachers knew the answer. Everyone always thought it was Billings. I'd say, "No, it's not Billings." Now and then, one would

guess Bozeman or Butte, but no one ever got Helena. When I was a youngster, my parents would talk about Florida or tell me about Hawaii. The palm trees and hula stuff sounded neat, but I always longed to go to Helena, Montana.

CHAPTER TWO: NEW ENGLAND

Growing up as a typical New Englander, we bounced around the other five states. We'd go to Maine, New Hampshire, Vermont, Rhode Island and Connecticut. They all just seemed the same at the time. Traveling was underwhelming for my younger brother and me; it was way too much time in the car. My dad loved to drive. Oh, did this man love to pack up the station wagon and drive to new places. It was torture to us. My parents sat in the front seat, smiling, enjoying the passing views, and we'd be in the back ripping the seats apart and repeating, "How much longer?" My dad would drive six hours just to get a sandwich and then drive back the same day.

My parents would drag us up to Maine because they liked a certain lobster roll or wanted to walk around Kennebunkport—a nice town but also boring and stuffy. Vermont was pretty. As I got older, I'd go snowboarding or visit friends. The roads with the snow-covered trees were radiant, but I'd rather have stayed in my backyard.

New Hampshire was a riot. East Coasters relentlessly praise the state as having the finest fall foliage anywhere. They cheer the multicolored White Mountains and the leafy Kankamangus Highway. They go on and on about its lakes and old-timey feel. In my budding opinion, the Granite State was a joke. When I heard 'New Hampshire,' the only thing to come to mind was fireworks.

We'd go to Hampton Beach, the redneck Riviera—a

bunch of sun-burned guys and fourteen-year-old girls walking around in cut-off jeans, smoking Newports. Salt water taffy and souvenir mesh t-shirts were always in season. I'd beg my dad to buy fireworks—all I ever wanted from New Hampshire was to smuggle bottle rockets or a coveted M-80 past the supervised Massachusetts border. One time, when I hadn't pissed off my parents, and they were in an extra good mood, my mom convinced my dad to buy a couple small strings of firecrackers. That was a rare occasion. When a pal of mine finally got his license, one of the first orders of business (after cruising for gals) was a jaunt to New Hampshire. We loaded the trunk with every aerial spinner, flying bees and helicopters they had. We stuffed that trunk with cherry bombs, crazy jacks, jumping jacks, roman candles and missiles. We splurged on a few mortars and base fountains, while grabbing rockets, which we'd never heard of. Crossing the border felt like you were entering another country. The Bay State was known for its random searches. We'd heard the stories of them confiscating the booty and everything else punitive that went with the crime.

Well, on that sunny summer weekday, we didn't give that a thought. We cruised right by, untouched. Now, my dad would never let me buy fireworks, and he would never consent to me attempting to buy them. He'd give me a lecture if I even mentioned I was thinking about acquiring them, but for some reason, he didn't make me throw them out weeks later when he found the stash in my room. He said, "Alright, really quick. Let's go light one off in the yard."

I grabbed the biggest, brightest mortar stand I had. This thing had to be illegal, even with a permit. We raced

to the picnic table in the middle of the yard. It was pitch black. I still remember the look on his face when this thing shot up, screaming toward the sky like a heat-seeking missile—so high and so fast. There was a brief pause and then the shining star went off. The sky lit up with infinite fluorescents and a thunderous boom, shaking the trees, the ground, and setting off car alarms. We stared, starry-eyed, up at the sky while the lights cascaded downward. We stood motionless with amusement at how shockingly huge this thing was—as big as something you'd see at a professional July 4th concert. It was lighting up our backyard in our quiet neighborhood. We savored the moment and then ran into the house. It wasn't a minute before the town police cars zoomed by, but we were already inside celebrating while our faithful dog Murphy hid under the chair.

CHAPTER THREE:
RHODE ISLAND

Yeah, Rhode Island sucks—next chapter. Haha, just kidding.

Rhode Island is a sneaky state. It's the smallest of all fifty states—less than forty miles wide and not fifty miles tall. It has the stigma of being goofy and insignificant, but Rhode Island was (and still is) a genuinely scenic state with stunning views—large cliffs, mansions, and many marinas. Certain roads imitate those of Europe, and there's decent surfing for the northeast. Narragansett and Point Judith have waves. The beaches in general were lovely; Misquamicut was our cache.

The 'rents loved Rhode Island. They'd load up the Volvo and drive to Newport for the day...never for the weekend. We'd walk along the water, grab some chowder at the Black Pearl and look at the sailboats. Newport has incredible chow-da and all around solid seafood. If you're into steamers, the Red Parrot will satisfy any palate. If you like calamari, some of the best in the world is located in Newport. Castle Hill is hard to beat if you're in the mood for a romantic date; it looks like a private country club or a jacket-only steak house but has a causal bar outside—a lawn you can sit on in shorts and sandals while they serve you drinks. It's comfortable and chic without forcing it. The view is an absolute ten out of ten—sailboats, water and bridges.

As I got older, some friends went to Providence

College. I'd visit to take advantage of their relaxed drinking age, perhaps lingering from the old days when it was one of only two states that didn't accept Prohibition. You could be eighteen and look sixteen, but you were in if you showed something at the door for the camera (most of the time a Tony Gwynn rookie card). An air of shadiness and corruption floated around the bar scene and most of the city, but if you were under twenty-one, this place was much more welcoming than Boston.

Still, I was never eager to go there since it seemed like a consolation prize. Maybe it was because we never got a hotel. It was the long day of driving that I loathed, as opposed to the pick-up games with friends back in town. If you get to visit the Ocean State, then no trip would be complete without a stop at Wrights Chicken Farm. It's an enormous, all-you-can-eat family-style restaurant, locally known for its tasty bird and Keno.

CHAPTER FOUR:
CAPE COD

As for Massachusetts and exploring that state, we'd go into Boston every now and then, but my grandparents had a house in Cape Cod, so we'd visit there a lot. You may see sweatshirts aplenty with the big "CAPE COD" on its chest, but you would almost never hear someone say that if he or she were a true New Englander. You refer to it simply as THE CAPE. It really was a cool place.

Good ol' Cape Cod. There was something about its laid-back, peaceful and approachable vibe. There was a lot of money in the Cape, but it was neither hoity-toity nor was it snobby or elitist like the Hamptons. There was a neighborly feeling in the summer. Everyone was outside on their decks, grilling or having happy hour cocktails. Welcoming fish fries were common too. When we turned sixteen and got our license, all we wanted to do was drive to the Cape. We'd try to wrestle up beers and go hit on chicks on the beach—we loved the Cape.

As a younger kid, it was a two-hour drive that seemed to take forever. The drive didn't improve by much as I got older. No matter what time I left, or what time I got there, I always hit some form of traffic going over the bridge. So, naturally, the first thing locals would say after hello was: "How was the bridge?" Then: "Which way did you go?" You knew the question was coming. You had to spend at least eight minutes giving a detailed traffic report; that was tradition. Then someone offered you a drink.

The only consistent traveling I did growing up was going to the Cape—it was the Central Mass thing to do, go during the summer and occasionally Thanksgiving. It was big news when somebody went somewhere else. If someone traveled to outside the U.S., then it most likely was their honeymoon or their recently retired, one-time dream trip. The only other inkling of travel inspiration I had as a young kid was from my aunt. She didn't live far away and was always stopping by the house. My dad would roll his eyes at the attachment between her and Mom. She'd stop by with her boyfriend Glen. They both had these incredible tans. They were always returning from some wild vacation, filled with the glow of fulfillment on their smiling faces. They'd go on cruises or weeklong trips to the Caribbean. Sometimes it was a ski-trip, but mostly it was a warm getaway. They'd go to Hawaii, Puerto Rico, the Virgin Islands, or the Caymans. They didn't have kids, and they weren't in debt. They were carefree and happy, with endless stories. I'd put my arm next to hers and snicker at how pale mine was in comparison. They'd arrive with coconuts and shot glasses, along with armfuls of other souvenirs. It looked like so much more fun than our stinking road trips. I was always asking my parents if we could go on one of these vacations, but my dedicated parents spent all their money on our education. They could've had a second house, fancy Mercedes or extra money to spend. Yet, they chose to invest their hard-earned money on private schools.

We traveled to Florida a couple of times, Disney World or whatever. Palm Beach, Delray and Orlando were all right but not like Daytona or the Gulf side. Flying was fun—the airplanes were an experience and the theme

parks were cool. Still, Florida was...eh...everyone went there. Most of the people you'd bump into were from Central Mass...some from your high school. Lame, kid!

My hometown was close to the Wachusett Reservoir—a panoramic body of water that supplied most of Boston. Hence, it made it illegal to swim or boat there. We swam there daily. We had to hike forty-five minutes to get to these cliffs. We'd picnic there, smoke smuggled cigarettes and jump off the twenty-foot cliffs that felt a lot taller. It was our escape and our secret hangout. We were almost entirely encircled by woods and water aside from a far-away causeway barely seen in the distance.

We indulged in whatever we wanted—Lord of the Flies meets The Beach. It was also a good date spot. Mostly, we went to jump off the cliffs. Some were easy, while others you needed old sneakers to get enough speed to make the deep water. Occasionally, we'd make a big enough splash that a distant car would see it; then, they would report us. It took the Rangers forever to get there by foot, so we were usually halfway home by the time they reached the cliffs. If we passed them on the trail, we were already dressed and dry, so we'd walk past them and say we were hiking. If we wanted a real chuckle, we'd say, "Hurry up, I think we heard some kids swimming." We had a plethora of routes to avoid them.

As a kid, running from the law was such a rush. Twice we had so many people jumping and swimming that they sent a boat to the cliffs. They yelled at us on the megaphone. It took so long to bring the boat to shore...we were long gone. Safely hiding in the pine maze, we knew the landscape better than anyone. The narrow trails reached a variety of paved roads, so if a patrol car didn't

see you the second you popped out of the woods, then you were just a kid walking down the street—a kid trying to contain his smile until he got to the tennis courts (aka, the safe spot). We named the cliffs Bull Rock and Elvis. I was content hanging out there. I didn't think about the future or what I wanted to be when I grew up. If you asked me about my travel goals, I'd probably have said, "I dunno. I'll be going to the Cape this summer and hanging around town."

I just wanted to play sports. I never thought I'd be a world traveler.

CHAPTER FIVE:
COLLEGE IN CONNECTICUT

I started getting restless around my junior year of high school. I'd never thought much about the future. I lived in the now, trying to have as much fun as I could. So, around the time I had to start thinking about where I wanted to go to college, I decided, "I've had it with New England and Massachusetts."

I needed to see other places and I needed to live somewhere new. One societal stamp of Central Mass was about leaving Worcester, which, after Boston, was the second largest city in New England. It's a large city, bigger than Providence. So, whatever small town you were from in Central Massachusetts, you said you were from Worcester. Then, you went into further detail if someone cared. When our parents were growing up, if someone "left Worcester" to go live in a faraway place, that was considered derelict. If someone went to school out west, there was a good chance they'd be labeled a hippy, a weirdo or even a miscreant youth. It wasn't considered cool if you went to Colorado or Arizona. Rather, it looked like you were running away from a drug problem or a baby-mama. Now it's just the opposite. If you don't "leave Wustah," then people look at you like you didn't get out. They'll say you're a nice kid, but sigh in slight condescension when they talk about it. "Oh, how is so and so?" "Ah he's okay...he still lives in town; got married, though."

It's funny because plenty of people stayed and did fine, but it looked like you'd settled and were labeled as not taking a risk. What kids did to escape that branding was go to school in Boston—forty-four miles east and far enough away that it was out of Worcester County. Still, parents could say it proudly and then exaggerate their job.

Even though Boston is home to many world-renowned schools, it was like moving next door to my parents. I wasn't going to go to school in Boston, no matter what—not even if I got a full boat to Harvard, kid.

I wanted to go to Miami, California or Honolulu. Heck, I was ready to go to Canada or Europe...anyplace. I required change. I wanted new people, fresh colors, and a dissimilar landscape with bizarre sounding accents. I didn't have a specific place in mind. I just needed to get away. The reservoir cliffs were no longer tall enough, so we started jumping off bridges—mainly the I-290 highway bridge. It was so tall that people driving by thought we were committing suicide and called the cops. The dive team would search the lake for hours. They never found us...but my dad did. He heard the whole thing on his scanner. It made the front page of the paper the next day. With all the questionable situations in which I was getting myself in, I'd have guessed my parents would have been happy for me to go away to school. However, they were adamant I stay close to home. I don't know why, but they were footin' the bill, so I ended up going to Connecticut. It was seventy-seven miles from my childhood town—far enough away to feel I was elsewhere, but close enough that if I got into trouble, my parents could drive down, take me out to dinner and yell at me.

College was fun—well, more than fun. It was Utopia.

You get this swipe card. It's this silly little piece of plastic with your picture on it and it gets you into places. It opens doors to buildings and buys you meals in dining halls. It has credits on it that get you groceries, snacks and sweatpants from the campus bookstore.

No one tells you what to do or when to sleep. You can do whatever you want—whenever you want—for four fantastic years. You have twenty-four hour access to anything you could crave: beer, sex, pizza, drugs, parties, frisbee...bliss.

I indulged in all the typical and joyous things college had to offer. It felt good sleeping in a different state, away from home. I could take a nap in the middle of the day and not get pestered to mow the lawn. I made friends with people from all over—admired the ones from afar and was intrigued to learn about their distant state. In between classes and parties, I tried out to become Howie the Hawk, the school's mascot. I had a blast for about eight games but was fired since I made Howie a little dirtier and darker than the university was comfortable with. I learned a lot about love and life, but after a year and a half, I realized I was still in New England. It was freakin' Connecticut.

Yes, Connecticut is a funny state. It seems like the most boring state in the world. If you were going to write a screenplay about a humdrum, lame couple, then you'd place them in Connecticut. Yet, they've got two of the largest casinos in the world, real racetracks with race cars, vineyards, a lot of scenic, waterfront towns facing Long Island Sound. It can be enjoyable to say the least.

FUN FACT: Many think Las Vegas has the largest casino in the United States, but that's inaccurate. With over one hundred casinos in Vegas, not one of them is

close to the size of Mohegan Sun or Foxwoods Casino in rural small-town Connecticut. Measure the largest casinos in Las Vegas. Foxwoods doubles them in square footage, slot machines, hotel rooms, employees and table games. It's triple the size of the average casino on the Las Vegas strip.

It can be a fun place. The school, however, was outside Hartford, Connecticut and Hartford is a miserable city. It's a small city but you can't walk around because highways cut through it. It's the worst of both worlds. It has a shady, dangerous vibe, even in the wealthy areas—watch yourself when it's late. If you're a girl, watch your drink. It's a crazy place—got the most insurance buildings and companies out of any city I've seen—sweet claim to fame guys. A destitute city once the Whalers left for North Carolina.

If there weren't something big happening on campus, I'd look for excuses to 'Get the hell out of Dodge.' On the weekends, I'd ride trains or buses to visit friends in other colleges. It was time spent to catch up, but I was more curious to see their campus and explore a new town. I visited a pal in Montreal, Canada. That was nice, but I'd been to Niagara Falls and Toronto with my folks. None of my close friends relocated anywhere that far for school. UMass Amherst was a zoo of a good time, but Western Massachusetts was still Massachusetts. I was wasting time, so randomly, almost out of the blue, I decided to go to Washington. Not the District of Columbia, no, no: Washington State—the one named after the first president of the United States. The one with all those apples that is located on the other side of the country, in the Pacific Northwest.

CHAPTER SIX: STUNT SCHOOL

You're probably thinking: what the heck is stunt school? Where is it? What do you do there?

I get these questions a lot. Yes, stunt schools do exist. Some specialize only in stunt driving, but there are a few reputable ones that teach you the common stunts performed by stuntmen in film and television.

I was studying at the Hartt School, an acting conservatory in Connecticut. The year was 2000, I was in love with acting and embracing theatre, but also working out and playing a lot of sports. I challenged myself constantly—jumping off bridges, teaching myself to do backflips on the ground, and doing swan dives. I did flips off 45-foot-high cliffs while filming it on videotape for my home movies. I was an action hero in my mind. I was doing student films that had chase scenes, just so I could act and do some physical stuff too. I did them for free in between my busy schedule, just to show off my skills. I had no idea how showbiz worked at that point, but I figured I was going to be in action movies and doing my own stunts—I would be doing everything.

One day, I came across a flyer on the bulletin board at my school that read:

STUNT SCHOOL
Go to stunt school for the summer.
Train extensively with the UNITED STUNTMEN'S ASSOCIATION.
Receive a diploma from the INTERNATIONAL STUNT SCHOOL

I brushed it off. I thought it was a joke or maybe like a clown college, but several classmates and teachers said I should go. I was always getting in trouble climbing the buildings and jumping off the roofs in between classes. I wasn't the business school type. I gave it more thought. Eventually, one teacher explained that from a training perspective it was actually a legit school. So, I decided: I'm doing it.

I told my parents: "Hey, guys; I want to go to this stunt school." I had to repeat my statement five times before they realized I wasn't joking.

"What? Stunt school? What the heck is that? Sounds absurd," they yelled.

"Mom and Dad, please; I really think it'll be good."

"Nonsense, you have to work this summer."

"It's a real school and a great thing to have on my résumé. It'll help me get roles in the future after I graduate."

They shrugged and frowned: Why us?

I insisted: "Look, some teachers suggested it. This is what I want to do. I'm serious about working in this industry; come on, guys. You told me I had to go to college. Well, this is part of my education."

My parents were strict, no fun, and said NO a lot. Still, if I was serious about something and gave them a solid plan, then they always took my side. They wanted me to have backup plans and kept suggesting civil servant jobs for financial security. In spite of that, I always insisted: "I don't want a backup plan. I'm going all out and giving one hundred percent."

They eventually moaned and capitulated: "Okay."

The school, which was located in Seattle, charged $4,000 bucks for the five-week course. This included room and board as well.

CHAPTER SEVEN:
SEATTLE, WASHINGTON

I called the school and applied. I was younger than most of their students, so they needed to chat with me and get some references from teachers. I wasn't even twenty. Most of the students were mid-twenties to early thirties; some were in their forties. The application board said they didn't accept yahoos: "You'll be doing some dangerous stuff here. We are looking for maturity and people that can be safe. No wild man attitudes."

I said I knew basic gymnastics, wrestled a bit and was in acting school. Then, I said wasn't a wild man. "I'm an actor and I want to do my own stunts. I'll be one of your top students."

I was accepted into the school.

I couldn't believe I was flying cross-country to Seattle alone. My dad dropped me off at Logan International Airport. His facial expression was like: "I don't even know what to say...good luck."

I remember thinking to myself: I don't know if this will amount to anything. Worst-case scenario is it's going to be a ton of fun and a much better way to spend my summer as opposed to lifeguarding or landscaping again.

Touchdown!! Jimmy Ford in Washington State.

Several instructors and students holding signs waited for me at the airport. It was friendly and welcoming as I entered their shuttle—a peaceful ride in the ten-passenger van. I looked out the window and, for the first time in my

life, I knew what it felt like to see something breathtaking. I wasn't prepared; I didn't see it coming. The Olympic mountain range loomed before me—a long line of white caps carved into the sky. I turned to my right and witnessed Mt. Rainier—large and solemn while standing majestically in the distance and resembling a volcano.

"Wow, look at that mountain!" I shouted.

Mt. Rainier stood there, clear as day, as if an artist hand-painted it a minute ago. It was so vivid it couldn't be real; it looked super-imposed. I could've stared for hours; I was shocked. I hadn't come here for sightseeing; I was all business. The driver asked where I was from. I said, "Massachusetts" and he raised his brow. "Wow, that's far. The rest of the guys in the van are only a state or two away." They all said hello and were shocked I had flown all this way.

It was something out of a skit as we pulled up to the hotel. About twenty students were hanging out in front of the lobby entrance, many with long hair and tattoos. They were doing flips, climbing the side of the hotel, and a couple guys were already on the roof. We were only going to check in that day, have a brief welcome and fill out some paperwork. The place was like a zoo—everyone showing off and running around. Dave Buche, the owner, walked out. I'd have bet money he was going to scream, tell everyone to get down and behave themselves. Nope.

"Don't get hurt and sent home before the first day," he said casually. "Your welcome packets are at the front desk. Get a good night sleep. See you tomorrow."

I checked into my room and met my roommate Kevin—a short gymnast, skater-type guy from Indiana. We hadn't even unpacked when he took off the window screen

and said, "I'm gonna jump. I bet I can tuck and roll on the pavement. We're not that high."

I smiled. "Cool. I'll go next."

He did it, no problem. Then, he ran around the building and came back in to try again. As I was leaning out about to go, a truck pulled up in the parking lot. This tan guy had a muscle shirt on—half Hawaiian and half Pilipino. With his spiked hair, he looked like you should call him DUDE, but his name was Cliff Heick. His first words were, "Sweet, you guys are jumping out the second-floor window? Nice. Let me grab my stuff and I'll do it with you. Maybe we can even jump off the roof."

We spent the better part of the afternoon jumping out our bedroom window onto the parking lot. We eventually got up on the roof. It was a bit too high to jump, so we hung out and talked.

Most of our classes were at the University of Washington. It was a bit of a drive, so I got to see different neighborhoods, depending on what route we took. Everyone kept saying that Seattle gets rain, but it only rained once while I was there.

A large part of the school curriculum was focused on fights and falls. Throwing a punch correctly relied heavily on the angle between you, the person you're punching, and the camera. It was mostly about the person and your relationship to the camera. Different angles of the camera showed different angles of your arm and fist, as well as punching styles. They had playback video, so you could see when your punch read as a hit or didn't work. They were full days. I was one of the youngest students in the class, but I got along with everyone. We were all unique people with much in common. Age didn't matter; plus, I excelled

in all areas.

A couple of the older guys, including Cliff, had friends that knew the area. So, we'd hang out. I had a fake ID from Massachusetts under the name Spruille Braden—a guy I'd never met. I swear that was his real name. It was a working license, too, and able to be scanned. This guy was foreign and looked nothing like me, but the ID worked every time. The guys and I would go out to the local bars, put back a few longnecks. We even gambled at some small casinos. Hanging with these guys, not yet twenty-one, was a rush. My unconventional method of playing blackjack even won me a hundred dollars.

I learned that commercial beers—say a Coors or Miller Lite, had different alcohol content in some states. A Budweiser back home was 5% alcohol, and a Bud Light was 4.5 percent. Washington State mandated it at 3.2 percent. I guess they didn't want people getting drunk. It's amusing to drink two to three beers and feel no buzz—a waste of time. Rum and Coke please!

Driving from the hotel to school, and then back again, was still as scenic as my trip from the airport. I remained in awe of the mountain range and the striking Mt. Rainier. We had most weekends off, or at least one day a week. On one of those days, my roommate Kevin and I went into Seattle to walk around. We didn't have much money. Everyone suggested we visit the Space Needle—the iconic image of the city. It is a tall needle, high on the skyline that had a revolving restaurant at the top. A revolving restaurant? I'm not in freakin' Worcester anymore. Kevin and I were poor as shit, but we had to check it out. We were dressed like skateboarders and needed a shave and a haircut, but they let us into the restaurant. We sat at a

table by the window, wide grins on our faces. The joint was polished and very fancy. My parents would sometimes take us to a nice restaurant, but nothing like this. John and Linda Ford were hot dog and hamburger type people, and I was a slice of pizza guy. This place screamed high-end elegance, or maybe my young eyes were easily impressed. To us, the Space Needle restaurant was wicked cool. We almost balked when we saw the menu.

We couldn't afford anything, but we couldn't get up and leave, or be wimps and just order a soda. The waitress was nice but probably wanted us to hurry up or put on a collared shirt. We ordered a beer and a cup of chowder—the only items we could afford. Even that was the most expensive meal I'd have all summer. It took forty-two minutes for the restaurant to complete a revolution. We sipped our overpriced three percent Belgium beer and savored our chowder while taking in the view. We saw the ocean and the cityscape, the parklands, mountains and Puget Sound. We spotted a skate park, which we decided we'd go check out when we were done.

One cycle around was good enough for us. We rode the long elevator ride down and grabbed some postcards. I called my mom. I was so excited, and she sounded so happy. We were on a natural high like we'd gotten away with something. We laughed and explored the city.

The student body ended up being diverse, coming from across the U.S. and from overseas—Denmark, England and Australia—about forty students altogether. Two chicks, and the rest were guys—motocross, gymnasts, skydivers, martial artists or wrestlers hoping to become stuntmen for film and TV. There were several rock climbers and rally car drivers too. The others had different

skills.

This guy Dan, from Utah, did live shows. Shane was a smoke jumper—a firefighter who parachutes out of planes into forest fires and tries to put them out by chopping down trees to contain the flames. The stories never ended. Several students, myself included, considered themselves more of an actor than a stuntman. We wanted to take this course to become more versatile and marketable. One such dude was Jay Hayden from Vermont, a Red Sox fan. We did some scenes together and became pals. He organized a trip for Cliff, Shane, James and me to go see a baseball game. The Mariners played the Oakland Athletics on a sunny summer day. Jay went up to the beer stand and bought everyone two beers each. "Here you go, boys. I have one request. If Seattle hits a home run, then you have to chug your beer."

I couldn't believe he bought everyone two beers each. My friends back home would argue over gas money when it was less than a buck. I liked hanging out with older guys. They were generous. We enjoyed the game with the sun on our face. The new stadium featured a retractable roof that could open and close in ten minutes. It was massive, weighing about twenty million pounds with enough steel to build a skyscraper. Yet, with one button, you could open or close it per the pitcher's preference. We walked around and found a cool bar inside the left field wall fence. It had seats up against the wall with a foot-high window that ran the length of the room, so that you could watch the game through the wall. We saw David Justice on the warning track, standing only a few feet from us. We asked him how he liked banging Halle Berry. I know he heard us.

The game was a blast while we talked sports, girls and

life. Then Ichiro Suzuki, the pride of the Mariners, came up to the plate. Known for his speed and batting average, he had an unmistakable swing. He wasn't powerful, but he was fast and smart. On that bright August day, this Asian sensation swung for the fences and SMACK!!—a towering fly ball to right field and deep...a HOME RUN for Ichiro and A HOME RUN for Seattle. High fives! High fives! Hey...chug your beer!

We left soon after and were happy to have seen a good game. Bouncing around the city at night was fun and different than eastern cities. Coffee shops were everywhere. I noticed more beards and lots of plaid shirts. Dive bars with live music. I kept hearing the word grunge. The city seemed clean and, for the most part, doing well. It was a mix of hipster and business types. We went up to every group of girls we saw and boasted that we were stuntmen. Cliff came up to us, pulled down his pants a little and said, "I'm going commando."

We chuckled. What's funny is that he'd walk up to girls and tell them the same thing. What was funnier was that most of the time it worked. Rarely would a group of girls be grossed out and walk away. Then he'd yell, "Don't worry, I shaved."

Most of the classes were at the college but we had one week out on a ranch far away from the city. Lush green trees, mountains in the background and fresh air. It was cool to be around horses and animals. The scent was invigorating. We did some horse work, which entailed jumping on the horse like a pro, making sharp turns, and riding fast. The finale...jumping off. They used a mat on the dirt that, on filming day, they'd cover to look like ground. You had to start way back, get going at a decent

clip, then dive off and hit the mat. It was fun to feel a horse accelerate. The instructors explained that momentum carries you further than you think. They advised to aim for the beginning of the mat or even five feet in front. Once you launch off, the speed will carry you to the middle of the mat, whereas if you aim for the mat like your brain tells you to; then, you'll carry over and crash on the dirt.

Come on, boy! Heya! I see the mat approaching and aim for the front. It was so counterintuitive. I dive off and see the middle of the mat go by me, while I slam into the last couple feet of padding. It was enough to break the fall, but I roll fast onto the ground several times. I get up in a cloud of smoke. "Close, Jim, next time jump sooner."

I couldn't wait to go again. The horse's acceleration felt like a sports car. I aimed about three feet before the front of the mat, lifted one leg, jumped off, hit the middle and rolled to a stop safely. Personally, I think it looked cooler if you rolled into the dirt to raise a little dust and drama. It was fun watching the other students too.

Growing up in Massachusetts, the Brazeaus (my neighbors) had a few horses. They had a big field and we could ride the horses but weren't allowed to spur them to run. It was fun nonetheless, and it gave me more experience than most of the other students. Some had never ridden a horse. The teacher let some of us do some moves for style. One was a quick take off, where you'd run and vault onto the horse from behind, praying he wouldn't kick as you approached. He'd take off once you landed and yelled. The horse seemed to love it.

Our next two days on the ranch were dedicated to getting lit on fire, squib hits, falling off a slanted roof, getting thrown through tempered glass windows, high

falls, and air rams. Some chose not to do certain things and that was fine. I did 'em all. We climbed to sixty-five feet for high falls. The air bag at the bottom was huge, like an enormous pillow. It looked like a postage stamp from where we stood. You don't take in the view. You focus on your mark. I still have a cool picture of me flying through the air with pine trees in the background.

After the ranch, we had a couple more days in the gym, training with weapons, stair falls, ratchets, wirework and obstacle courses. Our friendships grew stronger. Cliff, Jay, Shane, James, me, and this Canadian guy (whose name was Alex) hung out a lot. We'd stage fights in the supermarket and people thought they were real. Their angle to us was the camera, so we knew how to swing the melon and react accordingly. We'd work out at a nearby Bally's. I learned a lot from the school, but I learned a lot from these guys too. They were fearless when it came to hitting on women; they didn't play games or use gimmicks. They'd spot a group of girls and move in. Jay was smooth, Cliff was the wild man, Alex was the romantic, and James and Shane had the laid back California vibe. I took notes. Cliff would wear a speedo and pretend to be a stripper. It didn't matter what these guys said; they were from out of town and going to stunt school. We got invited to a bunch of parties. At one point, Cliff got the waitress's number at some chain restaurant, and asked how many cute friends she had. She invited us to her house that weekend, along with every girl she knew. Delicious!

I didn't know what to think about stunt school going into it. I figured I'd be a lone wolf showing off. I never imagined I'd make friends and be a part of this awesome

bunch. We were thick as thieves...we were the Brat Pack.

Our final days at the school were spent at an old Air Force base/airport. It was the driving training section—an old stretch of asphalt with a body of water behind it— the perfect setting for a week of tire shredding fun. One of the older instructors had jumped cars for the Dukes of Hazzard—a hit TV show in the seventies with that orange "General Lee" who flew like a bird. He was an exciting guy to be around and showed us some great moves. We learned a lot about manipulating the e-brake, tire pressure, and how to skid a car any way you wanted. One of the last days was a business class, where they talked about the movie industry and how to actually get into "the business." They could've saved us a lot of time by saying there wasn't any specific way—no clear path. It's not law school. There's no formula. It's a little bit of luck and lot of hard work. You don't take a test and apply for a job. You don't pass the bar then go work for a law firm. It's a vague and funny industry to break into. I wasn't too concerned because I had a few more years of college and planned to be an actor anyway. Though, some of the stories about crashing sets and dropping off headshots were engaging.

The Brat Pack had a few more nights on the town— more girls and gatherings. I wanted to hang out with these guys all the time. Sometimes, at a girl's house or a party, we'd just sit around and tell stories to each other. We all graduated and received the sweet diploma. The school threw a farewell dinner and drinks for everyone. Most graduates took off that night—some drove, and others had flights. A couple guys decided to carpool for the road trip home. I didn't fly out till the next day. I was excited to get home and share my adventure, but I wondered when or if

I'd see my buddies again. I stayed to the end of the dinner, sipped drinks with everyone as we said our goodbyes and exchanged contact information.

I made good friends, but what I didn't realize was that I wouldn't see most of these guys ever again. I never heard from Shane. Alex gave me a T-shirt—a brand made by his friend and one you could only find in Canada. We exchanged a few emails over the years. He'd been on a few sets and had some leads on work. I was happy for him but eventually the sparse emails died out. Jay and I talked a lot, staying in touch over the phone. A ski-trip brought me to Vermont the next year and we made plans to hang out one night. I told him about the toga parties. He was pumped I came to visit but, at the last minute, said that some family thing came up. He made the move to Hollywood and was in several commercials. That was the last I spoke to him. I randomly saw him on a TV show, so I hoped he was doing well. My roommate Kevin and I phoned a couple times, but he never made a move to either coast. So, I don't know what happened to him. Hey, Kevin: I've yet to see anyone else scale a movie theater building and enter through the roof—and I'm still impressed how you shagged the girl from the laundromat. Cliff is still a good friend. He was my roommate when I moved to New York...but I'll get to that later. Hey, I thought it's supposed to rain in Seattle.

CHAPTER EIGHT:
SEMESTER ABROAD

Returning to the east coast felt great. I was happy to be back home and on a natural high. I had a sweet trip and was the talk of the town. The local newspaper ran a story about this kid going to stunt school. People rushed up to me and asked about my adventures at any party or gathering I went to. I was also getting a lot more attention from the ladies. I'd always jumped off people's roofs into their pools, but now, after stunt school, some actually wondered: "Who is this guy? Maybe he's for real!"

It was a unique trip because no one I'd known in town had been to Washington State. I was the first—a pioneer that hadn't followed in anyone's footsteps. I was in a great place—my thirst for adventure quenched for a bit. I lifeguarded the rest of the summer and returned to college for my junior year.

My classmates were thrilled that I'd completed stunt school. Even my teachers admitted it was an impressive feat. My roommate and friends on campus constantly asked me to show them the moves I'd learned. I bought a jump suit from a thrift store and sometimes went to parties as a stuntman character. I didn't think I'd really become a stuntman. I thought there were only two or three anonymous stuntmen in the world, who worked on James Bond movies or helped Jackie Chan. They were like unicorns; you never saw them. So, I'd climb the school buildings, hang out of windows and roll down stairs the

way I was taught. If you were at a party and I showed up, you were in for a treat. I started dating a lot more girls. I was living in the now, and I wasn't thinking about graduation or travel. I was loving college and loving life.

About a month into my junior year, while still in Connecticut, it was announced that a semester of Shakespeare in England this year would be mandatory. It would be part of the theatre conservatory's curriculum.

A semester abroad? No way! They're telling me I have to go to England...to Europe...to another country! I tried not to get too excited because I figured they'd kick me out of school or not allow me to go because of my tomfoolery. Well, the time grew near when I was unexpectedly called into the Dean's office. He wasted no time. "Jim, you're going to behave yourself in England, right?"

I nodded. "Absolutely, yes sir."

"Good, I believe you will," he said. "Some of your teachers are a bit concerned, so I just want to say I'm very proud of this program. So, please be on your best behavior and have fun."

"I will, sir and thank you so much."

Wow, I was going across the pond. It was an academic requirement. My parents didn't have the choice to forbid me to travel. I couldn't believe it. This would undoubtedly be a most exciting adventure. I remember glazing over as the teachers prepared us for the trip. I didn't care about the different outlets—just get me there. I'll worry about the conversion rate and how they pronounce stuff later.

CHAPTER NINE: ENGLAND

Our flight was direct to London, even though our semester would be in Birmingham. The plan was to meet up with the class a couple days before and see the big city. A girl from class was hesitant to fly and asked if she could take the same flight as me...sure. She and her mom came over from Maine. My parents ordered a car service for us to Logan International Airport in Bean-town baby!

Touchdown, new country. I remember getting my luggage, exiting the airport and it being five in the morning. I had no idea where we were going. I felt alone, even though I was with a friend. No cell phone or GPS. Just a shitty pamphlet map. The only people awake looked sketchy and I felt like we had bullseyes on our backs. I was convinced by my parents' caution that someone was going to try to pick pocket us. I moved my wallet from my back pocket to my front pocket and wheeled my suitcase a bit faster over the dark, damp cobblestone road.

The jet lag wore off and we made it to the meeting point that night—some pub with a goofy name in an area of London near a colorful-looking bridge. The meeting point was a pub? F-yeah. I was going to like this town. As we walked in and were greeted by a few classmates, it was like we hadn't seen them in years. Smiles ear to ear. I walked up to the bar and didn't know what to get. Someone handed me a beer—a pint! What the heck is a pint? I was used to cheap beer in a bottle or cheaper beer

in a can. Their beer was heavy and full; it actually had taste. I went out of my way to say hello or just ask random people a question to hear their accent. Every second was stimulating.

The remaining classmates had arrived, and we were off. Our teacher said we were doing a pub-crawl. Awesome! We stopped at many pubs and walked around half the city. Our teacher, once strict and militaristic, was cracking jokes and drinking with us. No one got out of hand. It was like we were grownups that were treated like adults. Strolling down the streets, the lights bouncing off the ground, Europe lingered in the air. Then we saw a Burger King and next to it a Pizza Hut. What the heck? Snickered, amused and a bit surprised. One of my classmates and I chatted about it. It was almost a buzzkill. Here you are in a magical new land when you run into a chain restaurant that frequents every town in America. It is now staring you straight in the face, just screaming greed and lack of creativity. This should be illegal. The last thing you want to see in a new country is something you see daily at home—shitty American fast food.

Back to the pub-crawl, the signs, taxis and outfits were cool. We'd exited another pub and were walking down a quieter street when I saw a sign in a doorway: NUDE GIRLS ->

I laughed, pointed and started to walk toward it. I peeked up the stairway and took a few steps when I heard a fairly familiar: "JIM!!"

My teacher was staring at me and motioned 'come here.' I assumed he was going to tell me not to go looking for NUDE GIRLS but was I wrong. He informed my young, semi-drunk self that it was a trap. Sometimes when you

go up, there are no nude girls—just two big men who rob you. Ah, thanks. We laughed.

The people were nice in England, but they weren't ecstatic about Americans. Don't get me wrong; they were friendly, and politics rarely came up, but they'd seen Americans before in addition to loads of people from other parts of the world. London gets tons of tourists, so it's not a big deal that you're from the US. However, Birmingham was another story.

Birmingham, the second largest city in the UK, is about two hours northwest from London and some kind of wonderful. Birmingham didn't get many tourists, so as an American, you were a fucking rock star. All we had to do was open our mouths and the girls would go nuts. They would invite us back to their flat. Sometimes it was for tea, but most times it was for casual coitus. Then, they would put some bananas in your crispies, for breakfast.

One of the first things I noticed about England and Europe was how more laid back they were about the carnal embrace. In the States, a girl who sleeps around is a whore or a slut. Yet, in Birmingham, a hardworking, respectable, intelligent young woman will frequently need a break from studying at the uni and tell her friends she 'needs to go out on the pull.' Going out on the pull was a term you heard sometimes but was mostly referenced. Guys in the US try to do it every weekend. It is basically going out, getting drunk and trying to hook up with chicks. Girls in the US just want to dance. One-night stands do happen, but mostly after a couple courtesy make-out dates. In Birmingham, girls will tell their friends, "It was a tough work week. I need to go out on the pull."

It's no big deal or a special occasion. They aren't slutty.

It's just much more relaxed than the US, where girls get a happy hour wine buzz and give out numbers.

Being a student is cool because everyone knows you're poor and wants to help you out. The exchange rate was pretty rough back then, so your dollars in euros went quick and any little contribution helped.

They had a great strip of pubs. Each night of the week, one pub would do a student night special. This would never happen in the US...why? Because of American greed. The American bars would compete and try to one-up the other bars to get people in their bar every night. Then, the other bars would respond, and it would inevitably become a disorganized mess. Not Europe and not Birmingham. On Mondays, one bar had the specials; on Tuesdays, another bar had specials and so on. If you wanted a quiet night and a chat with your mate, then you went to the pubs having a non-special night. If you wanted the scene, the specials and all the people with whom to mingle, then you went to the designated pub. They shared. Imagine that; what a concept. They all let the other pubs have their night, so that they could have theirs. My roommate Zak and I really took advantage of this. It was a pound per pint and a pound per shot of whiskey. One euro for a beer and one euro for a shot. There's no tipping in Europe. Maybe a buck if you wanted, but you don't have to do it. So, for five euros, we could have any combination of beer and whiskey. Most of the time, we'd do two pints and three shots, get a nice buzz and tell the ladies we were from the USA. We couldn't go out every night because we did have some classes, but we definitely went out most nights. After a few weeks, we learned the real parties were the clubs.

Clubs in the US are pathetic, stupid, over-hyped and

over-priced crap. It's more of creating the image of a successful club then actually having a good one. It's a transparent scheme to make money. Long lines as advertisement, inflated bottle service and basically a bunch of people not drinking cuz it's too expensive. Everyone is walking around pretending they're somebody. Clubs in the US are bogus.

Clubs in Europe are tits! Tons of fun energetic people in a good mood, dancing, drinking, lots of skin and beautiful people. Crowded but not annoyingly crowded. People kissing and touching. Women in the US spend three hours to get ready and then stand around. In Europe, the girls still look hot but they're much more relaxed about it. Less makeup and more fun. They have energy. It's just a great world to visit with a few friends.

TIGER TIGER was the club we frequented. I have to say again—I'm not a club guy. I'm not a Guido-Murphy, gel in my hair, take steroids and go tanning, then stand around in a corny colored shirt like a douche. No—but this club was great—no line, no stupid cover, tons of girls and a good time.

We had a system. The pubs closed around 10:30/11:00PM and the clubs opened around 11:00PM. The drinks at the clubs were pricy in comparison to the student night bars, so we'd head to the pub around ten, get a nice and quick, five-euro buzz. Then, as it was closing, we headed out, hailed a taxi or a bus to the clubs for an eleven o'clock arrival. We'd buy one drink to keep things going and make a lap. It usually didn't take long—sometimes only minutes. Your place or mine? I had that question asked multiple times. If we did go home alone, then there were many a late-night fish 'n' chips stands waiting for us.

A little salt and vinegar...classic.

Q: Hey, what does a boat and an American beer have in common?

A: They are both close to water.

HAHA, cheers. It's true. A funny thing I realized was that you couldn't find a Bud Light or Coors Light anywhere. They hadn't even heard of them, only pints of Stella or Boddington. Drinking is big in England—a cool pub and soccer culture.

What? Oh sorry, football. Real football, according to them.

When we weren't studying the Bard or going out on the pull, some of the other classmates and I would go to the normal pubs away from the colleges. We would sit, swap stories and act mature. The English loved to hang out and watch soccer. They'd sip their pints while maybe having some food. French fries, bangers and mash, Yorkshire pudding, it wasn't fancy, but it was comfortable, and I liked it. We found it interesting to see families in the pubs too. In the US, a family may go to a pub and have a drink with their kids at the table, but they'd have one drink while eating and then leave. Here they hung out, sipping pints, while watching the game as the kids ran about or colored in notebooks. I'm not saying they were getting drunk, but they ordered multiple pints, and this was the activity for the day. You'd never see that back home.

One wacky English drink that amused us was the bulldog. I witnessed an older gentleman order it and it piqued our interest. The bartender half-filled a pint glass with lager. Then he poured a shot of vodka, and then poured a Smirnoff Ice into the glass. He purposely caused it to sloppily overflow down the side. With no apology or

a second napkin, he handed the glass to the gentleman whose goal was to chug as much as he could in one go. Chugging a pint can be done, but a full pint overflowing the rim, with a shot of vodka lurking inside that was mixed with a "spirit" was not an easy task. The man downed the beverage with relative ease. It may have taken him a cleanup sip to get everything, but he did it...and then left.

Perplexed, we bellied up to the bar. "What the heck was that?"

"It's an English Bulldog."

"We'll take three."

The smirking bartender grabbed three glasses and set them up. He looked at us and grinned. "The thing about a bulldog is you only order one if it's a really bad day or a really good one."

We laughed. "Oh, today is a very good day."

He poured the spirit, overflowing the cup. The sloppiness added to the appeal, its defiance part of the pageantry. It was a rush trying to drink it all at once. I'd like to think we came close. Immature high fives and howls came soon after. The rest was a blur. I believe we kept drinking.

At some point, I ended up arm wrestling some tan Brit, who looked like Mel B with bigger biceps. She'd just gotten out of prison and had a dirty cockney accent. I'm pretty sure I ran home. Thank you, bulldog. I love you, Birmingham.

TRAVEL TIP: Don't talk politics. You shouldn't do it. You're not going to change someone's view in a new country or a new state. I know you have a great point and the media is awful, but the reality is that this world is

divided on most big topics. I try to change the subject. I try to talk about sports.

Talking politics also gets boring fast. In high school and college, I had a group of friends who were politically divided. One group were Democrats while the other were Republicans. The two would constantly bicker over any number of topics. It went on for hours. They'd yell and get mad. They would call each other names but nobody ever won. Nobody ever convinced the other group about anything, and they wasted all this time. I always questioned where both sides got their facts and how either side knew if the information was a hundred percent accurate. I'd just stay out of it.

But the news is crooked!

CHAPTER TEN:
NEW COUNTRIES

Wait, what? You're visiting NEW COUNTRIES now? Jim, I thought this book was about the fifty states?

Oh, but it is! I compare and contrast a lot, so don't worry, dude. Quick detour!

My semester in England was so long that we had a spring break. I presumed we'd stay in town. I didn't think we were allowed to leave the school, but everyone seemed to be going somewhere. Some kids were going to Ireland; others were only going to London. Most were eagerly heading to Amsterdam. They must have asked me twenty-four times to join. I'd heard the typical draws to it and was almost tempted to get aboard. Then, a random email from a high school buddy told me he and his family would be in Spain the same week of my break. Spain or Amsterdam? Hmm. I'm sure it sounds naïve, but I hadn't any interest in prostitutes or smoking large amounts of weed. So, why else would I go to Amsterdam? I know, I know—the art, the culture, and the bicycles. But I'm in college, dammit! We occasionally have lofty thoughts, but mainly we drink beer and hook up with chicks.

As much as I wanted to see my classmate Turner's smile in the red-light district, I decided to go to Spain. I took small planes, trains and buses all over that stunning country. In less than a week, me, Mickey, Raj and Mr. Nath saw Malaga, Pamplona, San Sebastian, Bilbao and Madrid. We sipped wine and tasted tapas. We drank absinthe with

locals and partied with international women. I got lost a few times. I sipped port for the first time. It was months before the running of the bulls, but we ran the route anyway. It was still scary. We marveled at the Bay of Biscay, contemplated the curvaceous Guggenheim museum, dined at Michelin Star restaurants, soaked in the Spanish culture and learned about siestas. A siesta is a midday rest that almost *everyone* in the country partakes in. How long do you think siestas would last in the greedy USA? It would last about two days until the aggressive American business owner came up with the idea: "I'll be the first store open during siesta, so if someone needs something, I'll make a killing." Other people would follow and so on. Soon siestas would be gone. They would be destroyed by the indulgence and avidity of America. In Spain, not one place was open during siesta. They all relaxed and took a nap.

Traveling in Europe is great and so much easier than the USA. The flights are cheaper and quicker, but the trains are truly amazing. There's no reason why you should have to change trains a hundred times in Chicago, spending multiple days to go halfway across the country in the USA. You can't even go to Wyoming. What the hell is wrong with the trains in America? It takes five hours to go from Boston to New York, costing over a hundred bucks. The train is crowded, old, and full of idiots on their cell phones. In Japan, you could equivalently go from Boston to Atlanta in less time. The Euro-rail system is so much more efficient and less of a headache than the USA. Hanging out in a bar car sipping Stella Artois and white wine while watching the landscape pass outside the window is cool. We'd chat about baseball trivia and other

sports while passing the time in between cities. When we ran out of stories about girls we were seeing, we even played the capital game. What's the capital of Missouri? Jackson or Jefferson City? Good one. Tough One. Of course, Helena, Montana was my ace in the hole.

What a week. It felt like a year. I couldn't believe how much I had tasted, seen and learned. I bought a few knick-knacks, sent out a batch of postcards and hopped on another rickety plane back to Limeyland.

I was eager to return home—that being England and not the States. I was still far from Massachusetts and still had another month in Europe. It was a weird feeling. The next couple weeks went by slowly. I wasn't homesick, but I was missing home. It felt like I'd been gone awhile. I grew a beard and dyed my hair. We took some classes at Oxford—one of the most prestigious and renowned universities in the world. To study Shakespeare at Oxford was an honor. They had beautiful grounds. A sign on one of the lawns read: "Please keep off the grass." I jumped on the grass and snapped a few pics in front of the sign. BREAKING THE RULES!! We took a train to London where we saw some top-notch theatre. For live theatre, nothing but Broadway beats the London stage.

The semester was coming to an end—one more weekend and then finals. At this point in my life, I hadn't any desire to see all fifty states. I didn't think it was a possibility, and I certainly didn't think I'd see another county before I left.

For the first time in forever, my mother really surprised me. On a call with her, I told her I had one more weekend before finals. She said I should go somewhere. I replied that I was good, and that I had traveled enough.

Exploring England and Spain was more than fulfilling. She suggested Ireland. I laughed: "Mom, another country? I'm almost out of here."

She persisted. My mom was always telling me to do less or stop or no. This was the first time Linda Ford had ever suggested I do something more. She said it was close and easy for me to travel there. She'd even give me a hundred bucks if I was almost out of money. I couldn't believe she was giving me a speech about living in the moment and once-in-a-lifetime opportunities.

"Okay," I said. "I'm going to Ireland."

I almost felt guilty. I got myself to Liverpool at night and boarded a red-eye ferry to Dublin. Arriving at the terminal at five in the morning, I tried to sleep for a bit since nothing was open; but that only lasted twenty minutes. I was too excited...a new country. Taking a right out of the station, I didn't go two blocks before some stumbling drunk ol' man walked toward me. I tried to go left, as did he, so we both went right. The lush kicked me in the shin, walked past me and mumbled swear words. I hurt a bit, and normally would have been mad. I laughed. I wasn't in the country two minutes, and already I'd been kicked by a drunkard. They really do drink a lot in Ireland. I kept walking, taking in the misty fresh Irish air. The town was still waking up. Guinness was everywhere. All buses were painted black with the logo, as if the brand owned the city. I did their tour and it was all right. I accepted my complimentary pint of stout and sipped it on the observation deck overlooking the city. The view was plain—drab apartment buildings and smokestacks.

The tour I really wanted to take was the Jameson Irish Whiskey Distillery. A girl from class raved about the tour;

she said you get six shots of whiskey. I was so skeptical of her tale that I took the tour half just to prove her wrong, but she was right...very right. The Jameson Irish Whiskey Tour is no joke. They play a five-minute video to a room of about thirty people. Then, they ask for four volunteers. Every guys' hand in the room rose.

"Are there any female volunteers?" the guide asked. Only two went up. She picked the two women. Then she looked at me, my hand still raised high. "Okay sir, you, before you jump out of your skin."

A fifteen-minute informative tour was it. I learned cool facts about the difference between whiskeys and why scotch tends to taste smoky. Then the real fun began when we were done.

"Okay," the guide said with an intoxicating Irish brogue, "That concludes the tour. Everyone take your ticket and go to the bar for a free taste of Jameson...but the volunteers come with me."

She brought us to a back room with four seats at a table covered with four placemats. Each had five circles on the right side and one on the left that said Jameson. Someone quickly covered the circles with shot glasses, filling them with their designated liquor. The other gentleman and I took the Jameson shot—Slainte!

"No—wait, wait. You weren't supposed to have that yet. Please refill them and wait," she said, trying to be polite.

"Okay..." Snicker, snicker.

Me, the other gentleman and the two women volunteers sat at this table with six shots in front of us—five on the right and Jameson on the left. The other members of the group slowly filed in around us with their

one shot, salivating at what was in front of us. At no point did the lady or anyone say this was a large amount of hard alcohol to consume in a very short time. There was no disclaimer or caution. I guess they figured that you can drink if you're in Ireland at a whiskey tour. All she said before we started was: "Here's some water if you need it...pick up your first shot."

We all took it. Cheers.

"Now sip your Jameson," she said. "Do you see how it compares? The scotch is smokier because they burn a fire in a room below the barley. The smoke rises above to dry the barley, giving it a smoky or peaty taste."

Interesting, I thought. *Drink!*

What? We were already onto the next shot. A different Irish whiskey. Okay, now sip the Jameson.

Okay, next.

Next.

I pounded six shots in five minutes. I'm all for drinking games and love a challenge, but this family-run, reputable, daytime tour was giving me more to drink in five minutes than any frat party or college gathering I'd seen. I almost didn't get that last shot down. All four of us finished the shots. It was like we'd been through battle together. Then the guide surprised us with four thick certificates that said we were official Irish whiskey taste testers. I still have it today. They basically toss you hammered into the street. They have to get the next tour group going. Haha, Ireland. Slaunchaah!

So, there I was, cocked at noon and stumbling around Dublin's streets. I had to pee, so I pissed on the side of a building. I decided that if the constables came questioning, I'd blame it on the Jameson distillery. People looked on. I

just kept saying, "The Jameson distillery did this."

I bumped into this young Irish girl, told her about my tour and she laughed. She was in between classes but offered to take me to lunch at some local spot. We had a great meal and exchanged stories about our countries. I thought there was a chance we'd hook up or party, but she had to get back to class. She gave me some suggestions on where to go and what to see next.

The sun had set, and I was debating if I should call it a night, find a hostel and make my way back to England in the morning...nah. I walked near Trinity Square and Trinity College. Some drunk walked through a street performance. A young man was limbering under a stick of fire and the drunk almost got him burned. When he offered no apology, one of the spectators punched him in his face.

Well, another pint at a local pub and I was almost out of cash. I went to this other bar and it was nice. It was sort of like a club. Tons of people. I was chatting with the locals at a bar. Then, I went over to their booth to have drinks with them. This one girl was into me. She starts kissing me out of nowhere. I was thinking, *This is a fun town.* Then, she asked me if I wanted to take ecstasy. Laughing, I said no. She was serious. She really wanted to take ecstasy with me. After I told her no a few times, she not only stopped kissing me...she wanted nothing to do with me and ignored me. I had to leave the table.

I was chatting with some Irish guys about the Land of Liberty. I had only forty euros left and no credit card. It was getting late and I was thinking that I could go to a hostel. I'll wake up early and make my way back to England...easy. Or, maybe I could sleep somewhere else

and keep partying. I asked the guy I was chatting with, "Hey, dude. I don't want to impose, but are you guys all crashing somewhere tonight?"

"Yeah, everyone is going to come back to my place."

"I got enough money for a hostel," I said, "but I can keep drinking if I can crash at your place."

"No problem, Jim; you're more than welcome."

Another pint of the holy water it is. Slainte!

I kept drinking and dancing. As the place closed, I hopped in a car with these guys and girls. We were laughing, chatting and driving. After about thirty minutes of driving, I asked, "So where do you live...are you close?"

"We're a bit away still," he said.

Then it hit me. I'd assumed they lived in the city, and not an hour away in the country. How the F was I going to get home in the morning?

We got to his house and everyone was doing ecstasy but me. I was fading. They were nice, but I couldn't stay up any longer; it was almost five in the morning. I passed out. I woke up with the sun shining. I walked to the mirror and saw the stuff written on my face—a couple of penises and some jokes about the USA. Good one, guys.

I washed it off and went downstairs where everyone was still fast asleep. I walked outside. The birds were chirping, the sun blazing, and I was in the suburbs. How would I get to the ferry station? Which way was the ferry station?

I went back inside. People were waking up. I explained my situation but only got mild laughter. I hadn't any credit card. My ATM card only worked on rare ATMs. This was 2003. No Uber...fuck.

People were leaving but they lived down the street.

They wouldn't give me a ride but made sure to ask if I saw the cocks on my face. Yup, I saw them—thanks. Finally, the nice kid from the bar who owned the house woke up. "Hey, Jim."

"Buddy, I got to get back to the ferry station in Dublin. I didn't realize how far out you lived."

He yawned. "Oh geez, yeah. I'm going to back to bed."

After more pacing around the front yard, hoping to see a car drive by, I went back in and woke him up. "You gotta give me a ride."

"Dude, I don't know...I think Mary's boyfriend is picking her up. They live near Dublin; maybe you can ride with them?"

"What? When? Come on, man. I'll go to an ATM and pay you. I have to get back."

Minutes later, Mary came out of the bathroom and her boyfriend came through the door, upset. They stormed out toward his car.

"Hey guys, I'm Jim from the USA. I have to get back to England."

The boyfriend pointed to the back door. I got inside; not sure if I was even welcomed. They screamed at each other the entire ride, never once speaking to me or acknowledging I was there. They just kept fighting over Mary going out all night and doing ecstasy. I could barely understand their thick accents. I tried to ask them where we were, but they yelled at me.

I didn't know if we were going in the right direction. I didn't even know what direction was right. Finally, after an hour, the boyfriend pulled over and told me to get out.

"Here? Where am I? I have to get to the ferry station."

The boyfriend angrily extended his arm and pointed:

"Ten blocks that way."

"To the Dublin terminal?"

They both screamed: "Yes, go!"

After some walking, I noticed the familiar downtown area and the River Laffey. The herd of Guinness buses were a comforting sight. The Dublin ferry-port had to be close. I asked a few strangers and eventually got on the boat. By the time I got back to England, I still had a two-hour bus ride to Birmingham and a cab to the school. It was the middle of the night. I couldn't believe I made it back. Some students were still up making tea and getting last minute studying done. I walked by them with a smile. As I turned to go up the stairs, I heard Turner say, "Do you have a penis drawn on your forehead?"

CHAPTER ELEVEN:
BACK TO THE STATES

Finals went great even with little sleep. A few more cups of English tea and late-night fish 'n' chips. Then, I was back in Boston. My mom and brother were there to pick me up. They were all smiles until they saw my bleached blonde hair underneath a souvenir Bobby helmet. "Hello, mates."

You'd think it would be hugs and kisses from Mother Dearest, but nope: "Your hair, James! Your beard! What, they don't have razors in England?"

Ah, that's my mom. She hadn't seen me in five months. The longest and farthest I had been away from home and her first words are nagging me about my hygiene.

Once the fussing stopped, it was nice to finally have her cooking again. Mom's mashed potatoes with gravy were special and how I'd missed them!

My friends surprised me the next night with a welcome home get together. Ken Buron, a.k.a. Kenny B's, was the first to pick me up. He loved my stories a little too much. We weren't even fifteen minutes down the road, and already it was annoying how many times he suggested we take a vacation back to Birmingham.

"Ken, dude! I just spent five months there. I am not going back. You go."

We chuckled and went to the party. The usual suspects were all there. Man, traveling gets you some good attention. There were no smart phones in 2003 so people

actually sat around and talked to each other. They would listen and laugh. Everyone was making me do my impression of the cockney rhyming slang.

"Let me butchers hook your kettle and hob, my trouble and strife is Jack Jones and wants me home. Lend me your dog and bone and a couple of oily rags. I'll have some Fisherman's daughter, so she doesn't know I was getting elephants trunk at the near and far."

Cheers. It felt good to have some pizza and American fast food. Besides Mom's home cooking, I was really craving Wendy's and Burger King. A couple of my mates smoked cigarettes, so one of my go-to stories was about the time some English kids came up and asked me if they could "bum a fag," to which I said, "What?"

People couldn't believe that a cigarette was commonly referred to as a "fag" or "rag."

Certain Brits would actually say, "Excuse me, can I bum a fag?"

I thought they were messing with me.

Even though we were done with England, we still had a couple weeks left in Connecticut before our junior year officially ended. It was nice to share some watered down American light beers with the kids on campus and tell them about the time abroad. They eventually asked what it was like to study Shakespeare, and other things such as, "What was the Royal Shakespeare Company like?" or "Did you learn anything?"

I told everyone, including my 'rents, that I was supposed to be studying Billy Shakes. In reality, I went to travel and experience a new country. Most teachers respected my honesty as opposed to the other little kiss-asses. I mean, I'll give credit where credit is due. There are

more books written about William Shakespeare than almost anyone or anything on earth, except the Bible. He is responsible for inventing over 1700 words, not to mention phrases and first names like Jessica. He has rhymed entire plays. He captured human behavior and the human nature, more so than anyone and mischievously wrote certain sonnets solely about sex and his penis. (151 is a personal favorite.) But, ultimately, it bored me. It was long—way too long—and dry, and no one had the balls say it. Just once I wanted someone to say: Shakespeare sucks. He was boring and stuffy, and his plays are now insignificant. People pretend but no one cares. Just because a four-hour play rhymed doesn't mean it's any good. It appealed to me about as much as the opera—an event I would usually duck out of at intermission. I took from the trip the culture and the differences—the people, the pubs, the bangers and mash. The way everyone said, "cheers, no worries" if they bumped into you, or simply just "cheers." In America, you only say cheers when you drink, but in England you hear it all day long.

A semester abroad really is an enriching adventure. I could feel this experience had given me character and depth. Anytime someone brought up Europe I could join the conversation from first-hand knowledge. Anytime I met someone from England or the UK, I could immediately start a chat with them and sometimes make a friend. It was a wonderfully fulfilling experience that made me a deeper individual.

I also enjoyed winning a beer chugging contest for the first time. "Your Keystone Light is like water to me!" I exclaimed with great relish.

The summer flew by faster than an African track

runner and soon I was a senior in college.

I took a ski-trip to Colorado and spent spring break in Mexico. Colorado was cool, but I went there more for the social side than to see a new state. The mountains were larger, and the snow appeared better than back east. After Europe, though, I didn't think much more of it. In Cancun, my flight was overbooked, and I received my first ever first-class upgrade. You drink for free on first class! I sat next to some cougar, who was already sipping a cocktail. We started pounding Bloody Marys on the runway, courtesy of a very enthusiastic male flight attendant. It was a fun flight.

Besides the pool parties and typical shenanigans, I left the resort one day and hung out at a local shit hole, eating homemade tacos paired with neighborhood tequila. Sitting on plastic chairs, in what seemed like some lady's backyard, tossing back cervezas with the town folk was much more interesting culturally than the debauchery. The energy of the party down there is big time, but it's a shame Cancun is stereotyped as a drunken S.T.D. of a city because of only three weeks out of the year. The rest of the calendar, the climate and beaches are top of the world.

It seemed that I was traveling more than the average kid, but I hadn't been bitten by the travel bug yet. I was going to these places more for the revelry or to break from the monotony of Massachusetts. My travels were pretty typical. It wasn't my passion and I didn't have future plans or any big dream trips. I was learning that traveling could be expensive too. Most of the time I was scraping together to go, borrowing money from my aunt or only going because my friend's parents had paid for the hotel. Even though I only had to pay for my airfare and food, I always

felt like I was stretching it. I graduated from college and, that summer, I worked as a landscaper and a lifeguard. I was having fun, but I wasn't making much money.

Suddenly, almost overnight, my parents did the best thing they could have ever done: they became giant jerks. It was like I didn't even know them. They were so awful that it was almost comical. Complete and utter assholes. Some of my other friends were a bit spoiled. They could lounge around their pools, have friends over to party, with barely any prodding to work or grow up. Not John and Linda Ford. Something snapped. The party was over the instant that September arrived. The free ride had ended. My dad started charging me rent and would take away the car or even ground me for the slightest infraction. Anytime I complained, he was quick to shout the textbook phrase: "This is my house; you can leave if you don't like it."

My mom backed him up with: "Our house our rules...there is the door."

"I hate you!"

I didn't realize it at the time, but they were making life at the Ford hotel as miserable as possible, so I would want to leave. It was tough love, but it kept me from being one of the wimpy, weak spoiled losers. You know—the delicate little prissy type who stayed at home sucking off their parents' tit while never living up to their potential. They stayed at home where it was comfortable. You know, the type who missed their window because they delayed moving, drank too much for too long and convinced themselves their life had meaning because they knew everyone's name on the Red Sox. That wasn't going to be me, but man, it was a rough time. I had to do something. I didn't have a big plan. I was in the middle of a really bad

break up with a girl I was in love with. My parents were charging me rent I could barely afford. Everything just sucked. I kept driving back to Hartford to see this girl. She was a junior, so she still had a year left. Although we cared about each other a lot, I just felt like that loser who graduated and kept hanging around the campus. Kids were thrilled to ask me what it was like to be done with school and what the real world was like, but I just felt they were thinking: "Why is this guy still hanging around?"

My ol' pal, Ken was working at a Chevy dealership selling cars and doing well.

He said to me, "Enough with this lifeguarding; make some real money."

I had a plethora of jobs growing up from bus boy to cart boy, to weight room spotter, to landscaper, to the mysterious guy driving that funny truck that picks up golf balls at the driving range. I always liked trying something new. I figured this would be a fun experience. If anything, I'd have some stories and could always quit.

I love cars and love talking, so they hired me instantly. I could write an entire book based on what I learned from three months at Diamond Chevrolet, but you wouldn't believe half the details. You wouldn't believe the tricks and deception that were masked so eloquently. You would not believe the extent of mendacity. You also could not believe in a million years how much money these dealerships make. Zen in the art of selling cars. This dealership was big time. At one point boasting they were the highest grossing dealership in the country while selling a hundred less cars a year than its competitors. What does that tell you? They didn't just sell you a car, they fucking whacked you. The goal wasn't to just get someone to buy the car. It

was to convince them, that day, to spend $4000 above sticker without even looking down the street. It took a couple days to sell my first car but after that I was off running. It was a huge high. I felt like Giovani Ribisi in the movie *Boiler Room*. I worked thirty days straight without a single day off and put some serious cash in the bank quick. I worked another twenty or so days straight and had one of those Oprah moments—those silly AHAH moments.

I was on an easy path to making six figures. I had a girlfriend and suddenly I could see my whole life in front of me. I could afford a mortgage, a car payment and provide for a family. I could have a yard and a shed with tools and toys and—holy shit, I have to get out of here. This is not me! I am not a 9 to 5 person. I am not a steady job, plan for the future, think about job security, 401k's and retirement. No sir. What the hell was I doing? I'm twenty-three years old. The steady income and fancy suits were tempting, but that is not what gets me up in the morning. I could never work a job I didn't love forever. I was an artist. Money didn't drive me. I still needed to experience more of the world. I couldn't live in central Massachusetts working for the weekend like an unoriginal bastid. I couldn't work at a company I didn't care about, faithfully rooting for the Patriots while pretending they cared back. Crappy backyard barbecues gave me the creeps. I had to do something quick.

As if my life wasn't in turmoil enough, my parents told my brother and I they were going to Ireland for five days and we could come if we wanted. You've got to be kidding me.

I just went there. The nerve. These horrible people couldn't pick a new country? They couldn't pick a place I

haven't seen already?

It was hard to pass up a free trip, so I went. Many kids would be thrilled to go on a trip with their family, but at a time in my life where I was desperate to make a move forward, it felt like I was going backwards. I tried to be positive. It was a far different part of Ireland to which I had been, so at least that was something I could look forward to. We went to the countryside. The Cliffs of Moher and the car commercial drive to get there was astonishing. Croagh Patrick Hill in County Mayo and the whimsical grace of the little pub at the base was something we'd talk about forever. I had fun going out at night with my Dad and some locals he knew from previous trips. My head was somewhere else though. I was thinking constantly about what I was going to do next. Then it hit me.

When we got back to the States, I quit my job that day. No two weeks' notice, no explanation. I never even went in, but instead told Ken to tell them I was moving and mail my last check. I called up Cliff and told him I got enough money to make a move. Where do you want to go—LA or New York?

I had been staying in touch with him since stunt school and he had said multiple times that he'd be my roommate in either city. Still, how many people with less than a week's notice would quit their job and move across country and give a new city a try? A lot of people give you lip service and say yes to things that sound fun at first, but when it comes time to go, they change their mind or give you excuses. Well, C-note from Santa Rosa was a man of his word.

I got on a bus to New York the next day. My Dad drove

me to the Greyhound station in Worcester. All I had was a suitcase. "James, what's the plan? Do you even have a place to stay?" he asked, with dismay.

Dad, I'll figure it out when I get there. My plan was to not have a backup plan. My plan was no safety net...just go.

"I have to go."

CHAPTER TWELVE:
NEW YORK CITY

As I sat by myself on the bus to Port Authority, New York, I impulsively scrolled through my old cell phone and called the few people I knew who had a place in the city.

A lot of acquaintances over the years had told me that if I needed a spot to crash while looking for an apartment to give 'em a ring, so I wasn't too concerned. Lifeguards and kids with whom I had worked, or I had partied with over the summer all told me I could stay. If they flaked, I could always get a hotel...I was winging it, man.

A few summers ago, a filmmaker named Taylor Toole had cast me in his indie thriller Black Eyed Girl. The pay wasn't much, and the film didn't really go anywhere but the production housed me for three weeks on the tasty island of Martha's Vineyard. Martha's Vineyard, Nantucket and Block Island are all summer islands off the coast of Massachusetts. Many presidents have vacationed there because they're so nice (once you get off the ferry). I had been to the islands before on day trips but to be on The Vineyard for three weeks while filming a cool movie was a blast. We shot all over Martha's Vineyard and saw different places that the vacationers would never see. It was a great experience. It solidified my decision to forgo the typical business school route and become a full-time artist. I loved every second of making that film. Working on movies and creating was much more satisfying then job security.

Taylor had a place in New York for work but would often spend the summer in Boston or on The Vineyard. He had already lived in Los Angles and was really making a go at becoming a director in New York. So, he was my first choice to ask about crashing. I was thinking he could give some insight into the industry as well as a couch. Taylor quickly called me back and said I could stay for a couple nights, but he had a roommate. So, there wouldn't be room for Cliff and anything more than a few nights would be pushing it.

"No prob."

Cliff wasn't coming in for a few days. I'll be gone after that.

Taylor's place was sweet and in the middle of Manhattan. I didn't know what 'Kips Bay' or the other neighborhood names were yet but didn't care. I was in New York. It was a fun couple days catching up with T-Toole. Before I knew it, I was heading to JFK airport to meet C-Note. I still couldn't believe this kid dropped everything to move to the east coast almost overnight.

"What's up, dude?"

"SLAUNCHAAH!!"

(bro hug)

"Where to...?" asked the cabbie.

"I don't know...Times Square."

We had zero plans and currently did not have a place to stay. We looked up a few hotels and most of them were expensive; some were $500 a night! The hotels in my hometown were $48 a night...where were those? At five hundred a night, we wouldn't last a week.

We got out of the cab to the bright lights and cacophony of Times Square. We walked around and took

it all in. Slices of pizza were everywhere. There were so many people around. We tried to decide who to call next. Some people have a two-year or four-year plan. We hadn't even discussed a four-week plan.

If you had asked me of my guess, then I would have said we would spend three months here. I'd get a few film credits and then move to L.A. Maybe I'd spend a little longer if it went well. I never thought I'd be rich. I sort of assumed I'd be this hopeless romantic and artist-type dude, working on indie flics and Off-Broadway plays. Meanwhile, I would occasionally paint for fun. I'd be living in a shithole, but I'd be happy because I loved what I did. I could see myself looking down on all the wealthy people who had big bank accounts but hated their jobs and miserable lives. They had 401k's and large portfolios, and all the while they had little life experience. I wanted to live to work rather than work to live. I wasn't going to do any other job other than acting. I was going to hustle as hard as I could and, if I had too, I'd move back home. I would save up more money and go back and try again. I was never going to quit. One of the first goals I told my friends was that I would never be a waiter or a bartender. It's too easy. It's pathetic. It's so cliché and completely unappealing to me. I'd be poor or shovel rocks before I'd go into the service industry like all the unoriginal losers copying Bruce Willis and other actors of the eighties.

I really thought it would be six months max, until I'd go to the west coast. But currently, it was getting late and we still didn't even have a place to stay that night. Some hooker with whom I lifeguarded one summer let us keep our bags at her place, but the two of us couldn't stay because of finals. Oh yah, Mickey's brother Raj lived in

New York. Thankfully he was home. Generously, he let Cliff and I crash there. He lived in Hell's Kitchen with his fiancé and his gay roommate Chris. The apartment had two couches in the living room; that's where we slept. I assumed we'd find an apartment the next day, but it took a week to find a spot. Thankfully, the place was a gem, because we were beginning to run out of people to call and were starting to stink up the apartment.

A Craigslist ad from an NYU student is what we clicked on. He had a deal and a half. He was renting a four-bedroom apartment for nine hundred a month. Well, actually, an elderly couple had a rent-controlled apartment on the upper west side. It had been in their family for a million years, so their rent was like three hundred bucks a month for the entire four-bedroom apartment! They retired to Jersey but didn't want to give up the property, so they rented it out to trustworthy students just to keep the place. Every couple months, they'd pop in to check it out, but they were never there.

The kid from NYU who posted the ad met with us. "Look, here's the deal. This place is a find. They are charging me $900 a month for the whole place. Two bedrooms are off limits. The rest of the place is open. The apartment is old, but it is huge. I'm leaving for six months and want this place when I return. If you tell them that we are friends and you go to NYU, then the place is all yours until I get back. They will only rent it to NYU students."

All we have to do is tell these people we go to NYU and we each pay four-fifty a month to have a four-bedroom in Manhattan? YES and YES.

The couple was into classic movies, so we got along great. The next day we moved into a New York Story!

The low rent allowed for absolute stress-free living. I didn't understand all these people complaining about small cramped apartments. We didn't need to worry about the end of the month. I could focus on hustling the entertainment industry and Cliff could do the same. We hit the ground running.

Our pad was on 124th Street near Broadway and La Salle, one short block away from the 125th Street subway stop. 124th Street technically was not Harlem, so we could pleasantly say "Upper West Side" when asked where we lived. We'd buzz downtown daily from our elevated subway stop and return at night. Our place was mint! Cheap and big, baby. You wouldn't believe the size of this place. Although we were only allowed in two of the bedrooms, we told guests the whole place was ours.

It didn't take long to notice the things that make New York—well, New York. The city doesn't sleep. There are countless bars and restaurants that stay open till four every morning, not just the weekends. There are little stores called bodegas that stay open twenty-four hours a day, welcoming late-night sandwiches, common household items and even beer. I never moved to New York to experience the city. I was there purely for the industry, but man was this place for real. I'd visit back home and be dumbfounded at how stagnant life felt in comparison. There was something to do every day and every night.

I started noticing women for the first time. Not girls, but women! Mid-thirties or forties...the legs. Wow! Tight thighs, tone calves, and tan. Their legs went on for days, even in the winter. What is this place! I had only ever had eyes for college girls but sock me sideways. There were

beautiful woman everywhere. Nice skirts, sexy high heels, business suits, and blouses. They were on every corner and on every block. Central Massachusetts is not known for its style or fashion. Every town in America has cute girls, but most women let themselves go in their late thirties. They have kids and get frumpy. This was a sight. Cliff and I both started dating immediately. I didn't want to admit it yet, but the energy of the city was slowly winning me over. I still hated the place because it was an overcrowded, overpriced, smelly, unnatural, dirty, cluster fuck of an area but...there was lots to do as a young, single, actor. While everyone was still complaining about how small their apartment was and how much rent sucked, C-note and I were living it up.

I got an agent quickly and started auditioning. Overnight I developed this laser focus. I hit a couple commercials right away. They were small but Mike Amato, my agent, liked my energy. My first film credit was a big part in a low budget horror film: *Knock, Knock*. Soon after that, I was cast as a principle football player in Across the Universe. I joined the prestigious Screen Actors Guild the following month and got my SAG card. I was moving. I had a separate agent now for commercials. I was auditioning for everything and anything. I was going to read for stuff every single day. Film, TV, pilots, industrials, big commercials, little commercials, one-act plays, off-off-Broadway plays, student films, short films, voice-overs, and even print work. My days were constantly filled with appointments, meetings, callbacks, and rehearsals. Some weekends I'd do a student film for free, just to stay fresh and make potential connections. I may only have been on set a handful of days in a month, but I was working seven

days a week. When I wasn't working, I was working to get work. No day was wasted. I absolutely can sit still, I just choose not to. I was bouncing like a pinball all over the city.

I was more concentrated on my career than where I was living but I couldn't help to observe the drastic differences in each of the neighborhoods. A few blocks one way and it was like you were in a new country. Just a few blocks the other way and you were in a new world. There are over seventy-five different neighborhoods in the city of Manhattan. That's not counting the other boroughs. That's just within the Uptown, Midtown and Downtown of "The City So Nice, They Named it Twice."

Each part of this tiny, cramped metropolitan city had its own unique style and personality. Different colors, shapes, signs, smells and shops. I learned the subway lines in and out. I knew which way was east and which way was west without asking or looking. I could hail a cab with swagger, and I had the local assurance to yell at a cab driver if I thought he was running up the meter. I could tell the difference between the upper west and upper east. I loved exploring the lower east side and Greenwich Village. This city was a scene. The yellow taxis dotting the streets and the millions of people hustling about. From Wall Street to Inwood, I was seeing it all. I always loved the area around SOHO (South of Houston). You have this ultra-hip, high-end, neighborhood with big time shopping and stylish eateries. It's just a few blocks away from Chinatown, where hundreds of Asians peddle knock-off designer wear and bootleg DVDs. Rows and rows of pirated merchandise, phony cologne and stolen Gucci hand bags. Nestled just next to that was Little Italy, a tiny

area only a handful of terse blocks long, that made you feel you were in downtown Tuscany. The Italian restaurants were all next to each other in a row, one more authentic than the next. Each had a slick haired, well-dressed Paesano that was barking specials from the door. Even the parking meters were painted the colors of the Italian flag.

It always bugged me that most people who visit NYC only go to Midtown. They see Times Square, then walk to 5th Avenue. They snap a pic of the Christmas tree at 30 Rock and peak down at the ice skating rink. Then, they pick a gimmicky restaurant for dinner before seeing their Broadway show. They go home and tell everyone they went to the city!

Never once do they venture out to experience all the wonders lurking in lower Manhattan. Never checking out the real nightlife of the lower east side, with its posh lounges and vintage cafes. Never making it to the cobblestone streets of trendy Tribeca, where the locals live in lavish, loft apartments and cool sidewalk restaurants are everywhere. They may take a horse ride through some of Central Park but wouldn't dare go south to Washington Square Park and discover the colorful strip of bars on MacDougal Street. They'll see Radio City Music Hall but won't even walk by the jazz joints and comedy clubs in Greenwich Village. I love Times Square but can't imagine people visiting the city multiple times and never getting out of that area.

CHAPTER THIRTEEN:
SEX IN THE CITY

There is a reason they set the hit TV show *Sex in the City* in NYC. It was unbelievable. If you couldn't find a date in New York, then I don't know what you were doing.

Women do not move to New York to find a husband. No girl has ever once said: "I want to move to Manhattan to settle down."

No, they move there for their careers. Some girls just want to experience living in the city for a year before moving elsewhere to plant roots. Most move in hopes of becoming the next titan of industry. They'll work for a big magazine, boost their fashion resumé, jump start the law career, break into finance, get an internship at a top company and move up the corporate ladder. No one is looking to start a family in the city.

Europe is laid back when it comes to sex and one-night stands, but New York City is aggressive. No jokes; no games. The girls work hard and certain nights they simply need to play hard. The happy hours are intense— successful, advancing woman looking to blow off more than some steam. The late-night hours are effectual. The number of bars and patrons that you can find partaking in late night hours is astounding...but the number one thing that makes this city so accommodating to the casual, carnal embrace is the taxis and subway system. Without a doubt, the overabundance of taxis, on top of the reliability of the subway system makes this place a haven for

unplanned intimacy. This was before Uber! You see, almost every city in the country, small or big, has a bunch of big cock-blocks. The bar is empty. It's last call and there is low energy. People aren't drinking. The few candidates in the bar certainly are not getting drunk because they are driving. Or their friend needs to get home because of work. Someone is the "designated driver" and wants to get going. Twenty to thirty minutes in the opposite direction seems too far. "I have work in the morning and I don't know where I am going. Maybe another night."

Not in Manhattan, baby! Everyone is drinking every night. Thursday; Saturday; Tuesday—it doesn't matter. You know the spots where there are enthusiastic people up and out. If you start a chat with someone and you're having fun, then it doesn't need to stop. You can effortlessly and safely hail a cab within seconds and be at their place or yours. No need to give it a second thought as to how to get home in the morning. Another cab will be available then too. Don't have the extra cash for the taxi? The amicable, trusty ol' subway map will show you a plentitude of lines and stops. Wherever they live—whether it's Brooklyn, Queens, Uptown, or Downtown—you're never more than a dozen blocks from a subway stop. People always complain about the NYC subway system, but I think it is a modern wonder. It goes twenty-four hours a day, every day. The number of places it goes, and the amount of options you have, is ridiculous. Sure, there are delays; sure, it's a little less reliable late at night. Still, it will come, and there will be people around. It's awesome.

My favorite bar was Rudy's on Ninth Avenue, a neighborhood dive bar with free popcorn and hot dogs.

The booths were old and ripped but Rudy's was a warm place. The cheap pitchers of beer flowed like wine and the women would flock there instinctively like the salmon of Capistrano.

Cliff had gotten a tattoo on his ass awhile back that said: "your name." It literally read: "your name" in small black letters. If he overheard some girl's name mentioned at the bar, then he would have me go over and ask how she spelled it. So, for example, if the girl's name was Stephanie...I would say: "Excuse me, do you spell your name with a 'y' or an 'ie?'"

Then her friends would ask why. We would quickly explain that he has her name tattooed on his ass and wanted to see if it was the correct spelling. Sometimes we'd have a group of people crowded around cheering and demanding he pull down his pants and show us the tattoo.

"Oh, you spell it that way...I definitely have your name tattooed on my ass."

"I don't believe you; no way!!"

"Look, if that's really your name...then I have your name on my ass."

"No way, prove it!"

"Ok, if I pull down my pants and have your name on my ass, then what are you gonna do?"

We got a lot of free shots and had some fun. We also got kicked out a few times.

CHAPTER FOURTEEN: PRIDE & GLORY

Well, our party was coming to an end. The six-month sublet was almost over and we needed to find a new place. Surprisingly, there were no other four-bedroom apartments for nine hundred a month. Yah, we were shocked too! There wasn't anything even close—unless you wanted a basement studio in Far Rockaway. Rent was thousands of dollars in Manhattan and most of the listings came with other roommates! We searched tirelessly all week. The only thing close in the big city was railroad style. It was still twice what we were paying for our mansion. Eventually, Cliff found a place...in Queens.

It would be an enormous downgrade. There was a certain amount of status that came with living in Manhattan at the time. Williamsburg was on its way, but Astoria hadn't become cool yet. Saying you lived in Queens was like saying you had syphilis.

It didn't matter. I had to check my ego and do what I thought was best. Cliff found a puny bedroom for rent in a family's house near Jamaica, Queens for six hundred a month. We went from a colossal place on the Upper West Side to sharing a tiny bedroom on the second floor of a Filipino family's house. They had two small children running around and an old guy renting another bedroom. Wow. My portion of the rent was only three-fifty a month and that would keep me hustling. It was about forty-five minutes to an hour train ride into the city. I would go in

every single day, regardless of whether I had something or not. I would just harass my agent or knock on a casting director's door. (They don't like that.)

The house was a mess, and it was a horrible commute. After another six months, Cliff had seen enough of New York and moved back west. The family quickly replaced him with some random from Craigslist. He was a nice kid, but now I'm sharing a bedroom with some guy I don't know in someone else's house.

If things weren't going so well, you didn't want to go back and sulk in this place. It would make you feel worse. Living in those conditions made me work harder than I ever worked in my life. I didn't want to live like this for long, so I was beyond motivated. There is a fine line between persistence and annoyance and I was riding that line hard. The tough thing about the business side of the industry is that, even though you can make a decent chunk of change in just a day or two of work, it takes a while to get paid. Sometimes it's months and then your agent takes a commission BEFORE taxes and the whole thing sometimes kinda stinks. People, friends, and family thought I was crazy for the living conditions I chose, but I had to do it. My friends were all buying cars and saving for a down payment on their first house. I couldn't even bring a girl back home with me. Imagine that: Ok, we just have to go through the dirty kitchen and screaming kids. Then, when we get to my room, we can fool around on my bed. It is two feet from my roommate who is sitting on his bed looking at MySpace.

But, while my friends were slaving away as a corporate puppet, stuck in a rat race trying to make their car payments to drive to their job they hated...I was chasing

my dream. I still had a smile ear to ear. At three-fifty a month, I didn't have to be some goof working for tips. Working another job while you're pursuing acting is a bad move. Even if you make decent money being some monkey, it takes your time and energy away from what you really want. It distracts your drive and focus. I was available for anything, anytime the phone rang. I was so much happier hustling and seeking out something with substance.

Another six months of roughing it, The Filipino family found a different house in Forest Hills, Queens. Forest Hills was a much nicer neighborhood and a lot closer subway ride to the city. If I was out late, I could actually grab a cab without them saying: "No, I don't drive there."

I still had a fire under my ass to work hard. After I moved in, I stayed one month and then gave them my thirty days notice. I didn't have a place lined up. I just knew I couldn't live in a family's house much longer. My hard work was starting to pay off. The phone was ringing. I had been auditioning for some great projects and stuff started to gel. Suddenly something crazy and completely unexpected happened. I got a phone call about Ed Norton.

A year before the call, I met this seemingly random guy by chance in Grand Central Station. He said he was in the industry but mostly doing extra work at the time. He was cut like Jean-Claude van Damme and very enthusiastic. He was into martial arts and fitness, so I mentioned I went to stunt school. He gave me his business card and we exchanged a few electronic mails. Months later, he casually sent me another email saying he knew a stunt coordinator named Pete Bucossi. He gave me his address

and suggested I send him a headshot.

I was sending pictures and dropping off demo reels to everyone and anyone, so I didn't think much of it. I sent this stunt coordinator I didn't know a couple pics with a note, but I never heard from him and just forgot about it. I didn't even know what sending a picture to a stunt coordinator meant. I was acting. I didn't even know there were stunt coordinators in New York. Well, a year later, Pete called back out of the blue. He said that he got my pictures and was looking for a stunt double for Edward Norton on a massive studio film: *Pride and Glory* with Colin Farrell. Even though I went to stunt school, I wasn't pursuing stunts. I didn't know you could or even how to do it. I still didn't think there were actual stuntmen outside of James Bond movies.

I went down to set and met Ed's people, the director and some stuntmen. I got looked at by some of the hair and makeup department. Although I lacked the credits, I was his exact height and weight and had that funny stunt school on my résumé. I knew how to fight and wrestled a bit in school, so they decided to use me. I never thought this would lead to anything other than a fun story. The next week, I went from eating ramen noodles in this crappy room in Queens, to a multi-million dollar set with cranes, big lights, trailers and craft service tables the size of Greek weddings. I met Ed and Colin. We went over the x's and o's of the big fight scene for the end of the film. I thought at some point, someone would come over to me and say: "Ok, you almost fooled us...time to go."

But they let me stay and kept calling me back. We filmed fights and foot chases all over Washington Heights in Upper Manhattan. It was almost unreal. The filming

went great. I didn't realize how involved and fun being a stunt double was. The movie ended. I got a fat paycheck and I thought that would be it. I figured it was a one-time gig—an arbitrary experience and I would never do stunts again.

CHAPTER FIFTEEN: NORTH CAROLINA, COME AND RAISE UP

I had lived with that Filipino family for over a year and it was time to say goodbye. I was moving to Astoria. Astoria, Queens was very up and coming at the time. It was so close to the city and still super cheap compared to Manhattan. I had a bunch of friends that lived there, and they spoke highly of it. There were a ton of young artists, models and actors living there so it seemed like the place to go. Most of all...I was getting my own room.

A Greek college kid was going back to Greece for the summer and was looking to sublet his fully furnished place for one month. It wasn't anything fancy, but it was all mine. It gave me some time to look for a place a little longer term.

After he came back, I moved a few subway stops away to another spot that was month-to-month. I had the option to stay as little or as long as I wanted. I still shared an upstairs kitchen and a bathroom with some Indian tenants and a street busker. Downstairs was my own spacious room. It was like a studio apartment and bigger than just a bedroom. I had a bed, a couch, a desk and a TV in there. I could actually have guests visit. Friends could stay the night. I could finally have a girl over. Things were looking up. I was barely there a week and the phone started ringing.

Word had spread quickly that a young kid with no

credits landed a huge stunt job on a blockbuster movie with Edward Norton and he did a good job. A stunt coordinator named John Copeman, who lived and worked in North Carolina, gave me a call. He was coordinating a TV show called *One Tree Hill*. It was a huge prime-time drama for the CW. He needed a young-looking kid to stunt double the actor Chad Michael Murray for an intense fight. In the stunt world, it can be hard to hire young kids you can trust. Everyone trying to get into stunts says they can do it, but you have to be careful. You don't want any yahoos or wild-men. John had called Pete asking if he knew any young looks that were 6'1 and 165 pounds that would hit the ground. Pete told him he just got done working with me and I was that exact height and weight. Before I knew it, I was on the phone with a travel coordinator setting up my flight, hotel and car service to the "Old North Sate."

"Whoa, this is cool."

I felt like an important businessman getting flown somewhere for work. I had on ripped jeans and a faded skateboard t-shirt, but I felt like a million bucks. North Carolina always sounded interesting to me. I didn't know much about it other than Michael Jordan went to school there and won an NCAA championship for the Tar Heels. Most summers during my college years, I and all my preppy white friends used to blast Petey Pablo's hit: "Raise Up" in our parent's Sport Utility Vehicle and pretend we were hood. Other than that, N.C. was a mystery to me.

Touchdown Wilmington. A car picked me up and I checked into my room at the Hilton, just a few blocks away from the bustling downtown and a few miles from the beach. I was there for a week and what an adventure it

was. The rehearsals and filming all took place at Screen Gems Studios in Wilmington. Most of the country assumes the only studios are in Hollywood and New York, but Wilmington has been a huge part of the entertainment industry since the studio was built in the eighties. In fact, this studio is the largest studio outside of California. It enjoys many stages and 150,000 square feet of open, column-less filming. This place was surreal. All the rooms were fake sets. They looked like real bedrooms or working kitchens, but they had no ceiling—just miles of pipes with lights. The rooms had at least one removable wall, so large that cameras could be set. I was focused on the choreography of the fight, but at the same time, I was in awe at this new world I was in.

We had a day off in between the rehearsals and the filming. I got to explore a bit of the town. I noticed a lot of blonde hair and deeper tans than up north. Some of the cast was at the same hotel so we all hung out at the pool. I swung by the production office to fill out paperwork. Then, someone handed me envelope labeled: "per diem." Per diem is quite possibly the sweetest little treat ever invented. Per diem is a daily cash allowance given to performers by production to cover daily living expenses like toiletries or food. On top of a very generous S.A.G. weekly contract, which included pay for both travel days, I was given a small envelope with three hundred dollars cash in it. Their rate was sixty a day for my five days of work. I remember getting dinner that night and not caring about the price. Most of my dinners were slices of dollar pizza or below average Chinese food. I felt like a king. I was even able to leave a decent tip for once.

The filming was a lot of fun. I got tackled through a

breakaway table. Some wrestling and punching on the ground followed. For the finale, an actor and I picked up the other stunt double, John Gilbert, and threw him through a candy glass window with a balsa wood frame. It was scored to splinter on impact. The gag looked brutal. Behind the window was the stage wall and cement. There were tables with the crew, but they had a huge, blown-up picture of a backyard to make it look like he fell outdoors. There were crew members and extras eating soup just feet away from this canvas, but on film it looked like he fell onto someone's front lawn in the middle of a neighborhood. Movie magic. I could have stayed down there for a year.

In between takes and setups, I got to chat with Copeman and another stuntman, Dino Muccio. They had both been in the business for a while, and it was interesting to hear their stories while picking their brain a bit.

Afterwards, Matt Bar, one of the actors, invited me out. We had some beers at a local bar. Sophia Bush and Hilarie Burton stopped by for a couple minutes. It was cool to see the series regulars pop in just to say hello. They were in all the tabloid magazines at the time, so they didn't stay long. A bunch of us then hit the town. A clean, colonial era looking street is where we had a little pub-crawl. There were some bachelorette parties and people in the street. It was a friendly and classy town.

I'd go back to North Carolina a few more times over the years. They have almost all you could want up north, minus the traffic, the property taxes and crowds. Additionally, houses came with yards too. That was something you didn't see around New York. I could live in

North Carolina full-time.

> "This one's for North Carolina! C'mon and raise up.
> Take your shirt off, twist it 'round yo' hand.
> Spin it like a helicopter.
> North Carolina! C'mon and raise up.
> This one's for you, uh-huh, this one's for who?
> Us, us, us; yes sir!"
> > Petey Pablo

CHAPTER SIXTEEN:
THE BUCKEYE STATE

I wasn't back from *One Tree Hill* a few days and the phone rang again. This time it was from Alex Pucci, the head producer at Screamkings. I had auditioned almost a year ago for a number of different frat guy roles in their upcoming horror film, *Frat House Massacre*. The title alone says it all.

One thing I was learning about movies was that they took a lot of time to make. They take a while to edit and release, but sometimes it would take even longer just to get started. Stuff was always getting pushed. I went in and read for this film a year ago, had a callback a month after that, and a year later they finally call me to say that I'm flying to Ohio. Schedules change, money needs to be raised, locations fall through, and stuff gets pushed. As a new actor, you sort of take these films for granted. All the phone calls, meetings and effort to put this machine together...you don't see all that work. You kinda show up and everything is there; you just play. One million dollars is low budget for industry standards, but it's not easy to raise that money quickly. Well, I was soon on the phone again with a travel coordinator who set me up with a flight from New York to Columbus, Ohio.

Ohio is a great state in my opinion. It's very American. There isn't anything too extreme about the place, aside from the size of the Buckeyes' home stadium and their rivalry with Michigan football. It's normal. People are nice,

but not too nice. It's neither poor, nor is it fancy. The accents are standard and fairly neutral. The waitresses are delightful and cheerfully chubby. They are not trying to be anorexic. No one is running around preaching organic this or kale that. I like it. I have a few friends from Europe and other countries. They, like most people who want to see "America," think: New York, Miami, Vegas and parts of California. New York is so extreme that it's another galaxy. People in New York walk faster than any place else in the world. You get out of a subway, and it is one speed: move faster. Vegas, Miami and these other big cities aren't a real depiction of American life. I always tell people that you should visit Ohio. Drive around and get yourself a big breakfast at Bob Evans. Scoot down to Cincinnati and get some chili. See how typical Americans are. Go to the Midwest or the Great Lakes region for a couple days. Screw Miami.

I filmed for a week in and around Dublin, Ohio. I flew back to Astoria and, a couple weeks later, I was flying back again.

STORY TIME: So, I guess I was getting comfortable flying because this was funny. I got my next flight from production. Laguardia Airport to Columbus, Ohio. Short flight.

The flight leaves at five thirty-five in the afternoon. Astoria is so close to LGA that I'm there no problem. I post up at the FOX Sports bar, about ten feet away from my gate. One of my favorite places to have a drink is at an airport bar. I get there early, relax a bit, order a drink and smooth out the bumps. The airports know that a lot of people don't like to fly. So, they make it easy for you to get

buzzed up and spend your money before you depart.

"I'll have a beer."

"For $2.14 more, do you want to make it a double?" the female bartender tempted.

"Sure."

"For $1.62, do you want to add a shot of Jack Daniels?"

"Ok."

Geez. If I ordered a double beer and a shot, right off the bat, I'd look like an 'Alchy.' But, they are asking. They are asking everyone! A couple of girls with Indianapolis Colts shirts on are sitting next to me while doing the same. We are laughing at the entrapping drink deals and decide to order more. We are exchanging stories, making toasts and taking shots. We are having a jolly good time until someone asks what time my flight is, to which I say five thirty-five. The bartender hands me the check and informs me it is five twenty-eight.

"Do you board at 5:35 or is that the time of the actual flight?" she asked.

Dammit. I forgot you have to board a half hour before the flight. I settle up and run the ten feet to the gate, which is now closed.

I speak with the lady at the desk.

"Hi, I am here for my flight."

She looks at my ticket, then exclaims, "It's 5:30; we boarded a half hour ago. We had final boarding call ten minutes ago."

"Oh geez, I didn't know about boarding. I thought I was early. It's not 5:35 yet? I am early!"

"Sir, the plane is on the runway. We called your name three times. Where were you?"

"I was right there. I was sitting right there. I didn't

hear you. I have to get on that flight. It's for work."

"Hold on."

She picks up the phone, dials and says: "I have the last passenger...ya...ya...I don't know...Yah, ok."

She looks me up and down and says: "Ok, they are going to let you on. Follow her."

Some lady brings me through the doors, down the stairs and outside.

I am like: Now what?

She says: "Hold on, a shuttle is coming."

A shuttle bus comes and picks me up.

I am like: "What the...? Where are we going?"

The plane was already on the runway. The shuttle driver drives me five minutes out to the plane which looks like it's about to take off. He stops next to the plane.

I go to the door and he tells me to wait.

He is giving hand signals back and forth to the pilots. Finally, they give him some signal and he opens the door for me.

I walk out onto the runway. The plane looks so big up close; it's so high. How am I going to get inside?

Suddenly, the stairs open and move down.

"This is cool."

I feel like the president. I am walking all tall up the stairs...making a big entrance until I get to the top of the stairs.

Daggers are what the stewardess stared back at me with—daggers. I waved and smiled. She just looked pissed.

I turned to my right, thinking I would see smiles.

Nothing. Everyone was all buckled up and pissed.

They stared up at me hard with angry faces, thinking: "This is the kid...this is the reason we are delayed."

"Hi, hi everybody. Hi, sorry."

I walked down the aisle to my seat. I didn't even have my seatbelt on. We accelerated fast and took off. We were in the air seconds later.

Haha. Wow!

I was sitting next to a German girl. She was taking a semester at The Ohio State University. I told her my story and she was laughing. About twenty minutes later, another stewardess asked me if I wanted anything. I couldn't believe they were talking to me.

I asked if they had any beer.

She said, "Sorry, all we have is cans of Budweiser, and it's five bucks a can."

I'm thinking: "Are they really going to serve me...?"

"Awesome. I'll take a Bud-heavy please."

The girl wasn't twenty-one yet, so she couldn't buy a beer. I let her have some of mine.

We sipped Bud-diesel at 30,000 feet as we flew towards Ohio. She even gave me her number before we landed.

What a flight.

I was in and around Columbus shooting for a solid month. It was great to be on location and working steady for a month. It was refreshing to not have to look for work, but rather I could focus on my actual job and my character. Up until this point, most of my jobs were a couple days— maybe a week.

We were filming a lot of nights. Work all night and sleep most of the day. I loved it. They did a nationwide casting call for the frat guys, not just New York and Los Angeles. They held castings in Seattle, San Francisco,

Chicago, Boston, and even Indiana. They really wanted unique guys. I made some good friends over the course of the month. A couple guys were from LA, so I knew whom to call if I went out there. We all had a ton of fun. We were filming on pig farms, frat houses, and on college campuses. The local girls treated us like the Beatles. It was a blast. One night, I even gave that German girl from the plane a call.

CHAPTER SEVENTEEN: JOHN ADAMS IN VIRGINIA

The ball was rolling. I was back from Ohio, enjoying my one-bedroom castle in Astoria. I was getting bites for work constantly. I began to really enjoy where I lived.

FUN FACT: Astoria, Queens is the most diverse neighborhood in not just the United States but on all of planet Earth.

There are so many different races, creeds, religions, ethnicities, and national origins all in one town. This includes anything from Greek to Spanish to Polish to Armenian to Irish and Japanese. Easily eighty-five to a hundred different countries are coexisting peacefully in this urban space. It's something else. It's not just a couple people from each place or ancestry either. They have their own churches and their own communities. Each is deep in population within the city limits. Not one food style dominates the region either. Greek, Italian, Mexican, Ecuadorian, Peruvian, Pakistani, Chinese, Thai, African places from all over are everywhere. It's the opposite of Providence College and all their white people.

This place is rich in culture and never boring. I have had friends visit with the main intention to go into NYC for the night. On the way to the subway, we may pop in a place for a quick bite or a drink and end up spending hours. Some even say: "Dude, you want to just hang out in Astoria...we don't have to go to the city. I am having so much fun here."

Some great American pubs and wine bars were starting to pop up as well. Any place in Queens is always going to have the slight stigma of being dirty and dangerous, but Astoria is a very safe and friendly place. No sketch-balls roaming, just a lot of young fun people. It doesn't get a ton of attention because it's across the East River from the capital of the world. I guarantee you that if Astoria wasn't next to Manhattan and somewhere else...it would have the reputation of being one of the best cites to visit in the world.

I was working hard all day, still doing mail-outs in between gigs. I had sent my pictures randomly to a Canadian stunt coordinator named Branko Racki. Branko occasionally worked in the States and was looking for guys. He was currently running a huge H.B.O. mini-series called *John Adams*, in Richmond, Virginia. He called me right back and asked if my hair was still long.

It was.

He said: "Great, I'm putting you on a flight Monday."

Wow, things were moving.

We were based in Richmond but filmed all over. It was a period piece, so we were filming in remote areas way away from civilization. Fields and swamps were our office. A ship was one location, which we were at a lot. I couldn't tell you if it was The Beaver, The Dartmouth or The Eleanor, but it was a big-ass ship that was used to create a scene from the Boston Tea Party. There was a vast field of grass, miles away from anything that looked present day. A gargantuan-sized wooden ship with sails and everything sat in the middle. All around the vessel were even larger walls of green screen. They had huge chests of water,

hoisted high above the ship that would dump over the sides simulating waves and choppy seas. They had these big, round one hundred miles per hour wind fans to fabricate storm sequences. It was a fun world to live in for a couple weeks.

We worked off and on for about five weeks. Sometimes Monday through Friday, but they never kept us for the weekend. Production would fly us back to New York and back the next week. All those flights and vans from the airport, I would have thought it'd be more cost effective to just keep us in the Sheraton for the weekend. Yet, it was 150-million-dollar budget project with Tom Hanks producing it. I guess they weren't too concerned. Some days we were filming two hours away from the hotel. So, after filming for fourteen hours, you had to get in a van and ride another two hours to get home. It was long hours, but it was fun.

The stunt coordinator, Branko Racki, was a character. He had made it to the NHL as a professional hockey player. He even played and partied with Wayne Gretzky. He was so generous and really took care of everyone. We were making over seven grand a week with our contracts, stunt adjustments, travel time and overtime. I couldn't believe it. The group of guys I was working with had been in the business longer than me and still were excited. Honestly, I was having so much fun looking at that ship in the field and climbing the ropes, while pretending to be a sailor, I would have done it for free. Some people were there only a couple weeks but a group of us were there the whole time. Some were from New York. Even John Gilbert, John Copeman and Dino from North Carolina came up for a couple weeks.

One day, our job was to get into a rowboat and make it look like we had been rowing all the way from Europe. The scene never made the final cut, but it was an interesting day. We got vanned way out to the coast, and then got into wardrobe. They put us on a huge ship and took us way out into the Atlantic Ocean until you couldn't see land. They then lowered in our tiny wooden skiff. We got into the boat and started to row. The waves were big. They had several camera boats circling around getting various angles of our effort. Safety boats and divers were in the water in case we capsized, or someone went overboard. We did this for a couple hours, and then went back to shore and to the hotel. It was still a ten to twelve hour day with all the traveling. All that for a few minutes of footage that is on the cutting room floor.

As far as seeing the town, most of our meals were at the Sheraton bar and restaurant called Shula's. The older guys would prank us whenever the younger guys and I were eating at the bar. They'd buy the most girly, fruitiest drink of which they could think and send it to us with umbrellas in it. The bartender would come over and say: "Those gentlemen over there bought these drinks for you; and they think you're cute."

We'd look over and they'd be waving their hand all goofy. Haha; classic!

It was a lot of work and a lot of fun. A few nights we got to go and see the old streets. Branko lived a life that many of us hadn't experienced yet. He owned a Ferrari, made a fortune and had a very lavish lifestyle. When he asked us to go out to eat, I've never seen such bills. A hundred dollar bottle of wine to start, fine scotch, cigars, and more wine. It was a trip. He made most people more

money than they'd ever made in a week. But, you'd spend more money in one night than you could believe. I was starting to get a taste for the finer things in life.

It's always nice to hang out with older people. I feel you learn more from them. The only thing millennials can teach me is how to look at a phone more. I liked these guys and the project was a smash success. It was neat to be a part of a history piece, too. I never paid much attention to history in school. Imitating the teacher was more fun than learning about crap that happened a while ago. Now, I was learning about the eighteenth century, John Adams and the birthplace of our great nation. Virginia was named after Queen Elizabeth whose nickname was the Virginia Queen. More presidents are from Virginia than any other state. The big cash crop of the state is tobacco. There was even a huge Phillip Morris building outside our hotel. Kind of weird to see that every morning as you're driving out of the parking lot.

Hey, you know what they call cigarettes in Massachusetts...? Lung darts!!

CHAPTER EIGHTEEN: ARUBA

Hey, I thought this book was about the US, not random countries? Focus, Jim!

I know, I know—quick vacation.

I'd had enough of the Indian family's shenanigans and smelly kitchen, so I moved apartments. Then, I moved again—mostly one or two-month sublets, until I found a place near Ditmars Boulevard and Steinway Street. A kid named Alex had a three-bedroom apartment and one bedroom was empty. This was a regular place. The other roommate was a sleepwalker, but we didn't see her much. It was normal, and Alex and I got along great. There were two bathrooms, a huge living room, a clean kitchen and a small balcony. Alex was a musician but loved sports, so, we'd sit and watch games with our beer and sandwich that we bought from the bodega across the street. I liked this place a lot. It was near a ton of bars and restaurants. There were gyms, bakeries and sushi spots. The neighborhood was alive and well. I had a bunch of friends that lived nearby, and I loved my job. I didn't think I'd ever need anything more than this. I started booking commercials on a national level. Every time it airs, you get a check and some of them were airing all the time—present on multiple channels. I couldn't believe it. I was paying rent in a comfortable apartment as well as paying my bills as an actor. This is crazy.

A few years before, my aunt had a little cancer scare.

A small tumor near her ear had to be removed. She went through the whole process like a champ and was cancer free. Boston hospitals don't mess around with that stuff. My mom decided to celebrate her one-year anniversary of being cancer-free with a trip to Aruba. They didn't think of inviting anyone else, but they gave me a call when they checked their flights.

"We have a layover in New York," they said.

I shook my head.

"It's Boston to New York, and then New York to Aruba. I know it's last minute, but the hotel is paid for. See if you can find a seat on our plane," they continued.

I was really busy with work but realized I hadn't taken a vacation in a while. My work was a vacation. I was loving the United States and all my recent exploring, but something about a new country intrigued me. It sounds weird to take a trip with your mom and aunt. It sounds really weird, but I'll tell you that it was an incredible trip. Astoria's location is great for getting to airports. A quick train ride, and soon I was walking down the aisle of the JetBlue Airbus. The Bobbsey Sisters were sitting in the middle, smiling and waving like goofballs as I walked past them to my seat. "Oh boy!"

The second we touched down, I got why people like Aruba. I understand why my Uncle Bob and Aunt Judy have been here over fourteen times and still talk about going back again. Aruba has replay value. It's a quick and direct flight, straight down the east coast. Four hours and you're in pleasant, sunny weather. White beaches, gentle turquoise water and a happy vibe all around. It's so easy and hassle free getting there and back.

When I vacation, I like to run around. I enjoy seeing

and doing everything but not this time. I was really relaxed. I had been beating the streets of New York hard, without a day off or a vacation, for over three years. If I wasn't working, then each day I was working to get work. I was also working out constantly to keep the body looking decent. I didn't sleep in; I didn't take a day off. So, when we checked into this modern beachfront Marriott, I didn't do a damn thing. My daily decisions were: "Do I take a nap by the pool or take a nap by the beach?" Or, "Should I go get a drink at the swim-up bar or stay here and have one of those guys bring me a beverage?"

My mom would point to the booze cruise ships: "Look, they even have a rope swing."

"Nope, I'm good."

My aunt would go on and on about the trade winds and how ideal they are for windsurfing. She even offered to pay if I wanted to take a lesson.

Normally I would have jumped at that.

Not this trip. I am good right here.

Eventually they talked me into trying the local golf course. I played a round at Tierra del Sol, a championship track that combines ocean views with impressive desert scenery. The sun was hot and glaring, but the course was in immaculate condition. I had some good shots and a cold beer while I added up the scorecard. Ok, back to the pool.

One of my favorite things about Aruba is the sunsets. The island is just off the coast of Venezuela and situated very close to the equator. So, it's known for its stunning sunsets. You can watch the sun drop like an egg as the colors spread everywhere. Most people start lining up forty-five minutes before the show and clap admirably when it's done. They have their cameras in hand to

capture the colorful display. No one is swimming, though. The viewing point is only twenty feet from the ocean. It's odd. The water is so warm and calm. You could tread water or lounge on a float and watch the same sunset, but everyone gets out to look at it and EVERYONE is taking pictures. Multiple days in a row, too. The same people. I could see taking a picture one day, but then just enjoy it the other days. Nope, not these people. So, I would go swimming and get in all their pictures. Haha. Sometimes I would go underwater and then pop up like a dolphin and splash around. There were still disposable cameras in 2008, so I know I am on some people's refrigerator. I'd take a swim every night at sunset. I even have a canvas print of one of my infamous dips—the fiery star glaring on the horizon and just my head above water.

"Is that a fish?"

"Is that a dolphin?" I'd hear.

No, it's Jimmy Ford!

The hotel had a casino too, so we'd all play there. You didn't have to leave. I always felt like casinos are tighter outside the U.S. and this place was no exception. Craps, Blackjack and roulette—nothing. My mom got cleaned out at the slots. There is something funny about the tables around the Caribbean. There was also something shady. One night we ventured outside the hotel to some of the shops and restaurants. There are a handful of other casinos as well. We bounced around a few. I am in one and I am finally winning. I'm at the roulette table and I am hitting numbers nonstop. I am even getting a few green zero hits too. My chips are stacking up. I went in with like forty bucks and I am well over $300 at this point. They are

bringing me free beers, aggressively. Perhaps hoping I get lit up enough to make a stupid bet. I didn't; I couldn't loose. I'd hit a full number every spin. I am about to cash out and I am just waiting to lose one spin. I have to pee, too. As I have my chips spread out, I notice the dealer grab a chip of mine and hide it. They must have thought I was drunk.

"Hey, that's my chip."

"What?"

"My chip, you took my chip."

"What chip?" he says crookedly.

"The one on black, 22. You took it."

Some people start to look and eventually the pit boss gives him a nod.

He smiles and puts my chip back.

He kinda laughs like: "I was just joking."

What the F?

Hey, he just got caught stealing. The gaming commissions could shut a place down for this. I don't know if it was to see if I was drunk, so that they could screw with my winnings. I don't know if it was just a practice late at night to skim chips, but that was fucking shady balls. I took my chips and went to the cashier. I almost called the cops.

I cashed out about two hundred bucks. Maybe when someone is on a hot streak they try and steal a chip to piss him off, so that he gets mad and leaves. So, he leaves before he wins more. I don't know, but watch out for the Hyatt Casino, bunch of FN crooks down there.

Aruba is pricy too. I was able to speak with some locals about their economy. Other than tourism, there isn't much

else on which Aruba relies. The soil is bad, and they don't get much rain at all; so, they import almost everything. The only thing I hear that they export is aloe and occasional art. I bet with some effort you can find deals, or a decent meal that doesn't break the bank, but a banana was seven dollars at our hotel store.

The geckos by the pool, cocktails at the swim-up bar—the week was going by quick. We were having nothing but fun. My mom is so stressed out around my dad. She is always watching my brother and me like a hawk. She never relaxes, and she is never off duty. She always yells and stresses out. She smokes a lot too. Well, she really let her hair down. It's something about the Aruba air. I have never had so much fun around my mom. She even laughed when my aunt and I had a shot of tequila at the swim-up bar. She even ordered room service! This was a first. The two things my dad feared on vacation were: room service and the mini bar. He had this notion that if you took a soda and some M&M's, you'd get a bill for five thousand dollars. He'd send us to the vending machines for a Coke, but never from the mini bar. So, to get room service for the first time was a treat. We liked it so much that we did it again.

The guy wheels the cart right though the room *and* onto the balcony where we watched the sunrise and an elderly couple swim laps in the pool below. The best bacon and eggs I ever had was on that balcony in Aruba.

CHAPTER NINETEEN: LEAVES OF GRASS IN LOUISIANA

I wasn't back from Aruba a couple days and the phone was ringing again. Ed Norton was doing a movie called *Leaves of Grass* in Shreveport, Louisiana. Randy, his make-up artist, had pushed my name to the producers to use me as his stunt double again.

This was a special film. Edward would be playing twins in the film. The decision to play both parts would mean he'd need a stunt double for any fights between the two characters. Split screen editing, along with special effects technology, has been allowing one actor to play two parts for a while but it's hard to cheat physical confrontations. Even simple wrestling would require a second physical body.

The movie industry had been going through a huge change thanks to lucrative tax incentives. New Orleans and Shreveport were filming more movies a month than Hollywood. It was so popular that people who had lived in Los Angeles were buying houses down there and uprooting their families to work as a local. Casting agencies were opening up. Actors, stunt people, and crew members were flocking to Louisiana to take advantage of the boom. Imagine a movie that has a 50-million-dollar budget, but the state of Louisiana is giving a forty percent tax incentive. All you have to do is fly everyone down there. How much can that cost when you're saving tens of millions? The producers often favor local people to save

more money, but when needed, they have no problem flying the right people in from New York or California.

Within a few days, I was on a first-class flight to the Bayou. I didn't have an exact return date, but figured I was going to be there for a while. I even packed my golf clubs.

I sat next to a charming businesswoman from Texas. She was in the oil industry and looked like she had money coming out of her ears. We had a lovely chat. She even showed me how high-class people put their linen napkin over their plate when finished. You don't crumble it into a ball like a commoner. She draped it over the entire plate like a bedspread, completely covering the plate and half eaten food. Keeping it classy, I could get used to this.

A quick change of planes in Dallas Fort Worth International Airport and I was in the Pelican State. NO, that doesn't count for visiting Texas; I never left the airport. I checked into the Clarion hotel. The lady said: "I have you here for at least eight weeks, so make sure you like your room." Production even gave me my own rental car.

The filming was fun. Some weeks were light. I wasn't working every day. I had a lot of time off which was fine. The SAG contract they gave me had me on principal pay from the second the car picked me up from my apartment. There were some weeks I wasn't in any scenes, but you have to get paid to be there. You're getting paid seven days a week, so you can turn down other work. It was great. I got to explore a ton. When I wasn't playing thirty-six holes of golf, I was driving around, meeting people and taking it in. The food down there was so different. I was trying it all from crawfish, to gumbo, to jambalaya. Étouffée, shrimp and grits, po-boys and banana foster—I was loving every

bit of it. The true, local, cajun and creole style cuisines were some of the most unique meals I have ever eaten. The flavors and the seasoning were all outstanding.

The people were so friendly too. They often invite you over after meeting you for just a short time. An older guy I only knew briefly from the gym invited me over to his house to watch college football with his family. Back home this would be odd. You'd think he's a swinger or a sketchy criminal...but down here, this was southern hospitality. Nothing special; it's just the way it is. He had a huge house, two boats and a ton of family members over. I'd heard football is like religion down south but didn't realize the extent. It was a catered event. Everyone sat around in L.S.U. purple and gold gear and watched the game intensely. The Red Sox were in the playoffs at the time. So, during a commercial, I asked politely if I could check the score. The room went silent.

"Oh, we don't change the channel during football games."

I didn't know if they were kidding: "Oh, I don't need to watch it. I just want to see the score. Two seconds."

Nope, not even that.

They hide the clicker. It's dramatic. This wasn't even the finals. This was like game number three of the college football season. Baseball was just a few games away from the World Series. "We have another TV on the porch. You can put the baseball on if you want out there."

So, during commercials I would go out there with the smokers and watch the Red Sox playoffs. Crazy town.

There was also a lot of money in Shreveport—old money and currently lots of new money. There was a huge find, which involved some type of natural gas. Big

companies would drill in from miles away, suck the gas out and never even damage the yard. The people would get paid based on acreage and there were a lot of big farms. Random farmers were becoming millionaires overnight. Someone said they set a record for most new millionaires in one year. You'd think you'd see a lot of exotic cars or obnoxious luxury sedans...nope, just trucks. I'd never seen a hundred-thousand-dollar pick-up truck until here. Tons of them, all modified with after-market bells and whistles, lift kits and extreme accessories. They were beautiful and of course had mud all over them.

A lot of people look down at Shreveport because of all the strip malls and chain restaurants. I was loving it. There was a nice laid back friendly vibe to the place. There was also a downtown area on the water with a bunch of casinos. Sometimes the producers and I would head down there, if we got out early, and play blackjack. We'd spot some of the hair and makeup people there. It was like seeing a family member. "Hi! How's it going?" We were just with them a few hours ago and had seen them all week, yet bumping into them at the Eldorado was like we hadn't seen them in years. The ladies were nice too. In New York and California, people are not impressed with film and TV productions...they are annoyed. Where do we have to park today? Oh, what streets are blocked off? It's noise and traffic. Down in Louisiana, people had stars in their eyes. I saw a cute girl at a restaurant, so I asked if she was an actress.

She said, "No, why?"

I told her I was down here doing a movie and figured she was part of a film. She gave me her number and we started dating. You could have been craft service; the girls

didn't care. Even the guys were nice. They would invite me to go golfing or get a beer. So much warmer than the northeast. It was real friendly down there. I was loving it and didn't want to leave.

CHAPTER TWENTY: TEXAS

I was having way too much fun in Louisiana. We were doing fights and driving, filming all over the state. A stuntman, Jim Henry, was down for a week to play a stunt cop. We were chatting in between takes and he put me on the phone with a stunt coordinator, Jeff Schwann. Jeff was in charge of stunts on the hit TV show *Friday Night Lights*, which filmed in Austin, Texas.

He needed a stunt double for a brawl and was having trouble finding a tall, skinny guy to match this actor. Jim Henry told him that I fit the bill. Jeff was really nice on the phone. However, I told them I am being carried on this film, so therefore I don't think I'm available.

He persisted: "Texas isn't far at all. Check with the producers. Maybe you have a couple days off."

Sure enough, next week came and I had a string of days off in a row. I asked the producers if I could drive to Texas for a couple days.

This was risky. I had a great thing going. I am getting treated like gold, making wonderful money and having fun. Why risk messing up a good thing? Well, I really wanted to see Texas. I was also a huge fan of the show *Friday Night Lights*, not to mention that the credit would look really nice on my résumé.

I left for Texas on a Tuesday night after work. I drove my car three hours to Jim Henry's house in Dallas and crashed at his place. The next morning, we got in his truck,

driving another three and a half hours to Austin. I left my rental car in his driveway, since the TV show said they'd fly me back when I was done.

As we left Dallas and headed south to Austin, I remember looking back at the skyline. I hadn't heard anything about it, but I was shocked. It was remarkable! I kept looking back. It was so large and the buildings were so pronounced. There was a lot of empty desert and flat sand to the sides. Then out of nowhere these shiny, new buildings soared into the sky. They stuck out so much that it reminded me of the Emerald City in the Wizard of Oz. The tall skyscrapers were talking to me. They told so much about the city. It screamed: "Power, wealth and the oil industry." It made me imagine football players and billionaires going out for steak dinners. This was a skyline—perhaps, the best in the world.

I was shocked yet again as we got closer to Austin. Jim Henry had informed me we were entering Hill Country. I assumed Texas would be a bunch of large plains and cattle...nothing else. I only thought I'd see flatlands. Hill Country was amazing. Tall, colorful hills were sweeping all over. Differing landscape everywhere. Rivers, lakes, sink holes, rocks and bold limestone landforms. I didn't believe this was Texas.

We met up with Jeff Schwann at Lake Travis. I thought it would be all business. They'd probably just have me check into my hotel and get ready for tomorrow, maybe a short rehearsal. No way, not in Texas, baby! It was a beautiful day as we arrived at the lake. Jeff was snorkeling with his girlfriend in the sparkling water. The hills in the background looked like mountains. Jeff looked like a cowboy and spoke with a smooth draw. We exchanged

hellos, then quickly he handed me a snorkel set and fins. We swam for an hour or so. Jeff pointed out a snake on one of the rocks. I wondered if it was poisonous or not. I didn't get too close. Man, this place was cool.

We all dried off and he took us to eat at The Oasis restaurant. It's a popular outdoor spot specializing in Tex-Mex food, margaritas and sunsets. This place was insane. At 30,000 square feet, it's the largest outdoor restaurant in the state. It has a multi-tiered patio deck, that's perched atop of a 400-foot cliff, with clean views of Lake Travis and the hills behind. Yeah, you read correctly—a 400-foot cliff, on a lake...in Texas! I tried to hold back my excitement as we sipped gentle margaritas and chowed down on old-fashioned queso. The views, the atmosphere, and everything about this place was inspiring. I couldn't play it cool anymore. "Ok, this place is awesome! Seriously, are we really in Texas?!"

It was a quick van ride to set the next morning. Breakfast was near the fake football stadium that they used in the show. I tried Huevos Rancheros for the first time. People couldn't believe I'd never heard of the popular Mexican breakfast dish, consisting of eggs on corn tortillas with a tomato chili sauce over it. They put some re-fried beans and fresh avocado on the top...delish. I shoveled it down as I stared at the green astroturf and yellow field goals. This entire field and stands was only used for the show. I wasn't playing football though. I was doubling a sleazy character, who gets in a fight at a strip club. Their style of filming was very unique. They had a bunch of cameras all set up wide with various lenses. After a brief rehearsal, they did two takes of the whole scene. They did a few hand-held specials, a quick close up on one character

and that's a wrap. It was the most efficient style of filming I'd ever seen. I wanted to do more takes. We were wrecking the place and wrestling around half naked women. I wanted to come back tomorrow. That was it, though. It was only a couple quick hours of filming and we were signing out.

Jim and some guys from the scene took me out for dinner on the infamous Sixth Street. That's the main street in downtown Austin. It's where the action is, known mostly for its live music and restaurants. Sixth Street has all the bars, clubs, shopping and parties you could ever want. There was something different in the air though. This was not your typical city. Something was happening. The food scene was exploding, and you could smell it. A wave of new, innovative chefs was taking over and spicing things up. It was a food truck revolution. The tacos, the BBQ, the briskets and even the wings were special. They weren't just making meals here, they were making art.

I had a flight out the next day and the other guys had to get up early. So, we only went to a few places. I was in bed early, unlike many of the bar crawling patrons we saw. There is a great energy to the capital city.

I had a short flight to Dallas. A personal driver, who was provided by the show, picked me up and drove me to Jim Henry's house. This was where my hot rod rental car was waiting for me. Another three hours and change to drive home. I was getting tired. This was years before the days of GPS cell phones. I had fourteen pages of MapQuest directions printed out. The two hundred miles consisted of countless turns, merges, off ramps and on ramps. My eyes were getting blurry as I tried to make out the highway signs. I kept thinking of how fun the Lone Star State is.

There is an obvious larger-than-life attitude. It's friendly though it's rare. I kept thinking about all the Texas state flags I saw. Not just the flags, but logos of the state flag on clothing. Everyone is so honored to be from this state that they pretty much treat it like it's their own country. If you drive around Massachusetts, all you're going to see is an insipid sea of college hoodies and Boston sports jerseys. People have pride for the city of Boston, but you don't see Massachusetts state flags anywhere. Kids don't go around bragging they are from the Bay State or wearing the logo on their hats. Same with New York or almost any other state. Texas has the image of the state flag on their hats, shirts, front lawns, even the back of their cars. People are proud to be from Texas.

I finally made it back to my hotel room, my home away from home. I was beat, but thankfully, I had a few days off and a couple weeks left. Oh, yeah, I forgot. *Friday Night Lights* gave me travel pay and an envelope with per diem too. I was also getting per diem from the movie this week. Double per diem, dude!

CHAPTER TWENTY-ONE: HEADING WEST

After Louisiana, I was back in my Astoria apartment. Things were gorgeous. I was thinking about my next move. I was sort of dating this girl from Astoria and wondering if we would ever get serious. She was real cute...leggy, brunette with blue eyes. Cool personality too. I liked her, but I was married to my career. She was changing professions at the time and really busy as well. I was willing to move in together and give that a shot, but she suggested that we just be friends. I responded with: "Fack you, I have enough friends. See ya."

It amazes me that girls think guys really want to be friends with them. Any guy that says he is okay just being friends with a girl either has a rainbow sticker on his Jeep Liberty or is desperately hoping that one day you'll get drunk together and hook up. No thanks. Seriously, I am not being a jerk; I am being truthful and a romantic. If I have feelings for someone, then I want all of them or nothing. To just be friends with a beautiful girl would be torture. I couldn't do it. They can call me later when they're ready for something serious.

I had more money than I knew what to do with and no bills. I was also single and ready to mingle. In addition to my two-month contract from Louisiana, I had two separate national commercials running at the same time. One was for Snickers (yes, they give you free candy bars on set). I was getting more checks than I could imagine. I

was officially rich. It was burning a hole in my pocket, so I needed to do something big with it. Fitted golf clubs, expensive bottles of Barolo, and new clothes weren't enough. I needed some change. I had been in this apartment with Alex for two years now. That's the longest I have stayed in one unit since I moved out of my parents' house to go to college. I did move rooms within the apartment when the larger one became available. The police even showed up once because the sleepwalker went missing. A new roommate, Brandon, eventually moved into the apartment. A Korean girl was subletting for a few months while Alex was away on tour. The place was interesting, but I needed to avoid getting into a rut. I had to keep moving.

I told Alex that I was moving out. I found a dream apartment in Manhattan. An airy studio on 23rd Street and Seventh Avenue. The place was a bit over the top. It had a rooftop deck; it had it all. It was almost three thousand a month and the guy didn't make me sign a lease. I was going month to month and could leave whenever I wanted. This was like renting a Lamborghini and telling someone you owned it. In Manhattan, your address is a big deal. I was only twenty-six years old. When I told someone my cross streets, they were impressed, but assumed I had roommates. When I told them I didn't, their jaws did that thing. I was in the status-sphere.

It wore off after two months. That is so much money to spend every month just to party and tell people your address. It was a studio. Rent in the city is pure absurdity and I was over it. I was over Manhattan. Funny thing, after moving into my apartment, my first audition was at Kaufman Astoria Studios in Astoria! You should have seen

the smirk on my face, taking the train BACK to Queens after I finally moved out. If that wasn't a sign from above, telling me I shouldn't be in Manhattan, then I don't know what is.

I shipped all my stuff back to my parents' house, told them I was coming home for a couple weeks, buying a car, and then heading west.

I know it's cliché, but I bought a red Mustang. My dad's best friend and occasional golf partner, Paul Noone, bought it brand new a few years ago. It has always been his dream car. He babied it, garaged it, and made sure not a single raindrop or snowflake touched her oversized hood. After putting only 10,000 miles on it in three years, he decided he wasn't driving it enough. His wife also hated it. This was the real deal Mustang too; the one with eight cylinders. It was not your imitation V-6 but rather the GT premium edition. I was looking for something much cheaper, more A to B. My parents suggested a lease. Paul gave me a winter price that I couldn't refuse. I paid cash for it and the next day I told my parents that I was driving to California. I had to see what Los Angeles was like before I got too old. Life was moving fast. If I didn't go soon, then I would have regrets.

I finished dinner one night and said I was leaving. I didn't even pack much. I had no real plan; I just had to go. It was eight in the evening when I started driving.

"Where? What? Now? Where are you going to stay?" my parents asked from the porch.

"I have a book filled with business cards and kids' cell phone numbers that I've worked with."

"What if you break down? It's winter and that car isn't

meant for the snow."

"Guys... I have to go."

I can still remember the first time I dropped the hammer on that car and felt the power. I couldn't believe this American muscle car was all mine. I named her Eleanor after Nick Cage's Mustang in the film *Gone in 60 Seconds*. I was just about to pull onto the highway and "Black Betty" by Ram Jam came over the radio. I floored it and awakened the beast. The sound of those eight cylinders roaring was rousing. Three hundred and fifty horses were singing to me in a deep voice. Over 360-pound feet of torque sending my head back firmly into the seat rest. I could barely hold onto the steering wheel. This was living.

> Oh, Black Betty (Bam-ba-Lam)
> Whoa, Black Betty (Bam-ba-Lam)
>
> She really gets me high (Bam-ba-Lam)
> You know that's no lie (Bam-ba-Lam)
> She's so rock steady (Bam-ba-Lam)
> And she's always ready (Bam-ba-Lam)
>
> Whoa, Black Betty (Bam-ba-Lam)
> Whoa, Black Betty (Bam-ba-Lam)

The plan was to drive through the night. I had some family in Chicago, so I'd aim to stay there. I did no research of how long this would take or what routes I'd go. I was just driving. I had an old Garmin GPS, so I was fine. Nothing was going to stop me. Dammit—I am fading.

Why didn't I wait until the next day? Mister big shot

had to leave after dinner. It's so frustrating when you want to keep driving, but you can't keep your eyes open. It's embarrassing how quickly I got tired. I fought it for a bit, but I was about to go off the road. I tapped out somewhere between Albany and Syracuse. I checked in and crashed quick at a forty-nine dollar a night motel right on the highway. Dammit.

CHAPTER TWENTY-TWO: CROSS COUNTRY ROAD TRIP

Wow, did I feel defeated falling asleep that night. It was quick though. Boom! I was up at five bells.

A fast shower, breakfast to go and I was burning gas again by six o'clock in the morning. The most pathetic thing to me was I hadn't seen anything different yet. I'd been driving for a while, and I was still in never-ending Upstate New York. I'd been to the Baseball Hall of Fame. I've driven to Cooperstown multiple times—ugh. I said the same thing as I flew by Cleveland, Ohio: "I have been to Ohio. When do I see something new?"

Well, about seven hundred miles and ten-plus hours from the time I left, I pulled over in Indiana. Somewhere before South Bend.

"Ahh, Indiana. The Hoosier State. A new state!"

I got out of the car and rolled around a bit and stretched my legs. I got some food and gas, while also buying a few postcards and refrigerator magnets. I also annoyed the locals for a bit. It was starting to rain, so I got back in the car. There wasn't much more than corn to look at, but I was driving in a new state. That's all I needed.

I put my cousin's Chicago address in the GPS. I still had another one hundred miles and two hours to go. I was already whipped. Life on the road is tiring. It was getting dark and it was raining. It was a miserable drive. Heavy rain the whole way. You couldn't see a thing. I barely pulled up to my cousin Lauren's apartment in Chi-town

with my eyes open. Her friend Pat was over, and they took me out.

Chicago, Illinois. I didn't know much about the Prairie State, other than its capital was Springfield and Chicago was the biggest city. Chicago had always been a place I wanted to see. I was a fan of the sitcom *Perfect Strangers*, and loved the opening credits with the Sears Tower. I had some bites for work out there, but nothing stuck. Lauren and Pat took me on a tasty pub-crawl. There is a good vibe in the city, great people, restaurants and theater. Tons of stuff to do at night. The problem was it was foggy as EFF. I couldn't see anything. We went to some posh hotel bar that boasts views of the city. We couldn't see a foot. I would come back a few more times over the years, and yes, it's windy but it should be called the foggy city. Finally, I was able to get to Wrigley, devour a Chicago dog and a slice of good ol' American Pie. I can see why Swoonatra wrote a song about this town.

I crashed at Lauren's that night and took off early. I left the Land of Lincoln even before breakfast. I had lots to see and this is where things would get interesting. Everything from this point on would be new. Love it or hate it, it would be different, and I have a burning desire for different.

I dropped the hammer hard and headed south towards Missouri. St Louis seemed like a cool city. Come on, Nelly is from there; it's got to be good. The GPS said three hundred miles and four and a half hours. That was practically down the street compared to my twelve and a half hour itinerary the other day.

I drove south on I-55, noticing a lot of religious

billboards and Bible quotes. I think that I am entering the Bible Belt...interesting. Tons to look at on the road. Tandem eighteen-wheeler trucks, houses on flat beds, all the street signs with different cities. This stretch was a breeze. Before I knew it, I was approaching the independent city. I could see the iconic six-hundred-foot Gateway Arch high above the Mississippi River. Before long, I checked into the Hampton Inn, downtown on Washington Avenue. It wasn't even noon. I had the whole day ahead of me to see a new place.

St. Louis is a very enjoyable city to see in one day. I saw some landmarks and ate some hometown food. It's all pretty contained but you feel like you accomplished something. I investigated the Gateway Arch up close and it is beyond impressive. It's the tallest arch in all the world. It's also the tallest man-made structure in the western hemisphere. It's high, but you don't realize how high it is until you stand underneath it. They have some riverboat casinos there too. I popped in for a few throws of the dice and made sure to take a couple chips home for my collection. There is a nice, small downtown area with some fun bars and BBQ options. I had to try me some St. Louis ribs.

I got in a cab and told the driver to drive me around, and I told him to keep the meter running. It was a blast. He told me there wasn't much to see outside of where I was: "Downtown and by the river is where everything is."

"That's fine, just drive around for a few minutes," I said with a grin.

We went by the stadiums and different squares. He showed me a few neighborhoods. If you haven't realized this already, I love talking to locals. It's so much more

interesting than Googling things or playing on the phone. He told me tons of fun facts about the Show-Me State. It's where the soda 7 Up was invented, as well as the ice cream cone. He was also proud to tell me that St. Louis, Missouri was the first American city to host the Olympics, back in the summer of 1904.

Thank you, cabbie. When he dropped me back off at one of the casinos, I couldn't believe the meter was only ten bucks. Screw York's cab meters are a rip off. It's ten bucks to go two feet and now the meters go faster if you're stuck in traffic. Essentially, they are charging you more to go less. I was very pleased with this cab operation and the city.

"Here you go, sir. Keep the change and tell your friends about JimFord.com."

He chuckled: "Ok, buddy."

I checked out the next morning as fresh as a daisy. The gateway city left me feeling very content. I was now heading due west towards Kansas City and the Sunflower State. I called home a few times and left some voicemails for my friends. Yes, I am one of those friends who still leaves voicemails. Anything to pass the time on the long open road. It took about five hours to get into Kansas and I pulled over in Topeka, the capital. It was time for some dinner and a beer.

I ordered wings and fries, nothing fancy. The bartenders were especially polite and affectionate. I told them I was driving through from the east coast and just stopped in for the night. One bartender got another bartender and they kept asking me all about everything. Some young guys were sitting at the bar next to me. They

slid over and introduced themselves. They even offered me some of their appetizers. I thought they were messing with me. I thought they were setting me up for a prank because I was from out of town. No sir. They were just as chummy as the girl bartenders. This random little sports bar may have been the warmest, friendliest place I have ever seen. This was sincere, too. Not like the entitlement or fake-ness for tips you see in Jew York. This was genuine friendliness. Maybe even a little too friendly. The guys said to me: "Hey, buddy, not sure what your plans are but we are heading to a club tonight. You can come with us. The girls will love you."

I said: "That sounds tempting..."

"Last year, one of my buddies had a friend from out of town visit and we went out with him. We got all the girls. They love people from out of town."

I told them that I still had a lot of driving to do and had to get up early, but thanks.

They settled for one more beer.

They even gave me their info to stay in touch.

Everyone was so amicable, especially the woman.

If you're looking for a wife, then go to Kansas. My God, they are the nicest people. It appears as if the women actually want to please their man. A little different from the divas back east who read way too much Cosmo.

The next day, I woke up wondering a bit what my hangover would have felt like if I went out to that club. I am glad I didn't, but man this is a friendly town!

I gassed up and then headed south to the Sooner State. It was about four hours through Wichita to good ol' Oklahoma City. I had always wanted to see Oklahoma

because its capital was the easiest to remember. Oklahoma City—come on, that's a gimme. I saw Ford Stadium, home to the Oklahoma City Thunder and checked into my hotel.

I walked around a bit and was pleasantly surprised by the beauty of OKC. The downtown area is called Bricktown. There is a manmade canal that runs through it. It's the perfect stroll. Unique shops, bars and restaurants line the canal. It's visual and it's got that repurposed warehouses look. There is a fresh mix of locals and sightseers.

I eventually made my way to a rooftop bar to see a bird's-eye view of the city. They had a cover.

We'll see about that.

"I drove all the way from New York. Can I just go inside?"

"There is a ten dollar cover charge," she said, with a Midwestern smile.

"I'm bouncing around. I just want one. Can I just get a beer quick?"

"Sure, just one," she said, again with that smile.

"Thanks, I'll be quick."

I sipped my bottled light beer and took in the city from above. The lights and sounds bounce off the canal water at night. It's a good-looking city. One and done and now onto the next spot.

I was in the real Bible Belt now, so I assumed it would be tame and full of Oblates. The times had been a changin'. It was still more religious than most, but there was plenty of drinking, smoking, dancing and even some smooching in public. I grabbed a stool at the bar and ordered some food as a couple of smoke-shows came in and said hello. One even had aftermarket breasts and they both had

gorgeous blonde hair. One said she was from South Africa. A light-skinned girl with blonde hair from Africa? These girls were on the prowl too. I am usually tempted by upgrades, but I had to say goodnight. One more beer with them would have turned into seven, and I still had a long way to California. They started talking to some other people and made it pretty clear they were looking to party. It may not be spring break, but there were plenty of ladies looking to put back a few and get loose.

I settled up then grabbed a nightcap at my hotel bar. There was a police officer standing by the bar talking to the bartender. We all had a nice conversation about OKC and its peculiar ways. I asked them about what strange laws still apply. I had always heard that it was illegal for a girl to give a "Monica Lewinsky." You know, play the ol' skin flute. They chuckled. The officer said it technically was still illegal to wear your cowboy boots to bed. You could be jailed for making ugly faces at a dog. Just the other day, he said he arrested someone for swearing in the presence of a woman.

"Really?" I asked.

"We gave him several warnings, but he kept cursing."

"Wow, but seriously...is it still illegal for a girl to give fellatio?"

They chuckled some more.

I still wanted to know.

I was hitting the road again. This time, I was driving straight west to New Mexico. This was when it started to get painful. It felt like I'd been gone forever, and I'd never get there. I got on a highway and the GPS said: "Stay on this road for five hundred and five miles."

You're kidding. That number is a typo. Fack, that's a long-ass time. I had called everyone in my rolodex and called some again. I felt like I'd listened to every song that had ever been on the radio. My CDs were getting repetitive too. I found a mall and pulled off to buy some stand-up comedy tapes. I needed to listen to someone talk. I just needed to hear some stories.

The tough thing about the long days is managing your stops. Looking out the window and sightseeing is a huge part of the joy of road trips. You have to stop, though, and look around from time to time. If you can gas up, get a bite and hit the bathroom at the same time it helps. The worst is when the tank is full but you're hungry. You pull over for a snack and then an hour later you have to pee. Then, you stop for gas again an hour later. You have to try and get food, fuel and bathroom at once or at least two at a time. Otherwise, you feel like you're stopping every thirty minutes and making no distance. I started feeling like that on this stretch. I was pretty safe and preventative when it came to fuel. The muscle car actually got decent mileage on the highway, but there were large gaps between rest stops. It wasn't uncommon for it to be fifty, or even seventy-five miles, in between gas stations—or even longer. Well, I was getting sick of stopping every time the car got below half. I wanted to make some distance here.

I was well below a quarter, but I was moving. I didn't want to stop. I scrolled through my GPS for fuel stops. It said there were a couple gas stations in forty miles. I blew by a rest stop and kept driving. I was almost on empty, but the odometer said I had fifty miles to "E"—I kept going.

I thought about turning around. The last station was twenty miles back. I had twenty-five miles to empty

according to the gauge. This place better be open. Visions of Kramer test driving the car in that Seinfeld episode and how far below E he could go were playing through my mind. The needle was well below empty. The light had gone on and off several times. I kept looking at cars pulled over and people walking with gas tanks. Are these people really walking twenty miles? That would take two days. There is no way. You can't walk that far. The sun was starting to set, and this was stupid. I had ten miles to E and five miles to the gas station, according to Garmin.

I pulled off the exit and rolled up, crap. This place hadn't been open for years. Tumbleweed was blowing past the dust covered pumps. Fack.

I yelled at the GPS as I got back on the road, still driving forward. My mom always told me to update the maps. Update the maps, James. You should update the maps.

I had no choice but to keep driving west. I had five miles till empty. I would drive until I ran out and then I would call AAA. I wondered if they would come to me. It was getting dark. I questioned how safe it would be to stay in my car. Oh, thank God, I could see a Shell Station. A brand new one, so the GPS didn't even have it. The fuel odometer was below zero and that was the reserve tank. The car was bucking as I pulled to the pump. Oh, thank the Lord that it was open. I could hear the gas pissing into the tank with a loud noise—wow. It took a lot longer than usual to fill up this tank. Wow. It was another twenty miles to the nearest station and forty miles to go back. Ok, ok. I won't let it get below a quarter anymore.

CHAPTER TWENTY-THREE: FOUR CORNERS, USA

It was pitch black when I arrived in Albuquerque. There were a bunch of budget hotel options, but most looked eerie. I couldn't trust the hole-in-the-wall places, so I treated myself to the Hilton. I sipped a solid margarita at the hotel bar while I planned the rest of my route. The one hundred proof agave went down so easy. I ordered another while I told the patrons about how close I came to running out of gas. Five hundred miles on one road is too much.

I don't know if the road was wearing me out or the tequila was, but gosh-dang it, I forgot my room number. I know there is a three, and I am pretty sure a seven. Wait, am I even on the right floor?

The front desk had a ball looking up my last name.

The thing I was looking forward to more than most things was the Four Corners. As a kid, I was thoroughly amused by the notion of doing something in four states at once. Dancing, laying, a handstand...anything. I was thinking about what I'd do the whole drive up. It was almost dusk, and I was losing myself to the surroundings. Nothing, and no one around for days. It was a geologist's dream. All sorts of bold, dark rocks. I could have been on Mars. I pinned the Stang and finally finished the stretch. I was at the entrance gate to the Four Corners Monument.

Arizona, Colorado, Utah and New Mexico...look out,

here I come.

The monument was closing down soon. I was hoping this place wasn't crowded or tacky. I was hoping that it was just some random, no-frills isolated plaque on the ground. It was five dollars but the lady told me to hurry up and pay on the way out. I went in and was all alone. There were some t-shirt tables and souvenir stands but they were all closed up. All the employees had already left. I could not have asked for a better scenario. Sometimes I am weird, I admit it. I was looking forward to this more than the Grand Canyon or Vegas. I started breakdancing by myself in all four corners. I was dancing and playing twister. All by myself, smiling ear to ear. Eventually, I called my mom.

"Hello, Jimmy."

"Guess where I am, Mom."

"Four Corners."

(Dammit.)

"No...I am in Arizona."

"Oh, very nice."

"Nope, I am in Utah."

Pause.

"Nope, I am in New Mexico. Now Colorado. Haha. I am calling you from four different states!"

"Oh, that's nice. Well, have fun. I am watching TV."

"See ya."

I was having too much fun. I was like a kid at Disney World.

Then, a couple came walking up. They were from Israel. They asked if I would take a picture of them.

"Only if it's creative," I said.

They didn't hear me. They stood there next to each

other and smiled like stiffs.

"No, you guys can't do that. You have to do something creative."

The guy looked confused.

"You're supposed to do something unique in all four corners, you can't just stand there."

He thought about it...then he did a hand stand putting one hand in Arizona and one in New Mexico. His wife stood in Colorado and Utah, held his legs open and smiled in between his crotch, while he grinned upside down. I couldn't believe it—this was awesome!

"Amazing. That is a great couples pic!! Very unique. Way to go, guys. I am happy to have taken that picture."

They reciprocated by taking my pic, sliding headfirst through all four states, like Rickey Henderson stealing a base. I did a few more dance moves for safety. We all laughed and high-fived.

They took off with big grins, checking the camera as they walked away.

I stayed a little bit longer and took it all in. When I finally drove out, the woman at the gate had already left. Sweet, got in for free.

"Thank you, Four Corners!"

As I drove away, I really was in the middle of nowhere. Suddenly, I see some guy trying to climb a tree. It was the guy and his wife! She was taking some pics of him climbing this tree on the side of the road.

(Beep beep)

"Yah, buddy. Action shots!"

He waved back enthusiastically and yelled: "Action shots!"

"I love it!"

(Beep beep)

Action shots really are the key to life.

I may have just created a monster, though.

I kept smiling as I drove away. I expected to see some hotels or small towns. Nothing.

Man, the sun was setting fast. My next stop was the Grand Canyon over three hours away.

I really should have done more planning. I was driving though deserted Indian land. I was in Navajo Nation and it was already pitch black. You'd think there'd be a Four Corners hotel or something, but I guess it's not that busy.

I finally found a hole-in-the-wall hotel in some random town and called it a night. The place gave me the creeps. It was straight out of Nimrod Antal's 2007 thriller *Vacancy*. I didn't sleep that well. I was up at the ass crack of dawn and started burning gas towards northern Arizona and Grand Canyon National Park.

I knew it would be good. Some people spend a lot of time there. They do hikes. They take tours, check out different spots, maybe rent animals for a ride. I pulled up, paid, parked and got out. I went to the main viewpoint and laughed. It was so huge. I just laughed. I was in awe at this immense geological wonder. The size is absurd. Ok, I am good. Later!

I was eagerly awaiting my next destination, The Hoover Dam. I was driving so damn fast to get to this dam place. I buzzed along the windy roads leading up to the Black Canyon. I was again stunned. This time, I was stunned by the size of a man-made wall. It's impossibly large. I went inside and took a tour. I am not the type of guy to walk in a line, listen to a tour guide while idiots take

pictures and ask questions, but this was different. If I only took one tour in my life, then it would be this dam tour. Why, you ask? Because of the dam jokes. If you have ever seen National Lampoon's *Vegas Vacation*, there is a funny little scene: "Welcome, I am your dam guide, Arnie. No one wander off the dam tour. Please take all the dam pictures you want. Now are there any dam questions?"

Then Randy Quaid shouts: "Ya, where can I get some damn bait!"

I literally signed up for this tour, just so I could walk in and shout: "HEY, WHEN DOES THE DAM TOUR START!!"

I got some laughs. I also got some eye rolls. It was a fantastic tour. We took an elevator up and walked inside the wall. What an engineering accomplishment this thing was. You wouldn't believe how much concrete was there. It was built to prevent floods from the Colorado River. It also contains the water and utilizes it for irrigation and power to surrounding states.

At one point, we were on the elevator to go back down and I said: "Ah, not this dam elevator again...can't we ever take the dam stairs."

The guide was quick with: "Hey, leave the dam jokes to me."

Haha. That's all I wanted.

I DID RETAIN A FEW FUN FACTS: It's one of the largest concrete structures on earth and considered one of the seven Wonders of the Industrial World. It's over 700 feet high and 600 feet wide. More than six billion tons of concrete were used to build the dam. That is enough concrete to pave a road from New York to California—

three thousand miles. Cray-cray.

I left very satisfied. Even if you can't do the tour, then the bridge you drive over and all the terrain that surrounds it is sensational, too.

Oh, yeah, I was in a new state too. Nevada, kid...check!

CHAPTER TWENTY-FOUR: LAMBORGHINIS IN LAS VEGAS

For years, many people have told me that I need to go to Vegas. "It's so you, man. You'll have a blast."

I'll admit I was looking forward to it. The City of Lights and all its temptations. Maybe I'd get into a little trouble. Nope, crickets.

I pulled up to Sin City late on a Tuesday afternoon. I might as well have been at church. It was early December. The pools were closed, and the crowds were gone. It was all couples. I thought I'd see parties and people making me uncomfortable. I thought there would be big bunches of large-breasted bachelorette parties asking me to make some bad decisions, but there was none of it. What is this place? Grown-ups were walking hand-and-hand. Couples dressed like a Gap commercial while having date night. Retirees were leisurely taking in all the lights. This wasn't the debaucherous town I'd hoped it would be. This place was safe and touristy.

I walked to a nearby cantina after checking into the pyramid-looking hotel for the low 'bait and switch' price of thirty-nine dollars a night. I asked the barkeep if I was in the right town.

The streets and sidewalks were relatively quiet. "Is this the official strip?"

She sighed, "It's after Thanksgiving and a weeknight. This is how it is in the winter."

I didn't think there was a winter out here. Geez. I was

in the mood for a shot, but I'll just take a beer.

I called my parents and told them that Vegas was not what they thought. John and Linda Ford love to go to casinos. They play at the slots and have a little dinner but have always been put off by the reputation of Vegas. They'd drive to casinos in Maine, Canada, and Upstate New York. All the while, they were so averse to Vegas. I told them not this time of year and certainly not on a Tuesday. "Guys, it's all married people. It's a million times less seedy than Atlantic City."

They have been five times since my phone call.

I was worn out from the road. It was only forty-five minutes from the Hoover Dam to Vegas, but I had also seen the Grand Canyon that morning. I needed a break. At thirty-nine bones a night, I decided to spend a few days here and chill. I needed to take a break from driving.

Vegas definitely has got things to do. I walked the strip and saw the Bellagio fountains dance for me to Dean Martin. I poked my head in a couple different casinos. It's amazing how many signs there are for buffets. Some are as low as $5.99—it's like these places know you have got two to three HUNJ in your wallet and hope you're tempted to gamble after a full belly. Everything is a gimmick to get you inside. Once you're inside you'll gamble—that's how they make their money.

One of my favorite things to do is bet on sports. I'm small time, but I love it. It's no different from the stock market, especially day-trading. You do some research, check your stats, talk to your barber and then make a wager. Some stocks are risky but offer bigger payouts; others are slow and steady but less of a risk. It's still

gambling.

I have always loved sports. Being able to put a couple of skinnies on the game I'm already watching, just makes things cozier. Even if I only have twenty bucks on a game, it makes the event more meaningful.

I eventually crossed the street to the sports-book at Caesars. It's hard to think of a better guy scenario then having a burger and a beer at a legal sports-book, while also watching a game in high-def, that you happen to have a couple bucks riding on. That's my favorite part about Vegas. More states are moving toward legalization, but not fast enough. Gambling is legal in close to thirty states at casinos and race tracks. Why can you bet on horses but not sports? Some say it has to do with college and the NCAA being corrupt. The nefarious NFL is concerned they might become more corrupt? I dunno, but this sports-book was a beautiful thing. Every hotel on the strip (and most of the ones off-strip) has a small window. You can go here and place a bet on any number of athletic events. You can bet on the color of the Gatorade that will be dumped on the coach's head at Super Bowl.

The waitress just informed me it was now two-for-one happy hour. Touchdown!

I cheered to myself in a near empty room.

Sinless in 'Sin City.'

FLASH FORWARD: I would return to Vegas several more times in the next few years. One time in particular was with my good friend Ken Buron.

VEGAS 2.0

I met Ken and his friend Nick at Mandalay Bay. Look up Mandalay Bay's pool if you haven't seen it. Some simply call it THE BEACH. It's been voted the best pool in the world by many reputable publications. It looks like a beach and it has man-made waves—it's ludicrous. There is also a really fun-shaped hot tub. It's truly an adult aquatic playground.

Kenny the salesman somehow got us a hundred-dollar voucher to use at any restaurant in the hotel. We decided on strip steak for dinner. I had read an article in *Esquire Magazine* naming it the best steak in America. We would have never gotten the reserve Wagyu filets if we didn't have a hundred dollars coming off the bill...but we did. Ken ordered medium. I ordered medium rare, and the goofball Nick ordered rare. Ken laughed: "What are you, crazy?"

I, too, thought he was being bold, though, the waitress gave him a look of respect. I had read articles with top chefs saying that it's the only way to eat a filet. Still, it seemed dangerous.

While the fine South African Pinotage was flowing, Nick asked me if I wanted to try it. I had a nice buzz going so I agreed. I did it for the rush, while never expecting it to be good. I thought there would be a chance I'd get food poisoning. I took one bite and entered flavor country! I couldn't believe it. Fireworks went off and a symphony orchestra started playing. It was and still is the single greatest tasting piece of meat I have ever had. I had another bite—he was glad to share. It was like someone took a soaking wet towel and wrung the liquid zest out of it—pouring it into my mouth. That's how moist and juicy

this thing was. Taste was rushing into my mouth and not going away.

Nick said: "The flavor begins to dissipate when you cook a good steak longer than rare. You're an idiot if you order a steak medium-well or well-done out at a restaurant."

I was a believer. This was the truth. If you're worried about contaminants, don't be. That stuff can only be on the surface and they sear the outside. Trust me, you're good. You are wasting your money and missing out if you don't try a steak rare. Since then, wherever I go...Ruth Chris, Morton's, or Smith & Wollensky, I get it rare. Even when I'm home with the cast-iron skillet, I aim to cook it rare. A little butter and some rosemary, boom!

A childhood dream of mine came true the next morning. Kenny B and me drove twenty minutes to the Las Vegas Motor Speed Way. We got to drive Ferraris and Lamborghinis on a real racetrack. I was so fearful as I lifted those fancy doors and strapped into a beast. The Lamborghini Murcielago that I was about to dance with was almost half a million dollars. It has over seven hundred horse power, 770 lb. ft. of torque, a top-speed that was well over 200 m.p.h. and a 0-60 acceleration of "Ahhhhooooh my goodness, that's fast." It was four hundred dollars for five laps. I asked the driver: "What happens if I put this thing into a wall?"

"Our insurance covers it."

Cool.

You had to be alert driving this thing. If you punched the pedal, this monster would shoot like a firework wherever the wheels were pointing. You know how people say: "Ahh, a Corvette is too much car for the road." Well,

this car is too much car for a racetrack. It really is. It accelerates to 100 miles per hour and shows no sign of slowing down. No lag; it just keeps climbing like a freight train all the way to 200.

I was starting to see why people loved Vegas. There was tons to do. We grabbed a drink at Minus 5° Ice Bar. You're basically in a freezer that is made up to look like a winter wonderland. There are ice sculptures and an ice floor. Even the bar and benches are ice. They give you over-sized winter jackets and gloves, then serve you drinks out of carved ice glasses. It's freezing in there at negative five degrees. So, it's the best place to go for a quick drink and then hit the strip. Don't put it down for too long or it sticks—keep it moving.

We dined at Tao's and then went to their club afterwards. It happened to be the after-party for the adult film awards. There was lots of eye candy while we sipped our rum and cokes.

"You think those are stock?"

"Definitely upgrades."

The next day we did the one and only thing Ken requested. We went to the glossy, high-end buffet in Wynn. It was like seventy bucks for the buffet but specialized in premium food. In a city where you can get countless smorgasbords for less than ten bucks, it seemed like it would be a waste. I was wrong. They had towers of Alaskan King Crab legs, lobsters and other exceptional seafood. It looked like Arabian princes were dining alongside of us. I'd never seen some of this food. They had a section the size of small houses just for desserts, which included everything your little sweet tooth desired. Nick ate so much for lunch that

he didn't even go out for dinner.

I like Vegas, but honestly if you're looking to party, there are so many better places. Vegas is hard to walk around. It's not ideal for one-and-done tours or energetic pub-crawls. To control the pedestrian traffic, they have these large escalators and walkways that go over the streets. To go from one casino to the next, sometimes it can take twenty minutes. It's not the best for bouncing around. When I look at Vegas, I see it more romantic then they promote it. It's a great date spot. Take your girl there, eat at Paris, walk around, and go see the gondolas inside the Venetian.

CHAPTER TWENTY-FIVE: CALIFORNIA

Well, I took off after three days of rest in Vegas. I had two hundred dollars more than when I entered the gambling mecca. A couple good sports bets and a quick stop at the Mirage roulette wheel, then I was up. Always bet on the underdog and never play the slot machines. Amarillo Slim is a smart man.

I began the last three hundred mile stretch to Los Angeles. You're just done by this time. Seeing the "Welcome to California" sign offered a brief bit of relief, but it's still another four hours to THE CITY OF ANGELS.

The drive is boring. It's all desert, and pretty much the same terrain. I have seen it. It was dragging.

Finally, I was here. After 3,400 miles, ten nights and nine days of sub-par food...I could stop driving! The first thing I did when I got there was call up Cliff. My friend Slosky had said I could crash on his couch for a couple nights, but I had to jump in the ocean before I did that. I had to make my trip official and go all the way to the coast. Cliff and I linked up by the Santa Monica pier, then we jumped into the waves. It was symbolic. The road journey was now complete.

"Dude, the water is freezing in California. What the heck?"

Justin Slosky was an old pal from high school. You may have seen him on *Who Wants to Be A Millionaire* wearing a pink boa. We did some plays together in school. We also

made a bunch of student films and home movies together. We had caused a boatload of trouble back in the day, especially with the local law enforcement. We'd dress up like ninjas and film ourselves driving around, trying to get guerrilla footage without prior permission. One time we filmed ourselves in ski masks and guns trying to order value meals from Burger King. We got two miles down the road and were mobbed by a S.W.A.T. team. We were literally thrown out of the car. Thankfully, the masses weren't making movies back then. They were really just relieved and let us go with a laugh. We had stayed in touch over the years and it was good to finally see him again.

Slosky first took me on a hike after explaining how the burgers out here are amazing—it's what everyone does. We chatted a little about the industry, caught up and talked about travel. After gabbing with him and spending only a few days in Southern California, I realized it's Mexico—Los Angeles is essentially Mexico. It's the desert. There are millions of Mexicans walking around and working everywhere. Besides all the Mexican restaurants, there are taco stands and taco trucks on every other block. Back home, wine bars and breweries were becoming trendy, but out here tequila bars and tequilerias were in. The place was Mexico.

California is huge. I grew to love the state, but not so much Los Angeles. It's such an industry town that it gets annoying. Everyone is in the industry, but not really. No one has a real job and if they do, they are quick to tell you: "Oh, I only do this on the side. I am really an actor." Firefighters will tell you they have an agent. Real estate people are also models and still auditioning. Civil service employees are waiting for their screenplay to get bought.

It's annoying. The weather is so nice that no one really has any drive. Everyone is lazy with an: "I'll get to it eventually attitude." People from New England think LA-LA LAND is the best place. They think they'll visit and immediately see Julia Roberts at the supermarket or Brad Pitt sweeping his driveway. It's crazy.

My aunt came to visit once. She met me at some bar in Burbank, CA. She hadn't even ordered her wine and the bartender starts babbling to someone that she is really a singer and her boyfriend is pitching a pilot.

"Here we go!" My aunt giggled.

There are a lot of beautiful people, though. You've got to figure that every prom queen and hot girl from high school gets on a bus or a train and gives the town a shot for a bit. There are a lot of high schools and a lot of "best-looking" girls. There are so many attractive females that it's funny. Tall, skinny, tattoos in funny places. Even the girls working the fast food counter are smoking hot.

The traffic never bothered me, perhaps because I was prepared. Traffic is so bad in Boston and New York that I wasn't shocked. It's amusing, though. People in California are just like people in Cape Cod in regards to driving. They love to stand around and talk about how your drive was. You show up at a party and then everyone discusses the route you took. They enjoy articulating how bad the 405 is. And someone always suggests an alternative for next time.

"Yeah, ok pal, I'll try Sepulveda Boulevard."

"I know, I know, you have to take Fountain."

I did experience an earthquake, a big one. I thought it was fun. I thought I was dreaming at first and then I woke up.

It felt like a roller coaster or a theme park ride. There were some small ones after that. They didn't bother me. An occasional earthquake would never deter me from living there. The weather is too nice.

The most annoying thing about Southern California was how difficult it was to make plans with people. Everyone says "yes" to everything you ask, but they don't go through with it. They say, "yeah sure," but then have no intention of doing it. I don't think they are all liars, but it's completely acceptable to make plans and then bail on them. You don't even have to call. Seriously, why can't people say: "Oh, that sounds like fun...but I think I am busy next week." Or: "Great idea, but I will have to check in with you on Friday. I might have something." Or simply: "I'm busy next weekend. I can't, but thanks."

NOPE. Never heard that in two years. Want to go golfing Monday? "Yes."

Sunday night rolls around, you call to confirm, and they are in Vegas or Palm Springs. Or something came up and they forgot. Bunch of flakes. Thankfully, I had some friends from back home and a group of guys from the *Frat House Massacre* film. We could all meet up.

SAN DIEGO

This place is one of the finest cities in the country. It's a thousand times better than Hollywood. My parents came to visit, and they chose San Diego, rather than stay in Los Angeles. I had already worked down there for a week, so I showed them around. We would joke: "Do the weathermen down here really have to go to the same school as people from the Northeast?"

It's seventy-two degrees and sunny every fricking day. A cool breeze and an occasional cloud—it's outstanding. Surfing, golfing, good food, beaches and tan girls. It has it all, well, except for a winning sports team.

As I was driving there, the air valve in my tire sprung a leak. It wasn't a flat, but it was a slow leak from the valve stem. We stopped by the first auto body shop to have a look and figured we'd be there all day while taking out the checkbook. The guy was chatting about Massachusetts when he saw the plates and fixed it for free. What?! That's when you know you're in a good city. People are in such a good mood that they fix your tire for free. We gave him a tip and practically a hug, but seriously, an auto body shop and a family from out of town. Not only did they not take advantage, but they also helped. This city is first-rate.

The gas lamp district in downtown San Diego is filled with all types of entertainment. We walked around there and got a bite. Pacific Beach and Mission Beach have to be on some type of sexiest beaches in the US list. It's nothing but smoke shows. We got breakfast there, walked around and went to a Padres game. The San Diego Padres are one of only seven current major league baseball teams that still have yet to win a world series. I might feel bad for them if their city wasn't so damn amazing.

SAN FRANCISCO

Also an astounding city. You can get quick flights from southern Cali but do yourself a favor and drive. The cliff-hugging and hair-raising turns of the Pacific Coast Highway on the way up to San Fran are unbelievable. Talking about it over a glass of red in Napa Valley is even

better. I liked the look of San Francisco, especially the architecture and style of houses. Very colorful. They referred to them as Painted Ladies. (I also may have tried to jump the Mustang on one of those infamously steep streets.)

I was in California for two years. I tried to explore as much of the city and state when I wasn't working, but there is so much to see in the state. Mountains, beaches and vineyards are just the beginning. I still haven't been to Catalina Island or Joshua Tree. I was working in LA a bit but mostly I was traveling for work, sometimes for months at a time. Maryland, New Mexico, Philly, Ohio, Utah and New Hampshire. I was all over the place. A lot of times I worked back in New York. NYC was busy, and I was flying there constantly, I really didn't need to be in California, too.

While in Cali, I lived mostly in Los Feliz. If you don't have skinny jeans, or a spider tattoo on your elbow, then you better talk about buying your next Vespa. This place was hipster central. I checked out a couple places in the valley too. I love that every other apartment has a jacuzzi on the roof or on property. My buddy, Moose, and I were always down for a good soak, especially with a cocktail. The pool parties, the food scene and all the hikes were impressive, but it was time to drive back east.

A STORY FOR THE ROAD: Hanging out at 'Wet' was fun. Sneaking into The Roosevelt Hotel pool party was cool. Drinking tequila and talking about the Red Sox with Joe Buck at Happy Endings Sports Bar was gorgeous. Still, my favorite California story is below.

An actor friend of mine actually gave Hollywood bus

tours on his days off. We were driving around Beverly Hills and he was telling me about the town. He'd lived here for a while and had some fun facts. He is pointing out houses, telling me about different neighborhoods. Then, all of sudden, he goes: "Hey, the Playboy mansion is coming up. Let me show you this."

As he drives me through a concealed neighborhood, he is looking around and eventually finds the back entrance. It's pretty inconspicuous. The mansion is in a rich neighborhood, but everything blends in well. There isn't a huge sign or anything. They obviously don't want a herd of college kids trying to crash a party or taking pics. Well, sure enough, the gates are open. There is a catering truck pulling up and some workers are bringing in water and chairs.

Dave goes: "Oh man, I have been by here a bunch. I have never seen the gates open."

I, too, noticed the Central American workers carrying chairs though the gate with no security guard in sight. We walked inside. We didn't discuss the plan; we just walked in behind the worker with chairs. I was waiting for the yell: "Hey!" But it never came. I kept expecting, "Excuse me, can I help you?" It never happened.

When the worker turned right towards the yard, we hung a Louie and stopped at the circle. This is where all the cars would park or turn around. We stood there in awe. We had seen this in MTV Cribs and on the news. We walked right up to the main door and even looked in the windows. Even if we were caught now, we would still have a story. We could still say that we were inside the gates. Still, no one came out.

We admired the driveway a bit more. You could see

another road where the busses drop off people in a private entrance. There are lots of trees and bushes. The property was meticulously maintained, and so we walked around the side of the house. I started to feel like a creep. We could look into the game room and living room. At this point, I got the feeling we were breaking the law. I felt as if we were out of line and someone is really going to start screaming. We kept walking. We made our way out to the lawn. An older couple walked by us and just smiled. They looked like producers or event coordinators. They assumed we belonged if we were inside this far. They probably thought we were Hugh Hefner's grandson or nephew. We stopped at the lawn and took it in. This place was legendary. The history. There were a few workers setting up some stuff, but it was early. There must have been a party at night. We walked over to the pool and grotto. People knew we were there, but nobody thought we snuck inside the gate. Dave asked if I wanted to jump into the pool. I said quietly, "Look, we are almost on the other side of the house. I can the see the gate we came in. If we don't jump in, we are going to get away with this."

He thought about it.

"If we jump in, we definitely are going to have to run and are probably getting arrested."

We stood there for a couple minutes enjoying the rush. We decided to get our feet wet and then head for the exit. We have officially walked around the house as we go back to the driveway. We are only a pitching wedge away from the gate, but this time it was closed and the security guard was there. We kept walking. He looked at us and we had an unspoken dialogue within that twenty second walk towards him. He basically looked at us like: "Dammit,

these kids snuck inside. I should call the police." Then, he gave a look like: "Fuck, that would mean I screwed up and I'll get in trouble."

He thought about it. He pondered the options. We tried to give a look that said: "We won't tell if you don't."

The gate opened.

We wanted to run but didn't. We kept walking. A small nod was all we exchanged.

We got into the car, silent.

We drove off and then, yes, we started screaming like teenage girls.

Oh my God; we were inside the Playboy Mansion. We walked around the whole property. We put our feet in the mother-frickin pool. The grotto, baby!

David said it best: "Jim, do you know how many idiot frat guys and meatheads have tried to or want to do what we did? Do you know many high school and college boys have talked about doing that?"

That gate was probably only open for ten minutes. Out of the entire week, we probably had about a ten-minute window to go inside that gate and we did.

Beautiful, man—absolutely beautiful!

CHAPTER TWENTY-SIX: SECOND ROAD TRIP

This time I was with Pops.

When I did my first cross-country road trip, I knew I would see some new states. I figured I'd have seen more of the country than the average American, but I was really shocked when I counted. I sat in my Los Feliz room and colored a map of all the states to which I had been. I wasn't even close. I had seen over half the country but still had more than twenty states to go. What the heck? This country is huge! I was excited to take a different route.

It was tricky timing the drive back because I had some work in LA. I was also getting flown for work. I was back and forth between coasts so much that I had frequent flyer miles on almost every airline. I committed to it, though, when my Dad said he had some vacation days coming up and would do the trip with me.

I drove to Nevada and met him in Vegas. We headed northeast towards Utah after cleaning out the Monte Carlo Casino. I am seriously surprised The Strip was still standing after we were done with it. I am not kidding; the poor place didn't see it coming.

We were on Highway 15-North. Our turn was coming up in a few miles and it started snowing. I could see the exit on the right, but the snow was coming hard at us.

As we approached the exit to go right on I-70 East, we could barely see in front of us and had to slow down. Dad had checked the weather and there was a big storm

coming. He was worried about the sports car and the tires. Thankfully we could see the line of snow after we turned right. If we woke up an hour later, we would have gotten stuck. If we kept driving north, things would have been a mess and we would have had to turn around. We avoided it all, as we turned right. We could literally see the wall of snow like a line on the outskirts of the highway. We were glad we turned when we did. A blizzard was behind us and clear skies were in front.

I had already been to Utah for a movie. It was an eventful week. A stuntwoman and I had to swim in a river for the end of *Touched with Fire*, a Katie Holmes movie. It was a ninety-nine degree sunny day, but the river was glacier runoff, so it was in the thirties. It was painful, even with a wetsuit. The best part was that it was an hour drive from the hotel in Salt Lake City; so, we got to stare at the land as we drove there. Guys were fly-fishing in the rivers. There were mountains and green all around. It's picturesque, especially the further away you get from the city.

Salt Lake City is a funny city. The Mormons have all these quirky laws. You could be a fifty-year-old guy with a white beard and you need an ID on you to drink. It's about getting carded, so you have to have the ID on you. You could be a senior citizen and it doesn't matter. It's not about the age, but rather they are strict about the law requiring you to have it. It's like a passport for an international flight; you just need it. I'm sure that's written somewhere back east, but they don't enforce it. I'm not talking about thirty-somethings that look young. You could be a retiree.

They also can only give 1.5 oz of liquor in a drink. No

generous pours, no "gimme a double" or "make it strong" wink. It's mandated by the state. Most places follow another annoying law, stating: "You have to have food on the table before you can order drinks." There are only a few bars that you can get a drink, but the majority of places you have to order food before a drink. "Fine, I'll take chips 'n' salsa, in addition to five rum and cokes."

It's a weird city, but a beautiful state. My dad was happy just driving through it.

Our next stop was Denver. I had been snowboarding outside of Denver before, so I didn't need to see the flannel shirts and scruffy beards. After a grueling eight hundred mile stretch, we crashed at a Holiday Inn Express outside and above the city. It's got a great skyline and there are so many mountains. You have to like winter sports to live in Denver. It's all people talk about there. There are a lot of stickers on cars and around town that say "14ers." It has to do with all the peaks that are 14,000 feet high or more. It's a local thing to climb one and talk about it. "I bagged a 14er today." "We are thinking about doing a 14er tomorrow." Hippies.

One of my Dad's nicknames is "Johnny Preventative Maintenance." No man has ever scheduled more vehicle services than him. No human has done more oil changes or tire rotations on their personal car. He has always had several vehicles and he proactively avoids breakdowns by doing each and all types of preventative maintenance to the cars. He checks the fluids, tire pressure, and replaces filters constantly. He also has never missed an inspection...ever! It was no surprise that morning he had an oil change and tire rotation scheduled for the Mustang

at a service shop in Northern Colorado. Only him.

We were off in a clean car; and with peace of mind. We spent most of the day driving north though Wyoming. Just seeing the word "Cheyenne" on a highway sign tickled my fancy. It was one of my favorites from the dinner table placemat quizzes. Wyoming looked very wide, with lots of cattle and bison. Broad fields of orange and yellow were everywhere. For such a large state, it's the least populated of all. It's a fact since it only has approximately half a million people. That's less than every other state including Puerto Rico and the District of Columbia. Wyoming was, and still is, one of my favorite states. It and Montana are part of Big Sky country. I'll tell you that, if you have never been, then you can't describe it. Lots of people think it appears bigger because it's so flat and there are no trees. Well, you can find that scenario in many other states, but it won't overwhelm you like this. There are also no clouds, or the ones that are there are considered high clouds like cirrocumulus or cirrus. It's like having a room with a higher ceiling. We got out at some intersections just to look around. I felt so small. It was incredible and one of the prettiest stretches of road in our trip.

We shot east, then north into South Dakota. We drove through the Black Hills National Forest. Then, we stopped at some random, antiquated lodge near Mt. Rushmore.

We got a beer, some grub and enjoyed a little father-son bonding at an old restaurant. Then, we checked into our room. There was no one in the lodge but us. It was a tad bit frightening, but the road had worn us out. We fell asleep fast.

Seeing Mt. Rushmore was the highlight of the trip. I assumed it would be smaller. We were astounded as we

got out of the car—it's enormous. I thought it would be a cool sculpture to look for a minute, but I wasn't expecting the size. It has sixty-foot high heads and twenty foot-long noses. They were gargantuan. We walked up to the viewing area and stood there in bewilderment. What an artistic feat! It was around five hundred steps for the sculptors to reach the top each day. I just don't understand how they got the faces so accurate. To check your progress or to make an adjustment, you'd have to go five hundred steps down, walk to the vantage point, make some mental notes, and then go back up. I don't get it, but there they are carved into Mt. Rushmore. Washington, Jefferson, Lincoln and Roosevelt are just hanging there as clear as day. We spent awhile there looking at them and reading about the process. My Dad asked some lady if she would take a picture of the "six Presidents." She chuckled as she took our pic in front of them. It's one of the only pictures we took on the trip and it's a real beaut!

We kept on towards Minnesota when we noticed these peculiar wooden signs: WALL DRUGS. Some said "coffee 5 cents." Or: "Come to Wall Drugs."

Others just said the mileage left until Wall Drugs. There were dozens and dozens of them, many more than you would believe. It was silly. At first it seemed campy, but they just kept coming. There was nothing else to look at, so they started to grow on us. "Free ice-water, Wall Drugs." "Fresh pie, Wall Drugs."

I was a sucker for these types of things, but I didn't think my dad would take the bait. He did. We diverted off the road and made a quick pit stop in Wall, South Dakota. We wanted to see what this store was all about. It was the size of a small town. It was an old western looking town.

It looked as if a tumbleweed would come rolling by and a cowboy was going to hitch his horse up where we parked. The gimmick worked, but we were happy we stopped. I wanted to get a belt buckle and sure enough they had it. "Get your western wear, Wall Drugs."

I got a nice one that said 'Wyoming.' It had a cowboy riding a horse like the license plate. I told the lady: "I'm buying a Wyoming belt buckle in South Dakota."

My Dad was quick to joke: "Yeah, and it's made in Thailand."

We took off towards Minnesota. It would be another six hundred mile day. Dad entertained himself by playing with the GPS. He was old-school and, at the time, we still didn't have navigation on our phones. He was against GPS's and was into maps, but there was so much time on the road. There were so many miles that he began to amuse himself by looking up distances. "It's eighty miles to the nearest hospital," he would say.

"It's fifty miles to the nearest rest stop in all directions. What would you ever do if you broke down or something happened?"

It was a whole lot of nothing out there. We kept driving.

I wanted to see the Mall of America. We eventually got there, and John Ford wasn't too enthusiastic. "Great, looks like another shopping mall. Let's go."

I said: "Come on, we have to walk around a bit. This thing is so big that it supposedly has its own zip code" (55425).

The Mall of America is the largest in the US at over

four million square feet. It has mini golf, a theme park and 20,000 parking spots. As you walk around it, it really does look like any other mall—just a little bigger. He was really ready to hit the road.

It was icy and cold as we aimed for Wisconsin. The Stang was sliding its wheels as we exited the parking lot. Thankfully the highways were better. We were really pushing the sports car in the weather.

Next stop: Milwaukee, Wisconsin. Well, we made a quick pit stop in Madison. We had to try some cheese. The state's nickname is America's Dairyland. Ok, now the next stop is Milwaukee.

Milwaukee seemed like a cool town. It's somewhat industrial, but it's not trying too hard to be hipster. It likes its beer and its baseball. Pops wanted to check out the Harley Davidson Museum, so we went inside. Looking at old books and artifacts behind glass display cases usually doesn't do it for me, but the minutes from the first meeting of the stock holders was impressive. I've never owned a Harley, but I do have some of their stock and it has done quite well. It's a great way to spend an hour or so. This history of this company and how they built their brand is compelling. You get to sit on some motorcycles too!

We rose early and drove until it got dark, crashing at some chain hotel on the highway near Cleveland, Ohio. The next day, we punished ourselves and drove all the way back to West Boylston. The last two days was over 1,100 miles and twenty-plus hours. All business. We stopped for nothing but the basics, pulling into the driveway late at night. We were exhausted, but it felt good to be home.

CHAPTER TWENTY-SEVEN: QUICK BREAK FROM THE STATES

I officially had seen a lot of this country after that road trip. I needed a break. I really wanted to get out of it and escape for a bit. Take some time off. I wanted to put my phone away, shut off my email and unplug. I wanted to see a new culture and explore, but I also wanted to compare it to the U.S.

A young gal named Danielle, who I had been dating off and on, was about to take a semester in Rome. She had invited me to go. I said: "Do you mind if I come for the whole time?"

Thankfully she didn't think that was creepy.

That's what drew me to the trip. That's what pushed me over to turn down all the work. I love the U.S., but to get out of it for a month and a half is special. One-week vacations are fun, but you're running around trying to fit five hundred things into a couple days. You're packing and flying back before you know it. When you go for this long, you relax and soak in their way of life.

We had an apartment in Rome for the duration of the stay and most weekends we traveled.

We constantly compared the differences of Italians and Americans. The first thing we noticed was how big of choice whores we are in the States. We have way too many choices when we dine in the USA. We are so high maintenance. "I want it cooked this way but hold the

tomato. Can you put the 'whatever' on the side and give extra 'so and so?' Can I substitute the blank for this?"

And so on and so on. Shut the frick up!

In Italy, they don't care about your attention-seeking food allergies. They don't have a gluten-free option or a vegetarian-substitute. How they make it is how you eat it. If you don't like it, then take a hike. Don't get me started on the condiments. When you go out to eat, the plethora of condiments at the table is madness. You can always ask for more, but not in real Italy. It's prepared the way the chef thinks it should taste and that is how you eat it. I loved that. We didn't have a bad meal. Sometimes we'd even go to a place that didn't have a menu. A handful of tables and whatever Mom was cooking that day is what they bring you. No specials, no options, no thousand-page menu for you to discuss. Therefore, there was no second-guessing your decision. It's just: "Ciao. Today we have we have a pasta Bolognese. We will start with a split pea soup and then we'll bring desert."

It's exhilarating. If you go back another day, then it's totally different. There is no soup but a different appetizer. One time the main dish was ox-tail. You would never order it, but with this style of dining, you don't have a choice. It was lovely.

We are so picky and fussy when it comes to eating, but we are not doing things the right way. The way they eat in Italy is the way it should be—a nice lunch with that special glass of wine. Then, take a li'l nap. Get on your scooter and buzz to a little coffee bar for an espresso. Dinner starts a bit later than I am used to in the US, but it's wonderful. It lasts a lot longer; you talk and tell stories. You're tired when it's done, so they give you a shot of limoncello or

grappa after the meal...bellisimo!!

Most people have a glass of wine with lunch and it's no big deal. My favorite is that when you sit down, sometimes they ask "red or white?" They don't even ask if you're drinking wine, but rather they assume. I always say that if you had a glass of wine in West Boylston, Massachusetts at noon on a Tuesday, you'd get some looks or a comment: "Getting an early start?"

If you only spend a week in Italy, you may find them off-putting or rude. When you're there for over a month, you see the beauty of the language, the food and their way of being. There are so many trends in America that simply copy the Italian way. Trust me that they know what they are doing over there. They have been doing it a lot longer.

I was back to Boston after the island of Capri, the canals of Venice, a stroll in Tuscany and some pizza in Naples. The plan was to get an apartment in New York upon coming back to the States. I couldn't go back to Metropolitan New York, not after the west coast. I had my heart set on Long Beach. No, not Long Beach, California. No, not Long Beach Island...that's on the Jersey shore. Long Beach, Long Island. Some locals like to think it's separate from Long Island, really, it's debatable. It's a barrier island off the coast of southern Long Island but it's Nassau County, which technically makes it Long Island. No one wants to say they are from Long Island, rather, they want to say Long Beach. Long Beach is the best kept secret in the country. It's not perfect, but it is one of the most unique and interesting places you could ever live. It faces south, so it gets year-round surf. Any storm from Florida or the Caribbean can pump some pretty swells up there too. The

beaches are cleaner and nicer than the Hamptons. The Long Island Railroad, too, will take you express fifty minutes into Penn Station. Answer me this: Where in the world can you go surfing in the morning, then take a take an hour train into world-class dining, theater, museums and entertainment? The answer: Long Beach, New York.

The one hiccup was that, when I got back from Italy, they were having the Quicksilver world surfing competition in Long Beach. You couldn't get near the place. Everyone was subletting their apartments for thousands of dollars a week. I had to stay with my parents for another month. Oh, did I say "stay..." I meant to say "mooch." Yes, I mooched off my parents for another month. Thankfully there were some movies in Boston. I was able to stay busy. Danielle let me stay at her place in Astoria when I had work in New York. My parents weren't impressed with Italy or had any desire to talk about it. "Ok, we get it James, but this isn't Europe. You're not drinking wine during the day and taking naps."

Thankfully, I found a place the following month.

CHAPTER TWENTY-EIGHT: MISSISSIPPI

Long Beach was my new home. After a studio apartment for a couple months, Danielle and I decided to get an apartment together. We signed a lease (my first ever) for a one-bedroom apartment on the water. This apartment wasn't a block away from the beach. It wasn't across the street from the beach—it was on the beach. I could be in the water surfing in twenty seconds. We were living the couple life, cooking and taking walks on the beach. It was paradise, well, once we recovered from Superstorm Sandy. We decided we would take a quick trip to celebrate New Year's Eve.

She always wanted to see New Orleans. It's an easy trip, yet still feels like a destination within the country. Even though I had already been to Louisiana for an extended period of time, I never got to Nawlins. I agreed on one condition: I wanted to rent a car and drive to Mississippi one day. I wanted to see the state.

"Fine, Jim. We can go to Mississippi one day."

It was a good thing we did because we had to get out of New Orleans. You don't need to spend a week there. It's a fantastic city. Some may say it's the best in the country, but it's intense. We needed a break. I like to drink, but not like this city. Absinthe cocktails in the morning and hand grenade mixed drinks during the day. You're black-out drunk before dinner. Creole shrimp, gumbo, étouffée, and

jambalaya are all delectable, but it's twenty-four hours a day of that food. I wanted a slice of pizza or a turkey sandwich without cajun on it.

After three days of eating and drinking in The Big Easy, we headed northeast to Biloxi, Mississippi. We could see the stately beauty of the magnolia trees immediately. It was a breath of fresh air. I knew Mississippi was a southern state. I knew Elvis Presley, Oprah Winfrey, Britney Spears, Walter Payton and Jerry Rice were all born in Mississippi. I knew the Mississippi River boarded it to the west, Alabama to the east and Tennessee to the north. On the contrary, the thing I didn't know until now was that the Gulf of Mexico bordered a portion of it to the south. This was a remarkable discovery. When you think of the Hospitality State, you don't think of the beach. Biloxi, Mississippi sits right on the water with a beach facing the gulf. We had no idea. We got out of the car and took a quick stroll on its shoreline.

Biloxi is also known for its casinos. We love to throw the dice, so we headed to the biggest of them all: The Beau Rivage Casino. It's a polished resort also on the water. Walking into this establishment is something. It's very upscale but with a distinct look. It has old-world style, blended with modern day decadence. It was almost over the top. Danielle and I have a lot of differences, but one thing we learned we had in common really quick was we love the craps table. We both shoot well and have our own finicky systems of betting. This place is one of the few casinos in the country to offer Crap-less Craps.

I know what you're thinking: "Looks exciting but I don't understand the table."

Or: "Seems fun but it's too complicated."

It's actually very simple. Don't let the table fool you. There are a countless amount of numbers and situations on which you can bet. Don't even look at them. Stick with your bread and butter. You ready for a Jimmy Ford explanation?

CRAPS FOR DUMMIES COMING UP: You get the dice. Put five dollars down on the pass line, then throw. Whatever number you throw is your number. Now, you get the dice back and you're trying to throw that number again before you throw a seven. That's it. If you throw a seven, you lose and pass the dice to the next player. Any other number besides seven and you keep throwing. If you hit your number, then everyone cheers and makes noise. You win, and the game starts over. Pretty easy, right?

So, if you throw an eight, you're trying to throw the eight again. If you throw the eight, then you win! Throw a seven and you lose. You get the dice back and keep throwing with any other number that you throw. Now, there are a couple exceptions to the game, especially on your first throw. You have to learn over time, but the dealers will tell you as you go. That's basically it! Everything else is just additional side bets. You don't have to do them. There is strategy and other bets. You'll pick those up over time, but just try and roll the first number you throw again.

If you're intimidated about walking up and asking to throw, don't be. The dealers and players alike love a new shooter! You usually throw well because you don't think about it.

There is a version of craps called: "crap-less craps." That is rare. There are a few numbers normally that are

off limits to bet on, but in this version of the game, you can bet on them all for outrageous odds.

We won big! Over five-hundo as a team. Danielle kept stuffing big chips in her purse while the dealers laughed. Thank you, Beau Rivage.

We took our winnings to Margaritaville Resort for lunch. It was refreshing to get an iced tea and some normal pasta. Our hospitable waitress informed us of many fun facts about Jimmy Buffet. There are over twenty Margaritavilles in the world. Each one pays him $10,000 a month to use his name. Some, he gets a percentage of the food profits and merchandise sales from the gift shops.

Geez, I've heard the song before. I didn't realize how crazy people were for it. His net worth was over 500 million dollars and most of it isn't even from the music. This particular restaurant was his baby. It's the signature restaurant and the only one he personally sees to himself.

This lady talked to us for a while. I almost felt bad for the other tables, but things are much slower down here. She kept telling us how he drinks at that bar and once a month he flies in with his plane. He lands on the water and comes up. Okey dokey. I mailed my postcard: "The weather is here, wish you were beautiful."

With our bellies and wallets full, we head back past the beach and over the bridge to New Orleans. We got some beignets at the famous Cafe Du Monde and dined at the beloved, century old Galatoire's for New Year's Eve dinner. There is music and culture in the air.

Happy New Year!!

CHAPTER TWENTY-NINE: PUERTO RICO

Long before Danielle and I moved in together, and a year or so before California, we took a quick trip to Puerto Rico. We were casually dating, and, on a whim, we decided to book a trip. I had always loved to travel, and I was always looking to meet girls when I traveled. This was the first time I had ever taken a trip with a girl I was dating. It was marvelous. The second I booked the trip, I think I fell in love. The combination of traveling and romance is the best. I couldn't believe we were going there so last minute.

We had too much fun. She only wanted someplace warm, while I wanted someplace to surf. It was May, so Puerto Rico was a good fit. An easy and direct JetBlue flight to Rincon, then we were sipping fruity drinks by the pool in no time.

Our first night we ate at some hole in the wall. It was a Puerto Rican joint with authentic food. We had appetizers, beers, shots, a main course, more beers, and a dessert. The bill was less than twenty dollars. We were so stunned. We actually took a picture of the bill with a disposable camera. We did no research about Rincon or Puerto Rico in general. We just went with it.

Rincon is cool, and the waves are delightful. I'd surf for a couple hours and she'd lay out in her white bikini. We'd swim, gamble and have candle-lit dinners on the beach. Seriously, I was falling in love.

Us being the idiot New Yorkers, we assumed you could

take cabs everywhere; not really. Everybody but us had rented jeeps or cars. We kept calling this cab company. We called them to rent surfboards, to go to the beach and to go to the casino. We called the cab company every time we left the hotel and every time we got the same guy. One time it was late, and we were forty-five minutes away. We were stuck at a casino we assumed was open twenty-four hours. We also assumed they would have cabs hovering around the entrance. Nope, so we called the cab company and guess who we got...the guy. He was sleeping with his family, but he woke up and came and got us forty-five minutes later. He was the friendliest guy you'll ever meet but it was a bit strange. No one else was taking cabs. We kinda felt bad. We are renting a car next time.

PUERTO RICO 2.0

Years later, I am living in Long Beach, New York, working in Boston on an Adam Sandler film. When it's done, I headed to The Cape and met up with a high school buddy named Fitzy. His friend had a super old boat. This thing was a classic all right. It was all beat up and taking in a bit of water. This vintage vessel had character. We were on a pleasure cruise in the Bass River in between Dennis and Yarmouth. We visited Follins Pond, which many natives believe Vikings landed on long before Columbus and Plymouth Rock. Though Norse settlement isn't officially credited, there is lots of evidence to support the theory that Leif Ericsson, while searching west for new land, entered this river from the ocean. He drilled mooring holes in the rocks for their horses. Those rocks are still there today. The Cape is rich in history.

I checked my phone after cruising under the Route 6 Bridge, watching the kids jump off and spending the rest of the day swimming and snorkeling. I had a couple text messages from a stunt coordinator named Mark Norby. He was checking if I was available to stunt double Justin Timberlake in an action movie *Runner Runner*. I had to take some pictures of my hair and send it to him. It was all blown out from the day. I didn't think I'd hear back.

Later that night, he confirmed I was hired but I had to fly out the next day.

"Ok, can I fly out of Boston?"

"No, they'll have you flying out of JFK in New York—tomorrow morning."

SON OF A!

I had to leave that night. I was sunburnt and beat from a full day on the water. It was five hours without traffic from The Cape to Long Beach. I drove through the night, pulling over two separate times to stop from falling asleep. Finally, I made it to Long Beach, only to get a voicemail from the travel lady saying they pushed my flight to the following day.

It was all worth it. The next two weeks of filming were some of the best I'd ever seen. I did chuckle a bit. "Ugh, they couldn't have filmed in a state or a country I haven't been to?"

I have already been here! I'll just have to make the best of getting paid to play around in Puerto Rico on a Justin Timberlake action movie about sports-betting and exotic cars. Jerks.

This film was badass. I got to drive a suped-up Maserati spiritedly on a scenic cliff road for one of those classic big-budget wide shots. I also got to ride on a

million-dollar boat that was owned by a professional baseball player. I had to ride on the back as the bad guys watched over me and a camera boat caught the shot. If you watch the film, it's the scene where they take Richie out to see the alligators. We did a bunch of foot-chase scenes in all different neighborhoods and rooftops. We also stayed in the San Juan area, which was on the other side from Rincon. We filmed a ton of running scenes around there. I can't believe they are paying me for this.

The best part about this movie was that it was filmed to look like Costa Rica. So, we were shooting over an hour away from the hotel in jungles and odd neighborhoods. One time we filmed a scene in a very dangerous area. The police had nothing to do with this place. Drug dealers and gangs controlled the gates. Some agreement had been made prior with a local on the crew to allow us in there. It was beautiful in a natural and different way. Some houses didn't even have doors or roofs on them. It was a shantytown. We were amongst barking pit bulls and trash-littered streets. Old ladies were selling ice cream for a quarter. This was not on the tourist map. When we had to leave, some drug dealer had to signal for someone to open the gate. It was an experience to be allowed into these streets.

On one of my days off, I embarked on a four-wheeling sightseeing excursion. A couple guys, a guide and I took four-wheelers on a jungle tour. Even if the sights were bleak, you're screaming through mud and going off-road on a four-wheeler. The setting was spectacular, though. At one point these wild horses came running up next to me. They were so fast. I had to be going thirty-five mph over the bumpy muddy path and only inches off the dirt was a

field and I swear these stallions came galloping up. They even ran with me for a while. I think they were trying to say 'hello.' It was both scary and wonderful at the same time. I couldn't believe how fast they were. The large leg muscles flexing as they sprinted next to me. So strong and beautiful. It was almost spiritual.

I didn't want to leave. The hotel was deluxe in addition to the fun of filming—oceanfront with all the luxurious amenities for which you could ask. I flew back home, only to get a text asking if I could come back the next week for another seven days.

Hmm, let me think. Sure.

There was more running and playing around on expensive toys. I got to go out with some of the cast to the local casinos and play craps. I had a beer with Director Brad Furman, and another night we did a pub crawl with Anthony Mackie. It was August bliss. I was staying at the same hotel, right on the ocean. The water was the temperature of soup.

I have to admit my ignorance. I knew Puerto Rico was part of the US, but I just didn't know how much it really was. As I went to the post office to mail my post cards, I expected some sketchy shack with foreigners behind the desk. It's the United States Post Office. The same posters, colors and even the uniforms. Puerto Rico is the United States. There is still some debate as to whether or not it's an official state, but it's certifiably a United States territory. They pay US federal taxes and even vote on stuff.

Eventually it was time to go back home. I saw Fat Joe and the terror squad at the airport bar. They were all leaning forward, stuffing themselves with large cheeseburgers. After I landed, I was told production had a

car service for me. I've had these dozens of times. Usually it's a well-dressed man with a nice SUV or black sedan. The walk to the car was longer than normal. The man in the suit said: "I had to park this thing out back."

A stretch limo was waiting for me. I don't know if this was Mr. Timberlake being classy or the car company's fleet being busy. Still, I wasn't complaining. This limo was handsome. I had to laugh. I told the driver to take his time and go slow. I sipped sparkling wine out of a glass flute while I cruised by the Belt Parkway. I rolled down the window and waved at some lady.

"Heyyy."

I was having the time of my life. When I eventually got dropped off, I gave the guy the rest of my per diem as a tip. He almost cried when he saw how many twenties I handed him.

If you're looking for a good, clean, fun, summer popcorn movie...check out *Runner Runner*. Ben Affleck plays the villain. It's a fast-paced, enjoyable ride! You will learn a ton about the billion-dollar online gambling scene. Public transportation for these characters is sharing a private jet!

The movie didn't do that well at the box office but was in the top for DVD sales multiple weeks in a row. It's a fun escape for an hour and a half and visually very easy on the eyes. Mega yachts, grand locations and Ben Affleck...does it get any better?

CHAPTER THIRTY:
MONTANA, HERE I COME

I was heading to Montana and a few other states, too.

I really didn't think I had another cross-country trip in me. My goal to see all fifty states was on the back burner. I was still living the life in Long Beach while surfing and working. There is great seafood in Long Island, by the way. Fresh oysters and plank salmon. Mmmmm. Danielle and I were traveling to other countries. We went to Asia for a bit and I went to Central America a couple times. Believe it or not, I got to open the Panama Canal! I was traveling to the Caribbean and random cities for film festivals. I didn't think I would drive west again, but my cousin Kevin called me: "Jamo, I am doing a road trip to San Francisco."

Hmmmm, I thought. Hmmmm...

I had known Kevin a long time. He once lived in D.C. along with my other cousins, Brian and Mitch. After college, he traveled with the Marines. Then, he eventually came to New York for a temporary job. When he decided to go back to school in San Fran, he had to a do a road trip to get there with his stuff.

I had been looking at a map, still coloring in the states to which I had been. It was upsetting. I had done so much but still had so much to go. I looked at my map of the United States. I had colored in over thirty states, which is pretty good, but still had eighteen states to go. WTF. How do people do it? I mean, if you're retired, then I guess you just drive around for a year. You go to Alaska and Hawaii,

but seriously this is an effort. I knew I could always go to Hawaii and the other states, but if I was going to have a shot at all fifty, I had to get North Dakota and Montana. They are the hardest and least traveled to overall. They are out of the way and you can't get all fifty without them.

I called up Kevin and basically said: "I'll do the drive with you one way and split the cost, but you have to go through Montana."

Eventually he said yes. He had been interested in the northern states and could use the company. One summer day, he backed his Toyota Yaris up onto the sand in Long Beach. It was as far east as we could be. We scrubbed out and headed west.

We made *Message in a Bottle*, a short film, which can be seen on Vimeo and YouTube. We fill up a bottle with ocean water from the east coast and then drive 4,500 miles across the USA to see what happens when we mix it with water from the west coast. That's pretty much what we did. We tried to check off some other states along the way. We stopped in Iowa after the Mississippi River. Burlington, Iowa has the most crooked street in the world—even more so than its famous friend Lombard Street in San Francisco. From there we stopped in Lincoln, Nebraska. After some steak and eggs, we snuck onto the Cornhuskers campus and played pass on their football field.

FUN FACT: The stadium becomes the largest city in the state when it's at full capacity.

We entered North Dakota and decided to drive an hour out of the way and back just to see the KVLY-TV mast. It's the largest structure in the western hemisphere and the fourth tallest thing in the world. It's over 2,000 feet high.

It's basically just a skinny radio tower in the middle of FN nowhere. This definitely satisfied my random craving for the trip. There isn't even a sign for it. It's just next to some houses.

We drove into the capital, Bismarck. We grabbed a burger and a beer at this awesome bar that had free postcards. They even offered to mail them for you. They would pay for the stamps too. "Dear Gramma, I'm in North Dakota...cheers!"

We shot west to Montana after that. I was eagerly awaiting the "Welcome to Montana" sign. I was tingling all over knowing it was coming. I could see the dotted line approaching on the GPS screen...and there it was—a big blue sign with a circle in the middle. MONTANA.

It's by far my favorite state. I've wanted to stand in the state ever since that placemat.

When you're driving in the US, you see a lot of vast fields and views. Some states have mountains, some have plains, and some have rivers or bodies of water in the foreground...Montana had it all. It's the most expansive views you'll ever see. Big Sky Country and wide-open terrain. The snowcapped Rocky Mountains are dancing in the background with rivers flowing in front. Its nickname is "The Treasure State;" you can see why. There are parts of Maine and other states that have areas of spotless beauty, but with Montana, it's all over and bigger! We spent three full days checking out Bozeman, Helena and Butte. It was all gold from the post offices, the Helena sign, the whiskey tastings and the Lewis and Clark trail—not to mention the terrific people. Montana, dreams really do come true.

We spent a night in Boise, Idaho. Then, we drove over

the continental divide. Before we knew it, we were in Oregon watching the thick pine trees buzz by us. I noticed one thing had changed since my first road trip. There were fewer McDonald's. It had been around seven years since my first road trip and there were now officially more Subway sandwich shops than Mickey D's. I know Subway isn't perfect. The country has a problem with its bread and all processed meats, but it's a step in the right direction. It certainly is a healthier option than fried food and dollar beef. There were also Jimmy John's sandwich shops popping up too. I felt cleaner on this trip. We didn't have to flush the sodium out of our system with gallons of water when we were done. A six-inch on wheat with vegetables and no soda will keep you going and feeling good.

FUN FACT: According to some guy who is into fitness: If you order a foot-long sandwich, chips and a soda from Subway, then you negate all the health benefits of choosing the establishment. It actually becomes worse than a fried fast-food value meal. Subway is healthier by a long shot, but you have to get the six-inch and no soda.

We stopped at Multnomah Falls, a 600-foot-high waterfall. At the last minute, we decided to scurry up the two-mile round trip hike. Our bodies thanked us for the physical activity. We had been sitting for a while and it was nice to get the blood going again.

You'll have to watch the short film to see the beach onto which we eventually drove. Yes, we still have the bottle of water from the east coast. You won't believe what happens when you mix it with water from the west coast. Google: *"Message In a Bottle—short film"* and watch the adventure. It even played at a few film festivals.

The trip was over, but we still had to drive to San

Francisco. We both dreaded the last ten-hour, six hundred and fifty mile stretch of driving. There was nothing to look at and we had both already been there. We were starting to bicker a bit. Even the music on Pandora was irritating. Thankfully we found some stand-up. Do you know you can search Pandora for comedians as well as musicians? Instead of playing a song, it plays a joke or a story. It helped us through the last day. We listened to stand-up while we chatted. I ranted about how Facebook is a disease and destroying people's lives. I also went on about how people take way too many pictures now, and most of the pictures suck. We discussed sports highlights and why there is so much corn in this country. We discussed everything from casino strategy to renting vs. buying in America. Kevin explained that ninety-nine percent of Americans misuse the phrase: "third world country."

Do you know the term "third word" has nothing to do with wealth or poverty but simply the country's views during the Cold War? Calling a country "third world" because its impoverished is wrong. If you drive by a ghetto and say: "Geez, it looks like we are in a third world country," then you're using the phrase incorrectly. A country is third world if during the Cold War it was not aligned with either NATO or the Soviet Union.

We made it—San Fran again. Kevin looked for apartments, while I went to an A's game. The Oakland Coliseum is rated one of the worst ballparks in America. That makes me love it even more. It has the largest foul territory of any ballpark. It's also built to host both baseball and football games. Many suggest it's qualified to handle neither. I love to see different things and this ballpark did not disappoint. I saw a good game and a lot of

throwback Rickey Henderson jerseys.

Finally, I got to visit Alcatraz Island. It's fucking mint. You can't just show up to Alcatraz. You have to buy tickets months before, like a play or a ball game. It is the number one rated landmark in the country and one of the most popular tourist attractions in the world. More so than the Statue of Liberty or the Golden Gate Bridge. Over a million people a year visit Alcatraz Island and they all love it. I highly recommend taking the short boat ride. Even if you don't care about prisons or history, the cruise to and from the island is well worth it. The views of the city skyline from the water, with the Golden Gate Bridge and Oakland Bay Bridge all around, are absolutely spectacular. I also love the 1996 action film: *The Rock*, so it was cool to see where they filmed some scenes. There actually is a lighthouse.

The next day I was on a red-eye back to JFK. I ordered a cheese plate and a glass of wine. As I started to doze off, I thought about how cool the northern route is. I think it's the best route and definitely the rarest. It's by far the least traveled. I also thought about how long and much work it is to drive across country. It's a demanding, week-and-a-half expedition. Then, you get on a plane and you're home in a jiffy. It's almost depressing. All that work and all those miles—not to mention nights, meals and pit stops. All the check-ins and check-outs. All those roads and times trying to stay awake while fighting to keep going. All the gas, the food, and the motels—then, boom! You get on a jet and you're back in six hours.

CHAPTER THIRTY-ONE: AMERICA'S FUNNIEST HOME VIDEO

I had always wanted to get on *America's Funniest Home Video* as a kid. I know it's a stupid show, but my friends and I were always filming our sledding exploits and backyard shenanigans. We were hoping they would get on...nothing.

As I grew up a bit, I graduated to making short films instead of home movies and skateboard videos. I linked up with a production company called Fat Foot Films. The production value, editing and post-production quality has gone way up. It's still just as fun. I would try to film back in Massachusetts if I had the time, as it was easier to get locations and permission then in California or New York. I would submit the short films to film festivals in states or cities to which I wanted to go. I started traveling even more. I was traveling for work, I was traveling on vacation and I was traveling with my short films. Talk about a great write-off.

I tried to film a short film, *Timmy Text Message*, with a big glass stunt. We had to push it a week because of peoples' schedules. Instead of twiddling my thumbs, I decided I'd go check out Myrtle Beach. I hadn't been to South Carolina yet and it's Dirty Myrtle. I had to see it.

This was the most tired I had ever been driving. I thought I could do it all in one shot. There were no new states along the way, so I didn't care. I wanted to hit a

button and just be there. Skip the monotony of highways and plain trees. I was so tired that I kept dozing off behind the wheel. That's dangerous, I know. You almost go into denial. You doze off really quick then wake up. "That was nothing; it won't happen again. I am fine."

I was falling asleep hard, but I didn't want to stop driving. All the Red Bull, coffee, energy drinks, radio volume, window down and screaming couldn't help. I was downing all types of 7-Eleven concoctions. My body was awake, but my eyelids just couldn't stay open. They were heavy. I was yelling and jumping out of my seat but then I'd catch my head. I fell asleep for a second, then again. I had a dream. That's how long I was out—I had a dream. When I was asleep, there were no cars on the road. When I woke up, there was a car in front of me and another car passing on the left. Could you imagine what that looked like?

Oh, geez. I had to tap out. I pulled over at the next exit and zonked out in front of some general store. People were coming in and out, but I was gone. I awoke fresh twenty minutes later. I was tentative to start driving again but somehow, I felt refreshed. Wow, I was revived. I couldn't believe that's all your body needs sometimes. I was still in Virginia. I wasn't going to make it. I called up my buddy Adam Davis who lived in Raleigh, NC. I knew him from college and he had always said to give him a ring if I'm in the area. I met up with him for some Waffle House breakfast and relaxed for bit at his place. It's amazing. This guy had a two-story palace with a spiral staircase. It included a loft and balcony for six hundred a month. That doesn't get you a closet in New York. I like the Carolinas.

I splashed some water in my face and I was ready to

go. I called up John Gilbert and asked if he wanted to meet up in Myrtle Beach for some golf. He wasn't working that day, so he drove an hour and met up. We bought some fireworks and set them off on the beach. We even tried some local seafood, but the real story comes from the golf course. We were driving around all the prized courses in Myrtle, trying to choose which one, when it started to rain.

"I drove all the way down here. I have to see one of these famed courses."

Myrtle Beach is known for a lot of things and the quality of golf courses is one.

John simply said: "I have always wanted to play a round in the rain. Let's go."

So we went to Walmart and bought full rain suits. We drove to Man O' War Golf Club and had the place to ourselves. They were hesitant to let us out as no one was there, but we told them I drove all this way and even bought rain suits.

This course is one-of-a-kind. Water is everywhere. The website says it combines "daunting drama and divine design." The course is a "battlefield of back to back island greens."

We were having too much fun while laughing as we played in the rain. There were so many island greens and so much water that if you hit your ball into another fairway, you had to drive a mile around all the lakes to go get it.

Well, we were on one of the tee boxes and I am soaked. I have this little video recorder the size of a microphone. It's called Flip Video. It's good for getting quick video footage of stuff. I say: "Hey John, record this. I got to send this to my parents and show them how good the weather

is."

Haha. The whole point of recording was that when you think of golf in the Carolinas, you think sunny weather and pristine conditions. This was dark clouds, rain and heavy winds. That's why we were recording. I was going to send it to people as a joke. We were also playing pretty well despite the conditions. I was teed up, and as I swung, I hit a beauty right down the middle. Then, my club went flying. It must have gone a hundred yards right into the water. An enormous lateral hazard to the left and it went ker-plunk. I immediately started running after it. It was a $350 driver, brand-new. I had just bought it. I was already wet, so I had to go get this. Of course, John is still recording. I tentatively went into the water and reached the club while continuously yelling: "Are there alligators?" I was scared, but I had to get the club. The distance the club traveled was equally hilarious. I eventually ran back and said something to the camera.

We were cracking up as we continued to play. What a round! We hung out at the hotel that night and lit some more fireworks and tried all sorts of fried southern treats. I had to head back the next day.

I showed people the clip from time to time and everyone got a chuckle out of it. I put it on YouTube a couple months later. People kept telling me: "Dude, you should submit this to *America's Funniest Home Videos*." They kept saying, "It's good, clean fun. That's the type of stuff they show."

I submitted it. I didn't think I'd hear from them. About a week later, I got an email from the show asking me about the YouTube clip. They asked if I could remove it. I told them sure. I removed it from the Internet and wrote back.

I didn't hear from them; they never wrote me back.

I get a random phone call a year later. It was the most unenthusiastic call I have ever heard.

"Is this Jim Ford?" a monotone voice asked.

"Yeah."

"Your clip has been selected to air on *America's Funniest Home Videos* next Thursday."

"Really? Wow, thanks."

"Good day."

"Wait..."

(Pause)

"Ummm, what time?"

"You'll have to check your local affiliates for the time. Next Thursday, channel ABC."

"Ok, thanks."

"Have a good day."

"Is that it?"

(Pause)

"Oh, ya, do you want a t-shirt?"

"Yes."

"What size?"

"Large."

"Ok, good bye."

This kid must have made five million of these calls. He could not have cared less. Wow, did this make my day. I called all my friends.

It's kind of corny, but it did air. They even had the cheesy commentating: "It's not every day you see a golfer follow his follow through."

Haha.

Ahh, South Carolina. You are something.

A few years later, I made a short film called *Test Drive*. It was screening at a film festival in Charleston, South Carolina. I was happy to go back. I flew this time!

Charleston had recently been voted "Best City in the World to Visit." Yes, in the world. Not just the country, but the world. This old city in South Carolina beat all the places in Europe, the Caribbean, Central America and Asia. This is, of course, a very subjective accolade. I'll tell you honestly, even if your opinion differs, it's still got to be a top ten. The people, the food, and the scenery is all what you'd expect. What really gives some fact to the honor, in my opinion, is its proximity to such an astounding beach. Downton Charleston is fifteen easy minutes to Folly Beach. Folly Beach is my favorite. The friendliest beach bars, great weather and year-round surfing. The food is tops too. It's better than good. It has a unique southern twist to it as well.

Of all the places to which I have ever been, I personally felt the most at home in Folly Beach. Screw Florida. I think I'd rather move here one day. It's a quicker flight and the weather is just the same.

CHAPTER THIRTY-TWO: WHAT THE HECK IS WEST VIRGINIA?

A short film I made, *Fight Scene*, got accepted into an Atlanta film festival. I was stoked. It was a perfect excuse to see a new state. The festival was awesome, as was the city. Good ol' HOT-LANTA. I caught a Braves game and even got to chat with All-Star Geo Gonzales, thanks to a chance meeting of his dad in the stands. I spent a night in Delaware a few months later on my way to work in Baltimore.

I consulted my map. After Georgia and Delaware, I only had five more states for the continental forty-eight states. This was doable.

I didn't have a ton of time, but I had close to a week. I really wanted to see Tennessee and Arkansas, but they were just a bit too far to reach with a return trip in a car.

West Virginia was pretty close. If I could get to Kentucky, too, then that would be worth it. It would be a fine mini vacation.

My poor girlfriend: "You're driving to West Virginia?"

"Yes, and Kentucky."

"What the heck are you going do in West Virginia?"

"Oh, you'll see."

She says nothing.

"Do you want to come with me?"

"Nah, send me a postcard."

How many times have you ever heard someone say

that they were going to West Virginia for leisure? Most people don't even know it's a state. That made me lust it even more.

West Virginia is the thirty-fifth state in this great nation. It was the first place to celebrate Mother's Day and the first state to have sales tax. Many consider it the northernmost Southern state and the southernmost Northern state.

I was headed to Charleston, its capital, planning on spending a night. Then, I'd head to Kentucky. I did a quick Google search on things to see in The Mountain State. Articles about the New River Gorge Bridge kept popping up. I like bridges and it was on the way. Sweet!

I called Danielle to tell her I was driving to go see some bridge. She laughed from her office phone: "Ok, have fun with that."

This one takes the cake out of everything that has exceeded my expectations. This bridge is boss. It's over 876 feet high. Dude, do you know how high that is? It's definitely on the list of tallest bridges in the world, and, it's randomly stuck in West Virginia. It's so high. You think the Brooklyn Bridge is high—it's not even 200 feet. The Verrazzano Bridge, going to Staten Island, isn't even 700 feet. The Golden Gate Bridge is about 747 feet. This bridge is over 100 feet higher than the Golden Gate Bridge, which everyone visits and knows well. This bridge is a hidden gem! Driving over it is a rush, but seeing it looming over the river from down below is really impressive. They used to close the bridge one day a year and let people skydive off it.

After that, I made it to the capital and drove around. It was a tiny town and reminded me of Worcester. I wanted

a beer and some food. I found a bar that looked cool. A bouncer greeted me and told me there was a three-dollar cover. I told him, "I'm Jimmy Ford from Boston."

He laughed. I noticed he had a Red Sox hat on. I told him that I am from Massachusetts. I said, "I drove all the way here from the east coast. You can't charge a Red Sox fan a cover. Come on, it's five o'clock. There is no one in there."

He let me in. JIMMY FORD...no cover.

It started filling up and a group of people started talking to me. Everyone was so friendly. I am starting to realize most places are friendlier compared to the northeast. It must be the weather. My new friends and I had some drinks and started chatting. They were amused that I was just driving around by myself checking off new states. They said they were going to a gay club and asked me to join. I was hesitant, but they seemed so nice and assured me that straight people go all the time. All right, fine. So, these two straight woman and a gay guy drove me to this club. We picked up another queer guy along the way and headed inside. They all seemed so harmless. I figured I could just take a cab home if I needed.

We had a blast. I had heard going to a gay show or gay club was fun. It's a scene. It's not about being gay at all. It's culture. It's a show. The two girls were straight. There were definitely half-dressed waiters and guys prancing around but there were also a lot of women! Gay clubs have a ton of women and women who like men. It's a hoot. Yes, the guys can smell blood in the water. You did have to say "I have a girlfriend" a dozen times, but it was a ton of fun. We all had a lot of laughs. There was a drag show, which was super entertaining. They had guys with breast im-

plants going around handing out shots. I like shots. It was a party. The way this group danced was unique. We all had so much fun and the southern hospitality was incredible. Then, the ladies even drove me home.

I love the easy-going southern way of life. It's such a pleasant little city. I would have loved to have stayed another night, but one and done. I was off to Kentucky.

CHAPTER THIRTY-THREE: GETTIN' DIRTY IN KENTUCKY

Thank you, West Virginia, you sexy son of a bitch.

I was up early and out the door. It was about two hundred and fifty miles west on Route 64. There were a lot of horses and stables. This was the country but there was an equestrian feel to it. There were lots of big plots of land with wooden fences around. I stopped at a few bourbon distilleries for a tour and a taste. I was quick to realize bourbon does not have to be from Kentucky. It started in the Bluegrass State and the majority of it is made there. However, all fifty states actually make bourbon. To qualify to be bourbon, it has to meet the following standards:

#1—Be made in the USA.

#2—Must contain at least 51% corn.

#3—It can't enter the aging barrel at more than 125 proof and can't go into the bottle at less than 80 proof.

#4—The barrels have to be new and charred.

#5—No colors or other stuff can be added to it—only water can be added.

Whiskey isn't this strict.

All bourbon is whiskey but not all whiskey is bourbon.

Hmmmm, so smooth, a little sweet. A little bit of oak and some hints of caramel. Slainte!

I headed to Louisville after learning about the sauce.

I found a hotel in downtown Louisville. Louisville is the largest city in the state and sits right on the Ohio River. There is a fun area called 4th Street Live. It's a bright spot for dining, shopping, and entertainment in the heart of downtown. It's got a buzzing bar scene and a place they call Whiskey Row. I toured the Evan Williams Experience, where I learned and tasted more of Kentucky's most popular export.

The Louisville Slugger Museum will not disappoint. Outside is an oversized replica of The Great Bambino's bat. It's 68,000 pounds and 120 feet high. The factory inside is lovely. It's a quick tour and they let you swing some bats too.

FUN FACT: The average baseball player goes through one hundred and twenty bats in a season. The factory bangs out almost two million bats a year. They can make up to 5,000 bats a day when the season is in full swing. You won't believe how many trees this place cuts down, just for one team's season.

My next stop is the Kentucky Derby. Well, not during the Kentucky Derby. I think it was a few weeks before.

Seeing Churchill Downs was magnificent. You could smell the history in the air. During a tour, I snuck under the fence and grabbed a huge handful of dirt. It was a lighter color than I had thought and felt a bit more like clay. It was very soft.

"Hey what are you doing, kid?"

"Ah, nothing."

"I am just kidding." This old vet said with a smirk. "Go ahead grab some more. I'll block for you."

"Thanks."

I made it all the way home with two handfuls of dirt from the famous horse racing track.

A week later, I forgot to remove the dirt from my pocket and sent it the to the laundry. I realized what I had done a few hours later.

I raced back to the Wash 'n' Fold and explained the situation.

The Asian women laughed and said they emptied it into the trash.

I told them it was special dirt from Kentucky.

They let me go behind the counter and try and recover the dirt. Thankfully, there was no trash in the barrel. I was able to retrieve a portion of the dirt.

I had displayed it for years on my living room mantle in a plastic bag with black sharpie marker that read: "Dirt from Kentucky Derby and Laundromat."

It was in my living room for almost five years; then, one of the maids threw it out.

Dang it!!

CHAPTER THIRTY-FOUR: THE VOLUNTEER STATE

When my younger brother told me he was getting married, my first thoughts were: "Wow, he isn't gay."

Then: "Damn, I guess I owe my uncles fifty bucks."

He was the last person in the family I'd ever think would contribute to my traveling. We were close growing up. We played video games together, watched *A Night at The Roxbury* on repeat and had countless games of whiffle-ball in the backyard, until the sun went down. My broski was a kind and likeable kid. He was a bit listless, though, when it came to making plans; especially if those plans didn't involve the girl he was dating. I was honored to be his best man, but when the subject of "bachelor party" came up...I assumed he would want to stay close to home. I thought he may not even want one. Well, thank the bright stars above for his childhood buddy Brian Seiquist.

Brian, a.k.a B-seeks, fell in love with the city of Nashville a while ago. He'd been multiple times and couldn't stop talking about going back again. He persisted to get out of the state. "Don't do Boston." And, "We have all been to New York. Let's go to Nashville."

I told Brian that I was in with the plan. Yet, I kept saying there is no way the scrawny will commit to this. He'll back out. I don't know if he is capable of booking a flight by himself.

I couldn't believe it...he was in. He even showed me

receipts. A new state, a new city and an excuse to see it properly with some family and friends. No way.

There he was! Danny Thunder knocked on the hotel door, late one Friday night. B-Seeks, Scottie 2 Hottie, Jimmy Jams and I all hit the streets hard. We didn't just paint "Athens of the South" red, we painted it a whole bunch of primary colors. Bands and cans of beer at eight in the morning. They even have these things called Pedal Taverns, which is basically a mobile bar on top of this fifteen-passenger bike. You sit there drinking while you pedal down the—oh, wait. This is the bachelor party...this is TOP SECRET. I can say no more.

Good food and nice people—gotta go!

MEMPHIS

I liked the vibe of Tennessee so much that a few years later I would return to go see the city of Memphis. It was a bit smaller and a slightly different energy from Nashville, but man did they have some good BBQ. In fact, I'll go on record and say it was the best ribs I've ever had.

When you're in Memphis, the main thing you do is go to Beale Street. It's basically just a few colorful blocks of back-to-back blues bars, pubs and BBQ joints.

I have a little thing I do. Sometimes when I need a suggestion for a restaurant, bar or attraction, I ask a bunch of people. Then I wait until I hear something twice. Once a name is mentioned a second time, I go there. Screw Yelp. I don't need Google. I keep asking different people until I hear a place twice. It's fun talking to people.

I started with the hotel check-in girl: "So, where do you think the best ribs are in Memphis?"

I asked a few other locals, then as I was getting my postcards and a refrigerator magnet for mom...the girl at the register said she liked 'Blues City Cafe.' That was the second time I'd heard that name.

"Really?" I asked.

"Oh, yes," said the cashier. "They are fall off the bone, finger licking good."

I had my lunch spot all picked out. I strolled down the luminous Beale Street and popped into the Blues City Cafe. It's an old-school joint that serves up all sorts of soul food. It was like you stepped back in time to the fifties. The ribs lived up to the hype. They were the tastiest, moistest and softest I had ever encountered by far.

I was almost good with the state but had one more day. No trip to Tennessee would be complete without seeing Elvis' house. I wasn't even into his music, but man was Graceland worth seeing. The guy was renowned as the most significant pop culture icon of the twentieth century. The size of his dwelling certainly reflected it. I'm glad I was there on a weekday, because this place looked like it got packed. I thought it would be just a couple of grey-haired Carla Tortelli types from *Cheers* walking around. Nope, this place is the second most-visited house in the entire United States of America. Guess what number one is? The facking White House. Over 600,000 people visit Graceland every year. It's certainly an interesting piece of real estate. One of his trophy rooms is the size of most of the houses back home, and the other rooms weren't much smaller. He has a whole showroom filled with exotic cars and personal limos. He has multiple planes—not just one...multiple!! Screw Diddy. This guy was the man.

The other nice thing about Memphis is that it's very close to the Arkansas state line.

CHAPTER THIRTY-FIVE: ARKANSAS AND ALL FORTY-EIGHT

I was burning gas from Memphis, Tennessee across the Mississippi River, seconds away from the Arkansas state line and my forty-seventh state. I could see the state sign in the distance, slowly coming into focus. My heart was racing. The hairs on my arms stood tall. I was living. This was it. This was one of those travel moments. Stiffen the sinews!

This was the state I'd always wondered about. On my placemat, I always envisioned it barren and filled with flat, brown rocks. I loved that I knew no one who went there. The less a state is visited, the more I want to see it. This was uncharted territory. Nobody's opinion was affecting my decisions or swaying my take on it. There were zero suggestions from friends and family. This was pure. I didn't know anyone who even knew someone who had been to Arkansas. You don't sit around the dinner table and hear people tell stories about The Bear State.

I could now see clearly the sign on top of the bridge read: "Welcome to Arkansas, The Natural State. Buckle Up for Safety."

I drove underneath the glorious white sign and started yelling: "YES YES YES!"

I am in Arkansas. Forty-seven states and counting. That is legit, this is real. I am doing it, baby.

Dramatic pause...

"What the heck do I do now?"

I didn't care. I cruised over the rest of the Hernando De Soto Bridge on I-40 West. I rolled down the window and embraced my inner canine for a bit. The scene was invigorating. I headed for the capital of Arkansas, Little Rock.

I still didn't have Waze, so I searched my faithful Garmin for hotels downtown. I settled upon the Residence Inn. That would be home base for the next four days.

I hastily discarded my bags in the room and ran across the street to a seemingly elegant bistro. I was in the mood for a cocktail and a snack. I look to my left and there is a blonde beauty a few stools down. Of course. Without thinking, I ask her what she is drinking.

"A Moscow mule," she said, with an affable smile you can only find in the south.

"Any good? I have never heard of that."

"It's delicious."

"What's in it?"

She went on to describe the ingredients. She also pointed out that, for it to be official, it has to be served in a copper mug.

Interesting.

I'll have a glass of red...for now.

As I devoured my comfort food, I noticed she just ordered another.

Oh boy.

We were chumming it up. She asked what I was doing in Little Rock and I told her about my crusade. I asked her if she had any suggestions of what to do and what to see. She cheerfully gave me all sorts of recommendations, including some cool bars for that night. Then she says:

"Hey, do you want a ride to one of those bars? I have a car and can drop you off on my way home."

Absolutely. That'd be great.

The bartenders rolled their eyes.

I know how this looks. Trust me that nothing happened. It looked like I just picked up the blonde from the bar, but I swear, this is the south. She was just being polite. We did party, though. She decided she wouldn't just drop me off at the bar, but she'd come in for one more. This turned into about six more and a fantastic pub-crawl...one and done style. We went to rooftop bars and looked at the river. I ordered my first Moscow Mule.

"Wait, do you guys have copper mugs?"

"Yes, we do."

"They have copper mugs!! Wheeww heeeww!!"

I inhaled it.

We tasted clever cocktails all over the city, even stopping in a dueling piano bar with live pianists going at it. The performance was so cool. They were battling back and forth like a tennis match. At one point, one started playing the theme song from Super Mario Brothers. I love Nintendo. I love you, Little Rock.

This girl was so fun. She even drove me home. Don't worry—a friendly hug was all. She had a boyfriend too. What a night and I had a hundred things to do the next day.

See, kids, get off your phone and you receive a gallant tour of the city from a sweet girl. I also got a bunch of recommendations for the next day.

The first thing I did after nursing a mild hangover was hop onto the METRO Street car. It's a form of public transportation that connects Little Rock to North Little

Rock. It's like a trolley in San Francisco. It goes all around the city and then over the Arkansas River. The driver of the streetcar acts as a tour guide. He pointed out all sorts of significant buildings. A couple of restaurants looked vaguely familiar from the night before. As we went over the bridge, he pointed out a submarine that was stationed there. Some folks would use this streetcar to get somewhere, but I see it as a phenomenal way to tour the city. Oh, and it's only a buck!

The next day, I floored it to the city of Hot Springs. Hot Springs is known for its spas and natural springs. It may be the most charming city to which I have ever been. Screw Miami—Miami sucks. All the construction and auto-gratuity. No thanks. I'd take Hot Springs, Arkansas over Miami any day.

The city of Hot Springs is tucked away into the mountains about an hour southwest from Little Rock. The first thing to do is walk around Bath House Row. I always travel with a bathing suit, so as I was strolling up the beautiful streets looking at all the spas, I was able to hop in one for a nice long, relaxing soak.

According to the towel lady, Hot Springs became popular because of baseball. It was the birthplace of spring training. During spring training, the players loved to go out and drink. They felt the springs and thermal spas had healing qualities and helped cleanse them from the booze. Whether it's scientifically proven or not, some of the greats fell in love with the hot baths after a night of drinking and made the place home.

I smiled as I was sitting in the huge European-style public bath. I thought: some of the greats have sat in this exact bath. The architecture was captivating.

I walked around the town a little more after I dried off. I was talking to a storeowner as I shopped for knick-knacks. He told me more about the spring training origins. "Babe Ruth himself used to frequent the bath houses."

I told him I was a big fan of the Bambino.

He said, "Oh, well...Babe Ruth hit the first ever 500-foot home run right up the street."

"Really?"

"Yeah. The field isn't there, but the plate is still there. You can go see it if you want."

"Later!"

I was off on one of my most random adventures ever.

So, in the spring of 1918, Babe Ruth was playing for the Red Sox against the Brooklyn Dodgers. This was spring training and an expedition game. In the fifth inning, he smacked a home run with such astonishment and superhuman force that it sailed over the fence. It went across the street, over another fence and landed in an alligator farm.

The guy told me that the alligator farm is still there. They have a small sign that marks where the ball landed. I had to see this.

You couldn't look this up. You couldn't find this on TripAdvisor or even ask any people. The guy told me to take a couple turns and a right, then go for a couple miles.

I saw the alligator farm, a small sort of rundown place. Across the street was a parking lot to what looked like some insurance company.

I could feel it! This used to be Whittington Park and the baseball field. Now it is black asphalt and white lined parking spots. Ha! I drove around the parking lot and eventually parked. I was walking around the lot like a

weirdo looking for lost change. Some people ignored me as they got into their cars. There it is! Way over in the far corner is a white home plate. Oh, man. Why am I so excited about this? I ran over like a kid in a candy store and pretended to swing a bat. There was a small conspicuous sign by a tree that gave information about the baseball field and Babe Ruth's feat. What I loved was how discreet this plate was. There was no marquee or blinking sign. No group of tourists was lined up to take pictures or buy merchandise. This historic landmark was nonchalantly sitting quietly in the corner of a mundane, corporate parking lot. You could park your car over it and no one would notice. I was all by myself. Nobody came or even looked.

I could see the farm way across the street. I couldn't believe how far it was. I got in my convertible and went to see where it landed.

I walked timidly into the alligator farm, where I was greeted by a toothless, sunburned man with a thick accent.

"You want to hold an alligator?"

"Umm, actually I was curious about the Babe Ruth home run."

"Oh, yeah. He hit it from across the street. There is a little sign back there where it landed."

"Cool. Can I go look?"

"Sure."

He didn't even charge me. I walked around past the slow moving pre-historic creatures, until I stopped in front of a small pond. There was a faded yellow and red sign denoting where the ball had landed.

I looked back across the street to where the plate was. This was unnaturally far. The sign said it was over 570

feet.

That is just crazy-town. Nobody hits the ball even close to that today.

With steroids, intense weight training, scientific diets, and technological advancements in bats and equipment, nobody hits the ball even 500 feet—let alone 574 feet. I couldn't stop thinking about this prodigious accomplishment. This not only was the first officially measured and validated 500+ home run, it stands today as one of the top three longest home runs ever hit. And I am standing by myself looking at a worn-down sign in an alligator farm's pond. Wow.

I went back in and tried to talk to the gator guy about the blast. He didn't really care about baseball.

"Do you want to hold an alligator?"

"Ok."

I held a small gator in my hands for a bit and thanked the guy for letting me see the spot. I bought a t-shirt.

If you look up longest homers, Ted Williams and only a couple other people have hit a 500-foot dinger, and they were like 502 or 504 feet. There are only a handful of other recorded balls that landed that far. The other couple are "assumptions" or guesses and are not official. This was an extraordinary piece of history, and such a rare exploit ... and nobody was there.

I got a quick bite in town before heading back to my hotel in Little Rock. I drove back with the top down, smiling ear to ear, while still thinking about how rare that moon shot was. I bet the other team had to give him a round of applause.

I grabbed a bite at a wine bar up the street from my hotel before calling it a night. Hot Springs was legendary,

and I loved all of Little Rock.

I checked out of the hotel and headed for Alabama. I didn't have much time, so this was purely a check-off state. I used up my points for a free hotel in downtown Birmingham. I mailed a postcard and pushed my way into a crowded restaurant where I tried some collard greens and grits. I was out of there the next day. My trip here was so last-minute that I didn't even have a return flight back.

The next morning, I assumed I'd be able to book a one-way flight back from Tennessee. Well, the airlines told me I could, so, I did. They told me it was overbooked upon my arrival to the airport. They offered me a free hotel and direct flight out the next day. How is this legal? It's corporate greed at its finest. Imagine if I owned a movie theater. I sell you a ticket ahead of time to a show on Friday. When you show up, I inform you the movie is sold out and offer you no refund. You can come another day, though. Imagine the lunacy of that. But somehow it's okay for airlines to do it. Bastids.

CHAPTER THIRTY-SIX:
I BOUGHT A BOAT!

Well, we bought a boat on impulse at the New York City Boat Show. I swear the salesman is still laughing about how quickly we bought this thing. I honestly went into this showroom with the same intention that I would have gone into a Ferrari dealership. I was purely going to dream. Just browse, walk around a little bit and gawk at the new designs. I knew nothing about boats.

The money was pouring in faster than I knew what to do with. *Runner Runner* was doing great on DVD. I landed steady work on a primetime, network TV show, *The Following*, with Kevin Bacon. I had officially paid off my student loans (FU Sally Mae) and was looking to do something financially foolish. I am pretty sure Dean Martin's "Money Burns a Hole in My Pocket" was coming softly out of the showroom speakers.

I was planning on spending the day at the boat show. Payback to Danielle for the lengthy and uncountable amount of family parties she dragged me to in Long Island. She even agreed: "Ok, you have gone to a lot lately. No rush."

We weren't in the door five minutes and we're already climbing on a floor model, calling each other captain. I swear the salesmen hit a switch under the desk that released some smoke. It put us in a trance. I kept fantasizing about the open water. Suddenly, we were sitting in swirling bucket seats while discussing finance

options. I needed to get out of there!

I grabbed Danielle and ran outside.

She goes: "What's going on? What are you doing?"

I said: "Oh my God; we are about to buy a boat."

She laughed.

"Holy Christmas. We are going to buy a fucking boat!"

I need a drink.

We ran to the Molly Wee Pub on 8th Avenue. I was about to order a Guinness and thought: "Wait. I'm about to buy a boat and I'm sober." I'll take a Coke, so that I don't get any more stupid ideas.

We thought about it for a couple minutes, then we went back and bought the damn thing. Done and done. I don't know if we got a good deal, but we got a boat. I had done zero research and I knew next to nothing about owning one. I had never driven one, and I certainly didn't know how to dock one. I don't know the first thing about maintenance or upkeep. We hadn't even walked around the showroom. This was the first damn display! It was ten feet from the fricking front door.

Well, we signed the papers and went to the Morrell Wine Bar in Rockefeller Plaza to celebrate properly. "Yo Ho Ho!"

Shiver me timbers. We were proud owners of a brand spanking new, bright blue, 18-foot Glastron bowrider. It felt good owning a boat.

The salesman told me that Glastrons had been around for a while and were even used in the famous chase scene from the James Bond movie: *Live and Let Die.* That's probably what sealed deal. Boy, did they see us coming.

I wanted to name it 'Wasted Seamen' or 'A Salt Weapon.' I had a list of fifty other cool names like 'Fishing

Impossible,' 'Knot Too Shabby' and 'Channel Surfer.' We settled on 'Happy Ours.' Get it? I had an artist design a sweet logo for the back of the boat. The picture behind the name was equipped with cocktail glasses and a cheesy sunset.

I called my parents. I can't remember two times in my life when they were madder at me. They literally screamed. My dad went on a rant about how this was the most irresponsible thing I could do, then he hung up. Haha. They wouldn't talk to me for weeks. They were more disappointed by this purchase, then all the times I got brought home by the town police.

Blimey! All was well on the water. Every day on this boat was a jubilee. The stories didn't end. Wakeboarding, trips to The Nautical Mile, discovering the pee-ladder, Hasselhoff impressions—it was all gravy. My parents eventually came for a ride, even managing to squeeze out a few smiles. My mom wore her life jacket the whole time. Classic!

The hedonistic explorer in me simply adored touring the endless canals and inlets of Reynolds Channel. There was always a new route to take or waterfront property to look at. I was pleasantly surprised to learn about 'Dine and Docks.' They're basically bars or restaurants on the water that have docks for boats to park at. Instead of taking your car out to eat and parking in front...you take the boat and arrive by water. Mostly the dock is right by a balcony or a main door. Everyone watches as you try to dock smoothly. I always have the *Pirates of Caribbean* soundtrack cued up for the grand entrance. Oops, wait, hold on; ok, let me back up. Vroom. Let me try again. We are drifting a little right. Vrroom. Fack. SMH.

Owning a boat is a bit of an expense, but I'm telling you, it's brilliant. It feels like a vacation every time you go out. Take a slow cruise in a no-wake zone while you sip a little Prosecco. Drop anchor somewhere deep and go for a dip. Pack the cooler and have lunch in your own private restaurant. Go explore some private beaches or secluded bays. Buying a boat is like buying your own holiday that you can celebrate whenever you want.

My huge appetite for seeing new stuff was satisfied daily. I had multiple maps. I loved going out and getting lost. One interesting neighborhood I found while exploring was the neighborhood called Hewlett Bay Park. It's a village in a tiny enclave on Long Island's south shore. The place was a hidden gem. *Wealth Magazine* listed it the second wealthiest neighborhood in America. More so than Beverly Hills, Palm Beach, Malibu, even Greenwich, CT. The opulence of wealth was overwhelming. These weren't mansions, but rather McMansions...all in a row. One was bigger than the next. They were all on the water with a boat slip and a fancy lift. It was a treat to cruise by the winding canals of this town. The architecture and splendors of these homes were jaw dropping. The size of the lawns was notable. And they were all right on the water!

It was such a fun pleasure cruise. We'd make appetizers and cheese plates for our friends, pointing out the Snapple Lady's glass house. Some of the properties were over 20 million dollars and looked like museums. You couldn't get to it by car, but by boat we could sail right by their backyards.

The interesting thing was that nobody had ever heard of this town. Apparently, the mayor wants to keep it that

way. No high-profile athletes or Beibers are drawing attention to it. This place was a jewel. However, the yards were always empty for all their grandeur. Out of dozens of trips with friends and family, we never saw a single kid playing in their backyard or any parents enjoying their amenities. No parties or gatherings. No happy hour wine on the deck. Thousand-dollar swing sets and million-dollar backyards, but no kids using it. I never once saw a whiffle-ball game or a father and son playing pass. It was odd. It was like a ghost town. We saw lawn crews and maids cleaning, but no families. No people. One day, we finally saw a homeowner. It was an Asian guy. He was screaming on his cell phone and had his back to the water. Kinda makes you think what's the point in making all that money if you don't have time to enjoy it?

We were loving boat life. Every day we took this thing out was a great day. Anyone who says the two best days of being a boat owner are "the day you buy it" and "the day you sell it" haven't been on Happy Ours.

Ahoy, Matey!

CHAPTER THIRTY-SEVEN: THE DIRTY JERZ

Surfing is a precious thing. One of the most frustrating things is all the work it takes just to get in the water. Then, you still have to swim out past the break. There is no chairlift. You have to lug or load your surfboard into some type of vehicle, find parking, spend twenty minutes getting on your wetsuit and gloves. Carry your board another twenty minutes to the beach. Wax the board and put on your leash. You're not even in the water yet. Then, once you get in the water, you have to fight past the waves coming in order to get out past the break. Then, sit in the line-up waiting for a wave. That's after an arduous swim. Sometimes it's crowded and sometimes there is just no break. All that and you can be sitting on your board and it's flat. That's what makes surfing so special. It's no guarantee. When you buy a lift ticket to go skiing, then you're skiing. It's a sure thing that, when you get to the top, you're going to ski down. Surfing is rare. To live steps from the water and to be able to run out on a Tuesday afternoon for a half hour and grab a couple rides is the best. No need to check the surf reports—I can look out the window to see the conditions. If the waves are only so-so, well then, I didn't beat myself up to get out there. Catch a couple rides and come in to make some grub.

It's spiritual knowing this wave has traveled so far. You can actually swim into it and glide to shore. I can see how people get addicted. I am not obsessed with surfing,

but I can see how people become junkies for this sport. I had so many waves and so many great rides. I'd catch a nice early morning session and run upstairs. I'd feel like the man. I had a few scares when the rip tides changed. I tried to ride a few storm waves too big for my skill level and I got punished. I felt so small. I learned a lot about Mother Nature and respect from surfing. I loved it. That wave does not care if you had a billboard in Times Square, or that you get first-class flights for movies. It doesn't matter who you are. It will wreck you if you're not careful.

New York is this somewhat aggressive and tough state. It's funny that most the surfers in Long Beach are the least territorial surfers I have met. It may be that the waves aren't worth fighting for, but it's a very nice vibe in the water. They may not be the longest, or the biggest waves, but bro...trust me, Long Beach has surf.

My Long Beach days were coming to end. Danielle got a new job in New Jersey working for Major League Baseball. It was a sweet job with lots of free tickets...but she had a two-hour commute each way. The commute wasn't just killing her, it was also killing us. I had my motorcycle shipped up to us, just to use it as a placeholder for her parking. She'd come home late, and I'd move the motorcycle to a curb spot, so that she could park. We still had six months left on the lease and she stuck it out.

We didn't talk about it much, but I could tell another move was about to happen. I tried to hold on as long as I could to my beautiful spot. I'd wake up early, grab a cup of tea and walk on the beach. I'd walk real slowly, while trying to make it last. I'd make a fresh-squeezed cocktail and take a chair out to the sand. I would enjoy every sunset I could. I said goodbye to my beach volleyball team and my

favorite restaurants. Artie's Fish Market, thanks for the oysters and teaching me how to cook cod at home. Gran Paradiso, in Island Park, NY, you guys still have the best lunch in the country. Your cannelloni sing to me! It wasn't easy to put my closet full of wetsuits into storage. It was sad having to bring my surfboards to my parents' house.

Long Beach isn't the place I wanted to stay forever, but I will miss it dearly. There are some things I won't miss, though. It's crowded and has a funny atmosphere to it outside the water. It tries to be this laid-back surf town, but it's a huge city with a New York attitude and pace. Everyone moves here to relax on the beach, but a lot of people work in Manhattan. So, they are in a miserable rush. They are beeping, speeding and yelling. It's not perfect. There is an old school feel of corruption within the city too. I would have liked to spend another year, but I had four good ones. I was always tempted to try and live in a new state. I had been to Jersey before, but it would be an interesting change of pace to live west of Manhattan for a bit.

Most places I barely even looked back. I just moved. This one was tough. I broke the news to my surfing buddies and said good bye to the old ladies I'd see on our morning dog walks. We gave our notice.

I'd been to Atlantic City way too many times and regretted most of the trips. Atlantic City can be fun, but it's rundown and super shady. There are so many pill-addicted prostitutes and drug dealers it Atlantic City. It's just not what it used to be. I'd dated a few girls from Hoboken and had friends that lived in other areas. Hoboken never did it for me. It's all boring white people. There is no diversity.

You have big views of NYC skyline but you're not beating the system. It's crowded as fuck and just as expensive. I'd been to Jersey. It's one of those states that, even if you're born there, you're not always proud of it. If you move there, you're often hesitant to admit it's where you live. If someone asks, "So, where do you live?" many people say New York. Where? Oh...just outside the city. Oh, yeah, whereabouts? Fine, I live in Jersey. There I said it. I live in Jersey.

I guess it still has this outside perception of being the armpit of America. The Garden State has more diners than any other state. It also has the most shopping malls. There are seven enormous outlet malls all within twenty square miles, but there is some odd blue law that prohibits them from being open on Sundays. Jersey is crowded too. It's the number one most densely populated state in the nation. It's odd, too, because it's mostly suburbs. So, you'd think there would be space and an escape from city life, but the neighborhoods are so crowded. Every strip mall and outlet lot is jam-packed with cars every day.

We didn't have a lot of time to look for apartments, so we took the first place available in northern Jersey. Once you get past the factories, landfills and Jersey jokes, it's actually a beautiful state. It has tons of hiking, mountains and lots of shoreline. It has pretty women, great golfing and beaches. The Appalachian Trail even runs through the state. I like it.

Well, our first apartment didn't work out. It was newer than our beach pad, but it was also more expensive. It was fun to wake up and see deer in the front lawn. It was maddening to pay more to live in northern Jersey than it was to live on the beach. Our dog, Romeo, didn't love the

place either. We moved again to East Rutherford and then we moved again within apartments. (I promise I can sit still, I just choose not to.) This was my twenty-ninth move since leaving for college. It sounds clinical. I was done moving.

Well, we had to move the boat too. It was a two-hour drive to the marina. We paid too much for this piece of leisure to not use it. I couldn't sell "Happy Ours." We had to move the boat. We didn't have a trailer and I had a two-seater sports car.

We found a guy on Craigslist who moved yachts for a living. He was waiting out a tide change before his next job, so he reluctantly helped us out. His rig was twenty-five times the size of our dingy. He practically picked up the boat and threw it into our new body of water. The closest lake to us was Greenwood Lake. It's sort of an anomaly. Half the lake is in Jersey and half the lake is in New York. So, believe it or not, it's considered international waters and the Coast Guard patrols it. The lake itself is very visual. It has lots of green trees and pretty houses along the water. Derek Jeter, the captain of the New York Yankees, retired there and built a castle on the lake. I make sure to blow the horn every time I go by and yell, "Here we go, Red Sox!!"

My relationship to NYC was now all business. In and out by train or the Lincoln Tunnel. We both currently enjoyed exploring areas around the lake including the town of Warwick.

I still wanted to travel. I was getting close to all fifty but I was done moving! It was so easy in my twenties—I had no furniture. Now I had to get boxes and a moving truck. I was staying put for a bit.

I did enjoy exploring Jersey and I was just over the New York state line. Harriman State Park, Bear Mountain and Seven Lakes Drive have all the hiking, kayaking, camping and outdoor activities you could ever need. On a clear day, I'd take my two-seater or motorcycle to the top of Bear Mountain. I could see the Manhattan skyline in the distance. We would go to the vineyards in Warwick, NY on the weekends, or hang out on our vessel. Our modern apartment across from the MetLife Stadium started to feel like home. It was so close to the football stadium that a handful of NFL football players actually lived in our building. It was interesting to see them when I was out taking my dog for a walk. I'm around actors all the time, so it doesn't faze me. But seeing a professional athlete is something else. Their body...their wrists, arms and legs. They are just physical specimens. They are the biggest human beings I have ever seen in my life and they all have the tiniest little dogs.

Speaking of dogs, I was head over heels for my seven-pound Yorkie. I had a big dog named Murphy growing up and he was cool. I always thought a little dog would be silly, but this guy won me over. Taking him out to pee all the time made me think about myself. He wouldn't just go out and drain it. He would hit every bush, every sign and every object with a little squirt. I saw some interesting parallels in his behavior to my own. Perhaps we are all like animals or dogs in a way. My dog has this need to mark his territory. He has to sniff and smell everything. He has to run and leave his mark on every landmark wherever we go. It's kind of like this thing inside me where I have to see everything. Rather than spend a week in one place, I run around and poke my head in every place. I have to see it

all. I have to go in and see or touch everything. I have a meal or a drink in every place, much like Romeo has to pee and smell every single thing in sight. I am a dog leaving my mark.

I grew to like Jersey. You can go north, west, and south so easy because you're already out of the thick of it. I really enjoyed driving down to the Jersey Shore, but enough about Jersey. I could see the finish line. It was getting close. I only had two more to go. I had to go pee in a few more states.

CHAPTER THIRTY-EIGHT: VANCOUVER

So, before I stepped into The Land of the Midnight Sun, Danielle and I decided to do one day in Vancouver. I had a fourteen-day Alaskan vacation all mapped out, which would commence with a seven-day cruise. It left from Vancouver and then made its way north through the inside passage. It would stop at a bunch of cities, Glacier Bay National Park and eventually end in Anchorage, AK. The beauty of a one-way cruise was not just being able to go slower and see more off the ship and on. When you're done with the cruising, you're on your own. You can go wherever and see whatever without Princess Cruises telling you your schedule. You can see so much more of the state, and then get yourself home when you want.

So, we had a one-way flight booked to Vancouver, British Columbia from where the ship would eventually leave. Most flights get in late due to the time zone changes, usually eleven at night or afterwards. So, we decided to go in two nights before. Thus, we could relax, see a new a city and also prepare against any potential delays or cancelations with the airlines.

Touchdown Vancouver International Airport! It was about 10:30 p.m. Thank you Canada Air for a nice flight. Baggage claim, speedy cab ride to the hotel. Ditch the bags. Time for one quick cocktail at the closest bar: The Butcher and Bullock. We were fading fast. One and done, kid. Good night.

We rocketed out of bed at the wee hour of four-thirty, which felt like noon with the new time zone.

I convinced, well...begged, then eventually convinced, the lady setting up to serve us breakfast an hour before the place even opened and we were off. We showered, got dressed and were out the door easily before seven. Walking around a new city always gave me a tickle in my pants, even if it wasn't the best city. It didn't take long to see the beauty of Vancouver. The glass buildings seemed cleaner, shinier and newer than other cities. There were lots of skyscrapers and equally impressive, high-end, high-rise condos that sparkled. They appeared fresh and free of dirt. There was a polish to the city, like it was a model in a display case. I was in awe and we hadn't even made it to the seaport. We were amazed and it wasn't even nine in the morning.

None of the tours or businesses had even opened yet, so we walked around Canada Place, the iconic convention center and cruise ship terminal. It's right on the water. It has some shops and info for things you can do and see. It was also where we would need to be tomorrow to catch the cruise. The view was picture perfect. You're on the water and mountains surround the city behind that. A beautiful skyline, water views and peaks everywhere. I am not sure you could find many cities that could beat it. It's just so visual. We had no plan and we also had all day.

We grabbed the first shuttle bus to the Capilano Suspension Bridge, hoping to get there just as it opens and beat the crowds. The twenty-minute complimentary ride takes you north out of the city, through Stanley Park, over the Lions Gate Bridge and into North Vancouver. The bus driver gave us a wealth of knowledge about the city and

surrounding architecture. As we went over the Lions Gate Bridge, which connects downtown Vancouver to North and West Vancouver, he pointed out that it was built by the Guinness family. Yes, the Irish beer barons. They installed a toll to pay for the costs. Then, they gave the bridge to the city as a gift once they made their money back. How cool is that? As you drive over it, you can see the two mountains called "lions" from which the bridge's name is derived. The successful film studio, Lionsgate Films, which produces and distributes all types of movies, and the media company Lionsgate, both were later named after the bridge.

We were off the bus and the first into the park to enjoy all the excitement the Capilano Suspension Bridge has to offer. That is, before the hordes of Asians in fanny packs irritated the place.

The bridge itself is simplistic, yet scary, to look at. It just hangs two hundred and thirty feet above the Capilano River. It starts to shake well before the halfway mark, making it hard to enjoy the beauty of the rainforest backdrop and rushing river below. There is a sense of fear going through your body. I would have loved to say that it was no big deal, but it is uncomfortable. Only a few inches of cable and wood is all on which you're standing. I mean, thousands of people do it a day and 800,000 visit a year. It must be safe, but yet there is almost nothing to it. It looks so primitive. Ok, run across and back a couple times to get used to it—much better.

Now I stop for a minute and take in the wilderness. It's a pretty bridge to look at and it's pretty to look out from it. The bridge is the main attraction of this park but there are other things to do. Once you cross the four hundred

and sixty feet of uncertainty to the other side, there are some ponds and stuff at which to look, but the treetop adventure is the next best thing. It's a series of bridges and platforms going through the trees to give you a squirrel's-eye view of the forest. It's an award winning, one-of-a-kind feat of engineering, utilizing a unique tree collar system that allows the seven suspension bridges to connect to eight Douglas firs without the use of nails or penetrating bolts. As the informative signs tell you: "It's not just built for fun. It promotes and accommodates the growth of the trees." I'm not a tree hugger. Still, it is pretty badass that they can erect this attraction without hurting the trees one bit. We took some cool pictures, but I made sure we went around and did the walk a second time sans camera. This way, we could relax and enjoy the adventure. You are up over a hundred feet high at some points, bouncing from tree to tree while enjoying the unique view of the forest floor. You almost take for granted how well this thing is constructed. You're too busy enjoying the sounds of nature while being encircled by evergreens.

There are other things at which you can look and read, before heading back over the bridge. These include totem poles, informative signs about birds, erosion exhibits and other what-nots, but there is one more activity to really experience. This is the cliff-walk.

It is a thin steel walk that is way up high and follows a rock face. A handful of cantilevered bridges and stairs take you on a pulse-pounding journey. One of them goes way out and has a glass bottom on which you can stand. I don't care how thick they say it is—it feels crazy to be standing on it. It would have been scarier had we done this first. However, this was pure fun after the suspension bridge

and the treetop walk. We would stop from time to time to marvel at how minimal the amount of materials were used. Only sixteen anchor points support the structure, holding you high above the canyon. The brochure says it best: "environmentally sensitive and adrenaline pumping."

They have a gift shop and some more displays about erosion, but we have been here too long. It's time to leave the cedar-scented park and head back to the city. We jumped on a shuttle back, just as the masses were spilling inward. We saw the whole place and didn't get any annoying tourists in our pictures. I love waking up early!!

Back on the bus, we got to enjoy a new perspective of the skyline going over the Lions Gate Bridge again. We were back at Canada Place ready for our next activity. It was only ten thirty in the morning. We took a moment to gaze at the mountains. I noticed several planes with big water floats underneath them taking off and landing in the harbor. There was a bunch of them. Danielle knew what I was going to ask.

"Fine, Jim; we can go on one of them."

"Oh, yes!!" I roared.

I've wanted to do this ever since I was a little kid and I watched Indiana Jones. I always wanted to experience the rush of a water takeoff and landing from a seaplane. We watched them splash down and glide across the ocean surface for a few minutes, then ran down the walkway to the office. What were the chances there'd be any flights available? Surely, we'd have to come back after lunch or at five. Most of these people probably booked their flight days ago.

"Actually, we have a private tour right now if you like. It's a bit more expensive, but you can go immediately," the lovely lady at the counter said with a smile.

Wow, I couldn't believe it. There was a lull in the early afternoon. The morning rush was over and it was quiet. I swiped the plastic. We hit the restroom, then met our pilot, Matt.

We were walking down to the plane within minutes. I had always wanted to do this. I thought that I was going to have to wait until Anchorage to set something up, but Vancouver delivered. The planes looked so badass with their fuselage resting on two big pontoons. Boarding the plane gave me goose bumps. Danielle let me take shotgun so that I could check out the gear and wear the headphones. There was a quick safety speech and the engine was running. We accelerated hard, somehow gaining traction on the liquid runway. I was skeptical of how this thing was going to take off. Suddenly, and rather smoothly, I felt it lift—we were off. The plane was loud, but the lift was so light. I could see the water below and, before we knew it, we were up in the air. This was cool. It's packaged as a flight-seeing tour of the city and mountains, but I really just wanted to experience the takeoff and landing. Danielle was in the back being polite.

The postcard image of the downtown area surrounded by water and mountains was second to none. It was so peaceful and pretty. We hovered over Stanley Park and all of downtown. We went over towards North and West Vancouver. You could see marinas and houses. Matt explained some history of the significant mansions and how expensive real estate is compared to the world. Vancouver recently beat out Toronto as priciest city in

Canada. The average rent starts at about twelve hundred a month for a tiny one bedroom, while the median cost of a house is almost $900,000. That's insane. The city seems to be doing well, but it's not quite Silicon Valley. One of the bus drivers said that, even with two incomes, most families spend more than half their income solely on rent or mortgages. This leaves them with little leftover cash with which to do much else. They are in a housing affordability crisis. Rent and mortgages have skyrocketed ahead of inflation. It definitely didn't seem like a poor city. There were lots of Lamborghinis and exotic cars buzzing around the streets. We turned back around to see more of downtown.

The apartments and condos with pools were fun to spot from above, but I was really looking forward to the landing. The approach was from the east facing west. The city and cruise ships were to our left, while the mountains were to our right. Water and more water was in front of us. We kept getting lower and lower. I tightly grabbed ahold of the door, bracing for landing. Lower, lower...then the tiniest little splash.

Beat.

That was it. We were gliding along the water like a car on the highway. No big bump and no huge splash or loud shaking. Honestly, it was a little anti-climactic. It was smooth. It was like jazz and I was expecting punk rock. We floated back towards the aquatic hangar all peaceful while the sun still shone high in the sky. It was interesting to see how he steered the plane like a skiff. We discussed the difficulties of docking our own boat. Parking a boat is trickier than you think. I could only imagine how many attempts it takes to do it with a plane. We were in like a

glove upon his first try!!

I thanked him many times for taking us right away, telling him he had a pretty sweet job. We were back up to the seaport and planning our next move. It wasn't even noon.

I had heard two things about the city. It's beautiful and it has amazing sushi. Sushi was on the list but there was no time for a sit-down meal now. I hate when you're doing a million things and you're inconvenienced by hunger. Sometimes a meal just takes too long. I wanted fuel. It had to be in my belly quick, and then we had to hit the road. Energy baby. Keep it moving. Subway was the only thing close that was quick. A new city in a different country, I couldn't give in to those yellow signs.

We went to the Cactus Club. My rule of two was working again. This was the first restaurant that was recommended by separate people. I kept asking: any good restaurants? Nothing too fancy but near the water. "Cactus Club Cafe" was always mentioned. It's a chain restaurant. We were a bit skeptical but the C.C.C. was a delight. When you think of a chain restaurant in the States...you think T.G.I. Friday's, Crapple Bees or some other bullshit chain with microwaved drivel. This is not the case in Vancouver. There may have been more than one Cactus Club, but that didn't stop it from being awesome quality. It was upscale-looking with a casual feel. They used fresh, local ingredients and well over ninety percent of the menu was healthy. We ordered a health bowl and a salmon salad after chugging some water. We ordered a glass of white wine while we watched the people and took in our surroundings. The steel-aged varietal was only ten percent alcohol, so we weren't weighed down.

CHECK!! Let's move.

We wanted to do a bike ride and see if we could see a little more of the city. We hustled down to the convention center and rented bikes at Club 16. They have a one-hour option for eight dollars and a three-hour rate for sixteen. I asked if there was a grace period on the hour. She said about five minutes, and then they charge you for the three hours. "Thanks." We were off.

If—and hopefully when, I come back to this wonderful place—the thing I would do first was what we did next...bike Stanley Park. Vancouver has the longest uninterrupted waterfront bike path on earth. At seventeen-plus miles, or twenty-eight kilometers for the rest of the world, the seawall in Vancouver is an absolute must for anyone visiting. It's perfect for a cycle, jog or leisurely stroll. We opted to do the Stanley Park loop. The six-mile section is nothing short of sensational. It has views for days. You get water views, city views, mountain views, bay views, marina views, boat views, beach views, city views with water, beach views with mountains—it just didn't end. Every corner you rounded was prettier than the next. I couldn't believe I hadn't heard more people raving about this city. There were totem poles and people doing various recreational activities. There was so much to observe. The city is fit and unmistakably health conscious.

We took our time trying to take in as much as possible. Most of the pics we took were while we were riding. Action shots, kid! We stopped a few times at the beach and other scenic points of interest. I looked at the clock after I did some skids and other tricks to annoy Danielle. We were almost at an hour with a bit to go. We pedaled hard and

made sure not to take the wrong turn we were warned about. It appeared we were getting close to completing the loop, but we were already over an hour. Once we had passed some more restaurants and shirtless runners, I did a Cru Jones skid into the rack at just over an hour and eight minutes. There was a line in front of the girl waiting to inquire about renting. I pretended I was there for a while. Then, when she looked over, I waved. "Hey, I have been here a couple minutes. One hour and you said grace." She smiled: "We need your helmets."

"One hour, right?"

"Yup; you're all set."

"Sweet; later!!"

The heart was racing, and the blood was flowing. My shirt was covered in sweat and still the day was a puppy.

There was a real high-end sushi place just a couple minutes away called Miku. We had heard glowing reviews about it. We decided we'd do a big sit-down sushi meal the next day before boarding the boat, but this place was worth a quick in-and-out snack. As we walked through the sophisticated setting with sweat soaked shirts, I definitely got some looks. We made our way through the dining room to a window seat overlooking the seaport, bay and mountains.

"I'll take your finest Canadian lager and the lady will have the same."

"No, I want the Miyazaki. The original Aburi rum cocktail with mango puree and basil citrus foam."

"Right, one beer and what she said."

We drank the drinks and inhaled the delectable specialty sushi roll. I couldn't wait to get some sashimi

tomorrow. The tastes were so fresh and clean.

One and done, kid—later.

Gas town was a five-minute walk away. Although some know it as the souvenir section, there was a fun feel to it. There were a lot of hip eateries and stylish watering holes. There was a pleasurable mix of old Victorian buildings and funky art galleries as we walked up and down the old cobblestone streets. I liked the way "Vancouver" looks on a T-shirt, so I bought a couple t's and some postcards. The famous steam clock was hard to miss as we strolled through the streets. A few more minutes of admiring the vintage boutiques, fancy sandwich shops, brick buildings and tempting corner pubs. Then we headed back towards the hotel. We checked out a few menus but there were so many options. A cooking store on the way pulled Danielle in and charged her a couple hundred bucks for junk she'll never use. Do we need a nap? Nah, back to the room for some showers.

Now we were really making waves here. While she was taking a shower, I ran down to the goofy pub. What a coincidence the red-hot Red Sox were playing the Toronto Blue Jays. What are the odds? I had a couple sips of some cider while I watched the Sox bat. After a couple minutes, it felt odd to do something I could do back home. The Sox would be okay without me. I didn't even finish my beer. It was my turn to de-louse.

We were all freshened up and ready for dinner.

A restaurant by the name of "Joey" was the lucky winner. Of all the places we saw, it just seemed right. It was a few blocks from the hotel too. It was modern and the menu looked great. As we perused the appetizer and

entree sections, I chatted with the waitress and she said they had a tester menu. A few entree options were in the test phase for a permanent spot on the menu. They were offered at a reduced rate because they weren't official. Discount aside, the pasta was one of which I hadn't heard, so I decided to indulge. Danielle got a salad. We both had some glasses of red to pair. The waitress told me that this was also a chain. There were a dozen or so more throughout the world. Again with the chains that weren't like chains! A chain in the US is almost always bad, but this place looked and tasted like a Rosie O' Grady's and not a Red Lobster. It reminded you of a Del Frisco, or any one of the celebrated, long running, upscale steak and seafood joints in Manhattan. Chains in Vancouver are awesome.

We gave some notes to the waitress of how I would have cooked the pasta, but I told her it was great. With a full belly and a nice little wine buzz, we headed up the street to Grain Tasting Bar. Everything was small portions. Not just the food, but the drinks too. There were small plates and flights. I had never gotten or even seen a gin flight. They also had wine, beer, and vodka flights. You get three small drinks instead of getting one normal-size drink—so much more fun. I decided to go with the gin when the barkeeps told us they only used local distilleries, brewers and winemakers. Three small glasses of local made gins I had never heard of were put in front of me with a glass of tonic. I could taste the gin on its own and compare or...make three separate gin and tonics if I wanted to compare those. The bartender trustingly left the open bottles in front of its respective pour, so I could tell what I liked. GIN-SANITY, BABY! This bar was legit. I didn't try the food but the bar and tasting platform was

unlike anything I had ever seen. It was a refined sort of rustic atmosphere, and although it wasn't packed, it felt like a party.

I probably should have called it after that and ended the night there, but I always want more. We walked down toward the water again in search for a nightcap and dessert. It was time for bed, but after all that, the sun still hadn't fully set. The longest day of the year was just last week. We grabbed a bench at nine-thirty and watched the sun drop with all the typical colors filling the horizon and reflecting on the water. We stopped in one more pub for some cake, ice cream and a dessert martini. Delish!

Finally, back to the room a bit woozy. Might have been able to do without that last one.

The Capilano Bridge and treetop adventure, the city, the sushi, the plane tour, the bike ride, lunch, sushi snack, gas town shopping, dinner, drinks, all the info, the sunset and the nightcap—I don't know if there has been many a day fuller. Not a minute was wasted. I feel as if I saw more in that one day than some would see in a week. The people, the conversations, the pictures, the views...Vancouver is just a remarkable city. I can't believe our vacation hasn't even started yet. We still have fourteen days in Alaska!!

Despite all we did that day, the jet lag still woke us up again before five bells with no problem. A quick breakfast and we still had half a day before we needed to get to the boat. We didn't need to be there until three.

Before we checked out of the hotel, we grabbed some more of the fresh butter-like sushi and sashimi. Then, we took a quick cab to the Kisilano Beach Park. It's a local neighborhood with a scenic stretch of grass and benches

where you can sit and see the skyline shimmer over the English Bay. We took it in for a bit. It was a perfect way to say goodbye to the city.

It was time to go. The Last Frontier was calling.

CHAPTER THIRTY-NINE: ALASKA

It didn't take five minutes for us to be reminded how much we hate cruises. They corral you in like cattle. Mooooo...moooooo. Mass tourism at its finest. Obese asses and fanny packs galore. Get a long little doggy. Ugh, at least it's only one way. This ship was cleaner and much higher-end than the Norwegian shit-show we took to Bermuda a few years back. The clientele was a lot nicer too. Not many "drink special" types were going to Alaska. It's mostly retirees and some honeymooners. For most, it's a one-time dream trip. A very well behaved and classy bunch.

After cruising through the night, we had entered the inside passage. This was the first stop, Ketchikan. We were first off the boat early in the morning. I dramatically jumped off the ramp and slapped the ground hard with both hands. WHEEEW WHOO! Forty-nine states! Hello, Alaska. Already the trip was a success. Just touching that ground made me feel alive.

The best thing we could have ever done was to avoid the groups of tour solicitors barking their rates and services. They were borderline aggressive as they waved pamphlets and shouted, "See real bear. Come with us, see real bear." "Totem poles and bear, three-hour tour."

To clear our head and get away from the ship, we walked a few minutes to a parking lot. There were a couple cabs lined up. I went up to the first cab and asked: "Hey,

can you drive us to the place to see the bears?"

The cabbie looked at me like it was the first time he'd been asked that. He apprehensively said, "Sure. It's about twenty minutes away."

I told the guy: "I don't want to sit on a bus with fifty people, and we don't need to look at the totem poles. I'll pay whatever."

He seemed confident now: "Ya, I know where it is. I'll drop you off at the spot. You call me when you want to get picked up."

We were winging it, and man this was the best move we could have made.

The cab driver had previously been a tour guide, so he filled us in on the drive with a fantastic array of facts about the state and city. He pointed out how close the trees grow together. It's a protection method from the fierce winds. They grow closer to each other than any place in the world. The forest is so dense from the close-growing trees that it's difficult to even walk through parts. You couldn't run. It's essential to their survival from the extreme snow and winds, because it prevents them from breaking.

He dropped us off at a small park. He was about to tell us where he usually sees a bear and then he started yelling: "THERE IS ONE! THERE IS ONE RIGHT OVER THERE!"

About fifty yards away from the car in a field near a stream was a black bear. He was eating some grass and getting a drink. The cabbie looked at him for a bit and then quietly said: "I'm going to take off but call me whenever."

We stood at the lookout point and observed this small beast for a while. What a moment to see this guy. There was another spot much closer and a photographer was there. I slowly ran up to where she was. I was now only

about twenty-five yards from him. He was young and not huge but big enough to make me uncomfortable. I was so close that I could see the different colors in his nose. This was amazing. He looked at me once then looked back.

I eventually ran back to Danielle at the safe viewing spot. A couple people were now there with a guide. We decided to leave and walk around after another fifteen minutes of watching him eat and drink. Guess what we heard? One of the buses was coming. The sound of the bus from afar caused the bear to run away. The people on the bus saw no bear. They paid more money to sit on a crowded bus and they didn't get to see him. We saw him for thirty straight minutes. That's the thing about the tour. It takes forty-five minutes to get everyone on the bus, paid, settled, briefed and take off. We were already there.

We walked around and saw salmon swimming in the streams. There were dozens of bald eagles flying high above. At one point there were so many flying around and landing on branches and poles you lost count. The wildlife was gorgeous. As we waited for our cabbie to come pick us up, we stopped at a roadside stand and bought homemade blueberry jam and a few postcards with bears on them. Alaska, wow!

The cabbie was so happy we had a good experience. So, he took us by the totem poles as a bonus. They were cool, but we couldn't stop talking about that bear.

On the drive back, we saw a ton of houses that were off the grid. They relied solely on farming and taking their tiny boat out to fish. It was chilly in the summer. I could only imagine what these folks had to endure when it was zero degrees and seventy mile per hour winds off the water are blowing them over while they are trying to catch

dinner. Man, this was another world. These people don't go to the supermarket. They eat what they shoot and catch, then they store the rest in the garage.

As we kept driving, our cabbie informed us about the water around us. It looks like a typical canal or ocean inlet. It's so close to the paved road and so thin you assume it's only thirty, maybe sixty, feet deep. He explained that only a stone's throw out there it's nine hundred feet deep. It's one of the deepest ports on the planet. He also said, "Because of time in the Coast Guard, I cannot confirm or deny whether there are submarines there right now."

We checked out a lumberjack show and grabbed some halibut fish tacos for lunch. The fish was exceptionally fresh. As we headed back on the ship, we heard some people coming off the ramp ask, "Does this place take American money?"

JUNEAU

The capital city lived up to the hype. Fishing, government and tourism were pretty much your main jobs here. What I couldn't believe was the mountains. Walls of vertical faces barricaded this city. The only way in and out was by plane or boat. A tourist standing next to the cruise ship turned to her husband and asked, "What do you think the elevation is here?"

"I don't know," he answered.

A local worker was quick with, "You're standing next to a boat."

I don't blame her. I may have thought the same thing for a second. The rocks, the ocean and all the mountains

with heavy cloud cover you'd think you were in the Swiss Alps. There is so much snow on the mountains, too. It's July, and you think you're in a winter skiing village.

According to some locals, people thought it was a joke when we bought the area from Russia in 1867. It was so cold that they referred to it as the ice box.

SKAGWAY

The first impression of this town was it was fake. It has manipulated sidewalls and cheesy lettering. It looked like this small pop up town was erected by the cruise companies themselves, like a Disney World exhibit with a mining and gold rush theme. The town was a charlatan. We decided to take The White Pass Summit Tour. It's a short tour on a coach bus, so we could have time to do something else that day and relax back in town. We listened to an excellent narrative about the history of the town and the Klondike Gold Rush. The ride begins with a steep climb up the White Pass summit on the Klondike Highway. There is wide-open beauty at whichever side you look—waterfalls, glaciers, mountains, lakes and huge valleys. It was a sunny day, but still tons of snow in the alpine tundra below. You keep climbing and the views keep growing. You're in Canada before you know it. A few minutes later, when you turn around to go back, you get to see the WELCOME TO ALASKA sign.

We decided to rent a scooter back in town, with loads of daylight left. I didn't think anything could top scooting around the cliffs of Capri, Italy, but this one did. It's an excellent ride that is partially off road. You see rivers and waterfalls, glaciated valleys and abrupt mountains. Riding

a scooter combines the thrill of riding with the pleasure of sightseeing. The Taya Inlet, and all the overlooks was a ride for the ages.

We made it all the way to the town of Dyea and got to see the stunning tidal flats. It had to be close to twenty miles out of town. If someone said this was the most beautiful place in the world, then it would be hard to argue. You can't find this type of outdoor elegance anywhere else in the world. It felt like we were far away.

The boat was leaving soon. We had to race to get back to town in order to grab a quick beer from the Red Onion Saloon. It used to be a brothel. There was a ton of character beaming off the walls of this place. Some of the beer even had vitamin C in it. Cheers!

ANCHORAGE

When it comes to the beauty of Anchorage, I'd have to take everyone's word for it until the next day. We couldn't see ten feet in front of us for the entire first day we were there. We took a cab to the top of Flat Top Mountain and couldn't see a foot in front of us. It was light rain and the heaviest fog I'd ever seen. These poor people don't even get nice weather in the summer. I can only imagine how much of an icebox this place is in the winter. I'd heard eighty percent of the state is permafrost. We walked a few minutes from the trailheads just to smell the pure air. We were freezing. When we got back to the parking lot, the driver hadn't even left yet, so we asked him to bring us to the hotel.

DENALI

The beauty begins again. The train ride up to Denali was the best train ride I had ever taken. It was one of the absolute highlights of the trip. We sprung for first class on the way up. It's a few hundred bucks more, but instead of being downstairs with the commoners, we were in a separate car that was a glass dome. The entire ceiling was clear glass and spread from floor to floor. You could see outside anywhere you looked except down. This seven-hour ride north to Denali went by like a flash. We sat there with our noses pressed against the glass. It was more than just scenic—it was like a moving zoo. We kept spotting bear, then we spotted moose and bear, and then more moose. You'd see birds and other things but tons of moose and another bear. It was great. You get free wine and food with the ticket. I could have stayed on this train all day. It was the most remote and secluded beauty I have ever seen. There was nothing around for hundreds and hundreds of miles. No trash or cigarette butts, no fast food wrappers—just pure, untouched wilderness and rich wildlife. The ride, the train and all we saw were one of those definitive travel experiences. It was pure bliss the entire way.

When we got to Denali, it was still daylight—even though we had been traveling on the train all day. It didn't get dark until like two in the morning. We walked past signs warning of huge mosquitos and found a guy that was selling helicopter rides to a glacier.

There was one leaving in an hour. I had been on lots of helicopters before for work, but this was Danielle's first. We took off and flew straight up high above Denali National Park. You could see the park is bigger than some

small states. The pilot informed us on our bitchin' headphones that Denali National Park and Preserve is bigger than Rhode Island, Connecticut and Delaware combined.

As we floated towards a large mass of white, the pilot kept complimenting the state for its unique beauty. He said he had flown choppers all over the nation. There wasn't any other place that had the diversity of terrain like Alaska—not even Colorado or Hawaii. We finally landed on this monstrous piece of ice. We were on a glacier! Whoa.

We stepped out onto the white and it was silence. It felt like we were on another planet. We walked around carefully. It felt like we were a million miles from civilization. This ruled. There was a glacial stream running by, so I took my water bottle and filled it up for a drink. It was so pure and tasty. We filled up another bottle to take home for dinner.

We weren't there long but we'll cherish that time on the glacier. It was super special. As we hovered back towards the helipad, the pilot informed us of some good news. It was clear enough to see Mt. Denali. What a gift! Mt. Denali, formally named Mt. McKinley, is the highest peak in North America. Its summit is over 20,000 feet high. There it was, poking its chalky head out above a small cloud. Loads of townsfolk said it's pretty rare to see the mountain, as it has to be an especially clear day. There are t-shirts that say: I'M PART OF THE 30% CLUB. Less than a third of the people who travel to Denali get to see the mountain.

The next morning, we headed inside the actual park to the visitor center. It's quite nice just visiting the center. All the maps and visual aids. The rangers are there to offer

helpful tips for planning your day. Everyone kept telling us beware of bear and moose. "This is not a zoo," they cautioned.

Danielle was concerned enough to buy bear spray.

You could take shuttles into the park or large buses deep inside. We took the free shuttle a few miles in and marveled at the pristine earth. Cool rocks and plains were interesting to see. After all the fog in Anchorage, all we really wanted to do was take a hike.

A ranger suggested the Horseshoe Lake loop. We started walking from the center into the tree-covered trail and soon we were immersed by trees and wilderness. It was still early so we didn't pass many people. It was so quiet and still. When we got to the lake, the reflection of the trees and mountains off the glass surface was majestic. I skipped a few rocks as we sauntered through nature. As we started walking back up the hill, we saw in the distance some branches moving. We tried to make out what it was as we walked. The tree branches were really moving and rather high up. Oh my God. It's a moose!

Look, look it's a moose. This thing was enormous. I thought my eyes were playing tricks on me. It looked like a dinosaur. It started coming towards us. My mind was racing. Do we run?

I kept thinking of all the sayings: "Don't run from a bear, run from a moose. Don't run from a bear, run from a moose."

Ok, this is a moose. A huge moose. Should we run?

We moved off the trail behind some trees. Danielle took out the bear spray. It started walking on the other side of the very skinny trail towards us.

"Oh no, it's got a baby."

Those are the more dangerous ones. They are more aggressive when they are with a child. They need to protect the baby. Is it going to charge? I was prepared to run. I could see its body in all its glory as it came to us. I swear this thing's head was fourteen feet tall. I thought it would resemble a horse. This thing looked like a Brontosaurus.

It stopped for a second across from us. The baby looked our way. I swear it wasn't ten feet from us—it was just on the other side of the trail. The moose looked and then kept walking. It must have thought: "These wimps aren't gonna do anything."

As it walked past us, we were still scared and ready to run.

"Take a picture."

"I am not taking a picture. You take a picture."

"I am not taking a picture."

"Ok, I'll take a picture."

I took a picture, really quick and shaky. We took a few steps once it was twenty feet away. Then we sprinted faster than a Jamaican, hard up the hill. We ran until we were out of breath. We looked back, relieved to not see a charging brown mass of muscles and antlers.

We got to a lookout point and caught our breath. A few minutes later, we told a couple coming down about what we saw. They were in awe and so happy for us. We said, "We are happy now but were scared. It was so big."

They pointed to the lake below. The moose and the baby were now walking into the lake. The couple lent us their binoculars. We could see the two animals as they bent down and had a long drink.

What a wonderful, natural experience.

We walked back to the visitor center telling everyone we passed: "We saw a moose. We saw a moose! It was so big!"

Wow. That night we had supper in town and tried reindeer pizza. Good food, but they are in no rush up here. I didn't mind the wait like I usually did. I didn't want it to end.

We took the train back to Anchorage the next day. There wasn't any first class this time. We were down in the bottom level with the peasants. Your views are still amazing even in coach class. It's not a glass dome but you have tons of windows. More moose and bear, and then talk about the glacier silt in the murky rivers. One night at an Anchorage airport hotel and we'd fly back the next day.

This trip is why you travel. This is why you spend the money and effort going to these places. You want to get scared, see new things, try different food, and almost get charged by a moose. It isn't even fair to compare Alaska to the lower forty-eight states. The rest of the country is 1080p and this place is 4K. Everything seemed crisper as if in high definition. It's a fictional paradise like Lord of the Rings. One in seventy Alaskans have a pilot's license. More people have pilots' licenses than driver's licenses. It's pure isolated wilderness with animals everywhere. You can't compare it to any other state. It's in its own category. It's another world.

CHAPTER FORTY:
ONE MORE (LOVE) STORY FOR THE ROAD

I got married.

Yup, it really happened. The hopeless romantic, the eternal bachelor. Johnny Fear-of-Commitment actually did it. We did it. I never would have thought I'd get married, but it was one of the best decisions I have ever made in my life.

So, we had booked the Alaskan adventure a long time ago and almost canceled it several times. We were fighting and came close to breaking up. It's sad to even think about it. It's a bit painful to even recount how rough a patch we hit in our relationship. Danielle and I had known each other for ten years. We're best friends, lovers, travel buddies and had lived together for over four years. We got along so well and had so many funny, quirky, little sparks in common. The fact that we were not married, however, was tearing us apart.

You can call me difficult. You can call me a non-conformist. You can call me selfish or even an asshole but saying, "It's just what people do" or "Everyone else is doing it. It's the thing to do" is the worse attempt to convince me to do anything.

Truthfully, Danielle is a special person and I am so thankful to have found her. As time went on and our relationship grew, I was no longer scared about "being married." It was the process necessary to get married that

I detested. What in the name of all that is holy and sacred makes people think they have to spend seventy-plus thousand dollars to say: "I do"? How did this become the trend? All that money for a party...for a girl to play princess for a day. The planning, the phones calls, the arguments, and the stress just so you can dance in front of your friends and family for a few minutes.

I've been to hundreds of weddings and they aren't about the bride and groom. They are about table settings, dessert fountains, and outdoing the next guy for bragging rights and social media pictures. I can't remember a wedding I went to that was romantic. The bride gets pulled in five hundred directions—it's just odd. Fifty years ago, your parents had a ceremony in a church. Then everyone cheered and threw rice on them as they got in the limo to go on their honeymoon. NOW, it's morphed into a marathon of obligations: engagement parties and engagement pictures, bridal showers, bachelor parties, rehearsal dinners (I know how to eat), and hour-long ceremonies. It's three-hour-long gaps so the bride can selfishly take more pictures while the guests wait, enjoy cocktail hour, dinner, toasts, the dances, the party, the after party, and the breakfast in the morning. When does it end? Who are these people? And what is up with matching groomsmen and bridesmaids? Does anyone stop to question this anymore? Does anyone ever say: this whole thing is just fucking stupid?

Well, I couldn't do it. I was so happy to spend the rest of my life with Danielle, but we were in a rough place. Trying to come up with a way to tie the knot was pushing us apart. We were fighting over locations, logistics and everything in between. I suggested City Hall, Vegas, or

even a romantic elopement in Hawaii. Anything simple, easy and fun. To me, that's romantic. It's two star-crossed lovers professing their love to the only people who matter: THEM. I finally compromised and said, "Fine, if we are going to be fools and spend all this time, effort and money to make things official, then let's do a destination wedding." We couldn't agree on a place.

"But then some people wouldn't go."

"Who do we invite?"

"The Dominican Republic is getting tacky."

We looked at places in Upstate New York. We even considered someone's backyard. Nothing felt right. The most disheartening thing was that we were in love. We were the best of friends. We had been all over the world together, but also had just as much fun sitting on the couch watching trash. We supported each other, we laughed and shared so much in common but the societal pressure to wed a certain way was causing our relationship pain. I kept trying to think of a way to give in and just do what she wanted but I couldn't. It wasn't me. There are compromises you have to make in life, but I couldn't do this one. It wasn't me.

We had booked this Alaskan trip almost a year before and two weeks before we took off...we almost didn't go. We came so close to canceling the whole trip and calling our long-term relationship quits.

Then, while trying to work on things, we drove up to Warwick, New York. Danielle loves this farm-to-table place that even makes their own condiments. No matter how rough a workweek she has, the regularly changing menu in this tiny eight-table establishment automatically brightens her mood. She began to smirk while we sipped

a glass of locally grown red wine.

She looked up and said, "What if we get married in Alaska?"

Dramatic pause.

"Ok."

I didn't think she was serious. I played along.

She ignored her assortment of regional cheeses for the first time I can remember and continued, "I've been looking at excursions for the trip and saw one in Juneau. You can take a helicopter to a glacier. There are a few where you can get married on top of one."

Suddenly, I became a bit more intrigued.

She said, "I know you kept suggesting destination weddings, but they were all in the Caribbean. Tons of people from Long Island do that. I also know you suggested eloping in Hawaii or a beach, but I just don't want to do it on a beach. This package will be at a glacier. I have never heard of anyone doing that."

I practically spit my cabernet all over the place. I almost started crying. It wasn't the wine. It was a natural buzz. Oh my God—she is serious. We went home and set the whole thing up.

It took less than a week to plan. One day the next week, Danielle bought her dress during her lunch break and I grabbed a blue tux up the street. There were no arguments over who to invite or who sits where. I taught myself how to tie the bowtie on YouTube. We didn't even give it much thought aside from lugging her dress on the plane and around Vancouver.

There we were on the 4th of July, about twelve miles from downtown Juneau on a private patch of land with the Mendenhall Glacier right behind us. That leggy, blue-eyed,

brown-haired girl I met randomly in Astoria was about to become my wife. It was just the two of us. There she was looking as beautiful as the first day I met her, staring back at me. What a feeling. As the random guy read the vows and his foreign wife witnessed, it was becoming very real. I was nothing but happy as I looked into her eyes. I tried to enjoy the moment as he read his little piece. For a second I thought of ol' Shakespeare and a quote of his danced through my mind. "When I saw you, I fell in love, and you smiled because you knew."

I could feel the tears start to form in my eyes. I was trying to hold them back and then she stuck her tongue out at me. We laughed.

We kissed, and we laughed some more.

We may have high-fived a few times and cheered like goofballs, but that was it. We sniffed in the surroundings for a few minutes. A cool ceiling made out of clouds hung just above the glacier. There was a waterfall to the right. Danielle had a photographer fly in who snapped a few pictures but that was it. No fuss. An interesting thing about this location was that other people visited this glacier, but they didn't know how to get to the private plot on which we were. You had to push through some bush and walk down a hidden path to get to our viewing point. It was as private as you could get. People cheered when we walked back onto the main road. "Did you really just get married??"

"Oh my gosh, look at the bride. She is wearing a dress."

"Did they get married? That's awesome!"

We got back to the parking lot and the Justice of the Peace had some champagne waiting for us. We discreetly swigged a glass of the bubbly next to his old pick-up truck.

It couldn't have been more easygoing...and that was it.

We threw our clothes back in the ship's room and went out. We got King Crab Legs and white wine, then enjoyed the rest of the day in Juneau. It was over. No stress, no fuss, and no saying "Hi" to three hundred people. There was no semi-obligatory breakfast, no nothing. We were walking on air.

The next night, word may have gotten back to the cruise ship about us and somehow we did end up being contestants in the newlywed game. I hate to admit how much fun we had answering questions about the other. Couple B had been married twenty-five years and couple C had been married almost fifty.

We cleaned up! We may have divulged a few intimate details about the other, but we answered the most correct. A fancy bottle of champagne was the prize. As the other contestants and other couples from the audiences congratulated our victory, I was thrilled to hear stories of how their relationship sustained the test of time. Seemed like a common theme: "Remember who the boss is."

Haha—what a night!

Oh, and mothers of the United States, your daughters are safe. Jimmy Ford is off the market.

CHAPTER FORTY-ONE: HAWAII

Yeah sure, let's take our honeymoon in Hawaii. Why not? Post-marital bliss and a new state.

Good ol' Hawaii, the Aloha State. The fiftieth state in the nation and the fiftieth state I visited. I'd love to say I saved the best for last...but Hawaii was not my favorite. I liked it, but I didn't love it. Hawaii is good in general. It's like pop music. It's popular for a reason. It's fun to listen to and enjoyable. It's definitely a top ten and maybe even top five. Don't get me wrong, we had a fantastic trip and a ton of fun, but...it didn't blow me away.

First off, if you're from the east coast and you're looking to just go someplace warm with a beach, then you don't need to go to Hawaii. Go to the Carolinas, go to the Gulf of Mexico or the Bahamas. It's a quick flight and you're on the sand. If that's the only thing you're looking to do, then it ain't worth the flight. Getting to Hawaii is a pain in the ass. There are a few twelve-hour direct flights out there, but only from certain airports. It was six hours to San Fran. It was a three and half hour layover there, and then another six-hour flight. F that. Delays, crowds and way too many fake service dogs...I'd rather take Cathay Pacific to Hong Kong than those two flights with a layover. I wouldn't rush back unless it was direct.

Touchdown Oahu. I assumed we'd get lei'd. I thought when you got off the plane that some tan girl put those things around your neck. What the heck, kid! We told

everyone, "Hey, it's our honeymoon. Can't we get lei'd?"

I liked Waikiki. It's crowded but that didn't bother me. We stayed at the Hilton Hawaiian Village and splurged for an Ocean View balcony room. I could have sat there staring at the waves and people doing yoga on paddleboards in the lagoon for hours. The food is great. It is the US, so you can easily get your fix of pizza, burgers etc., but the local fish and island flavors of certain meals are a pleasant alternative.

Waikiki is wicked expensive, like 5th Avenue Manhattan expensive, maybe more. Like...we got breakfast and it was almost a hundred bucks. I saw the bill and asked, "Does this come with a back massage?" That's for the hotel standard buffet. We didn't care, though. Makes more sense than blowing thousands on table settings.

The Hilton Hawaiian village felt like the biggest hotel in which I have ever stayed. It was no surprise to learn later that it's the largest hotel in Hilton's 570-property chain. It's also the nineteenth largest hotel in the world. It is a literal village. Like an oversized casino on steroids, it's equipped with five different pools, twenty different bars and restaurants, exotic wildlife, ponds and waterfalls all within the grounds. There are also six separate towers with over 3,000 guest rooms. One of the towers has the world record for the largest tile mosaic on the side of its building.

This hotel is excellence. They don't call it the Hawaiian Village to be cute. There are over ninety shops! This hotel is larger than a town. Do you know how many shops ninety is? High-end shops, jewelry, clothing, athletic, but also convenience stores. There is a Hawaiian chain store called ABC store. It has multiple ABC stores within the

grounds. They are like mini supermarkets carrying all the essentials you would ever need from sunblock to souvenirs to food and wine. In addition to it being beachfront property, there is a calm lagoon next to one of the towers where one can partake in a number of aquatic rentals, like kayaks and what not.

You wouldn't have to leave this place for a year. You almost forget there's lots to see outside the place. I rented a surfboard and surfed a couple days. Surfers talk down about the waves in Waikiki. Yes, in general, they are small and crowded but that is in the middle. The Hilton is at one end of the beach and has its own break directly in front. It's sort of localized but they didn't seem to mind my baseball hat. It was also Christmas Day. It was the longest swim I have ever done to get past the breaks. Sitting in the line with some jovial locals wishing me a *Mele Kalikimaka* brought an early morning smile to my face. A couple of people even had on Santa Hats. The exhausting swim was worth it. I had the longest, calmest rides ever.

Hawaii was wonderful so far and we hadn't even left the hotel.

In September of 2013, I read an article in *National Geographic Traveler Magazine* titled "Hawaii's Most Exhilarating Drives." There was a small paragraph on the top of page thirty-six that I saved to this day. It read: Oahu: The North Shore. Then, it suggested the best drive you can take. Basically saying:

"Drive an hour from Waikiki to the North Shore. Stop in the historic town of Hale'wa Town where you can shop for local art or get a tasty frozen treat from the famed Matsumoto Shave Ice shop. Head east along Kamehameha

Highway to Laniakea Beach where you can see green sea turtles basking in the sun. A few minutes further and see the North Shore's most renowned spots: Ehukai Beach park, also known as Bonzai Pipeline and Sunset Beach. After that keep driving to Oahu's northeast coast to reach the town of Kahuhu where you can eat tasty shrimp from one of the many ornate food trucks."

I kept that article all those years while hoping I would one day visit Hawaii. I brought it with us. We did exactly what it said plus more. There were no turtles because the waves were too big. We shopped, we had shaved ice and stopped at Bonzai Pipeline to see the waves. It was a childhood dream come true. In December, the storms from up north create massive swell onto the north shore producing some of the largest waves in the world. What makes the place famous besides the wave is it's a beach break. You can sit on a very basic beach and right in front of you is a world-class wave with championship surfers. There's no need for binoculars. They are right in front of you. Just thinking about this beach gives me a rise in my drawers.

We sat on a towel with a snack. We had a little picnic while we watched the crazies ride fifteen-foot barrels. Before the ornate food trucks, we stopped at Turtle Bay Resort. Danielle is a big fan of the movie *Forgetting Sarah Marshall*. I had heard this hotel was voted one of the most luxurious in the world. You don't have to be a guest there to walk around. We wandered around the pools and saw where they filmed the lobby check-in scene, then made our way out to Roy's Beach Bar. It's a casual open-air spot, right on a sandy beach in a cove. We sipped French white wine while we watched a man and his dog surf a long

board. We chatted with the patrons about mermaids, whales and scuba diving. An over-served, and very friendly couple from Texas even bought our drinks. What a day!

After coffee and tea on our balcony, we scooted up to do the Diamond Head Hike early in the morning. It's a thrilling hike to the top, with gratifying views of the ocean and the Waikiki strip from above. This is no stroll in the park. Steep and challenging at times. Get there early. It wasn't even nine in the morning when we finished and were at the bottom. There was a lengthy line of cars waiting for parking spots and oodles of taxis trying to get through the mess to drop people off. Herds of people walking and biking in, ready to crowd the trails like ants. I could only envision what this place would be like in another hour. It was pleasant for us, but by only about ten or fifteen minutes.

Farewell, Honolulu. We were off to the Big Island. The flight was less than thirty minutes in the air. It's always fun to pound wine as you're landing. I hammered down hard in our new rental car, accelerating fast across the diversified island. It hosts eleven of the thirteen possible climates. Plains, valleys, fields, waterfalls, volcanoes, trees, rivers, oceans and then a big mountain with a snowcap looking over your shoulder.

The pinnacle moment of the trip was Volcanoes National Park. If you could only do one thing on this island, it's going to this park. You hike down into the crater that used to be a lake of lava. There are steam vents all over and you can even walk through the Thurston Lava Tube. We did the Kilauea Iki Trail Hike. It's exemplary. You're looking at an active volcano as you walk. The info signs

chronicle the height of the lava fountains. What a display of Mother Nature's power and ability. It was a natural miracle and you get to hike right by it and see it.

I didn't know what's more rare—a glacier or a volcano. But we loved walking on both of them. I can see why so many people rave about Hawaii. The next day we drove to Hilo and checked into our Airbnb maiden voyage. We rented a cottage on a cliff, overlooking the ocean. The place is only a three-minute walk to Honolii Beach Park. Hilo has a kind, local, laid back, mood to it. Almost no tourists. We mostly enjoyed the property and took in the views of the cliff with coffee in the morning and wine in the evening. The surf spot down the road was rocky but still yummy. Danielle got some sun while I grabbed a few rides.

We stayed in Kona the next couple days. Some ducky waterfront restaurants and typical bars and souvenir shops. We were ready to go. We tasted the local lager at the Kona brewing Company. I even did some shore diving. I tried S.N.U.B.A. one day. It's a quicker, easier substitute for SCUBA diving. It was a fun filled trip for sure. An interesting thing about Hawaii is there is no Spanish signs or translations. If it's not English, it's all Chinese and Asian.

The colors, the climate, the cuisines and people were all top notch, but ultimately Hawaii didn't wow me as much as I thought. I think it mostly has to do with how long it takes to get there. I didn't get that storybook Aloha feel. Hawaii might make my top five favorite states, but I wouldn't rush back. I'd have to try Maui or Kauai and only with a direct flight. I'd rather go back to Alaska, Montana or Wyoming first. I'd go back to South Carolina or Little Rock before I'd endure the flights again.

The trip did go very smoothly, until our last day there. We were in Kona, at Don the Beachcomber's Bar, sipping kitschy concoctions, while watching the waves splash high on the rocks. Then we get a travel alert. Our flight from Hawaii to Los Angeles is fine, but the second flight is delayed. And, by delayed they mean canceled. One day? Two days? No, try four. The weather was so frigidly bad in Boston and New York that the airports were all shut down for days. Fack.

We flew to LA and decided to avoid going to the airport. We grabbed a hotel outside LAX and just waited. At first it seemed annoying, but when we looked on the bright side...we got to extend our vacation a couple days. Raar! Southern California is a great place to visit and the hotel even had a jacuzzi. Finally, we got the lady on the phone. She said we could get you on a flight a day before, but it's JFK...not Newark. Ugh, its thirty miles away but the biggest clusterfuck in the US. You might as well send us to Logan. Driving through or around Manhattan may be the most challenging drive in the world.

We'll take it. The airports were like a homeless shelter, flights still canceled and delayed. Everyone was sleeping on the floor while not wanting to pay for lodging. Get us out of here.

Touchdown New York at around eleven at night and then one more delay. The weather was still so bad that the stairs they drive to the plane to get you out were frozen and wouldn't start. It was another forty-five minutes before we could get off the plane. Finally, we got our bags and hailed an ice-covered cab.

Coming home for the first time in a long, long time felt just as good as going, maybe even better. I stared out the

cab window as we drove home. I wasn't chatting with the cab driver like usual...I was quiet. I reflected on Hawaii, but also the places I'd been. Golfing in Arizona, surfing in Folley Beach, trying new food in Louisiana. Running through the abandoned Packard plant in Detroit while laughing like a fool. Fond memories from The Cape to the west coast, and Montana played through my mind as the city lights danced off the taxi window. It felt good coming home this time. They had a marching band for me and a big sign that said: WAY TO GO JIM. CONGRATS ON ALL 50! No, just kidding; they didn't. No one knew, but it felt good.

I missed my dog and my apartment. It felt warm and fuzzy to be back in my own bed. Some years I would spend more nights in hotels then at home. It's fun but can be chaotic at times. Romeo was by my feet as I fell asleep that night, the bags still unpacked. A little calm came over me. I drifted off with a funny little smile on my face. I thought for a second. Maybe I can relax now—the proverbial monkey is off my back. I've accomplished something tangible. The validation, which so many people look for, I had found it. I was only thirty-six-years old and I had officially visited all fifty states.

Maybe I'll slow down for a while and sit still for a few years. I could stay home and play with the plants or read the paper. Maybe I'll be normal and take one short vacation every couple years. Maybe, I'll grow up a bit and be content just going back to the same place. It will be my go-to. I'll take solace knowing I have a place waiting for me. I'll become a regular—nah, I want to go around again—see 'em all twice!!

THE END

POSTSCRIPT

WHAT I LEARNED OUT ON THE ROAD

This country is big and it is beautiful. It was a journey for sure, but I loved every second of it. All the delays, cancelations, traffic, fast food, seedy motels, fake service dogs and almost-running-out-of-gas scares, were all worth it.

You could spend years just visiting a few states or the fifty-eight national parks. There are so many destinations, different cities and unspoiled gems everywhere. Seeing the way the south becomes The South is an incredible thing. I loved witnessing the accents that changed along with the food. The people become friendlier and more inviting to visitors. I couldn't imagine it possible to forget the beauty of the Painted Desert in Arizona or the glaciers in Alaska. The endless panoramic views of Skyline Drive in Virginia were stunning. The weather, the women and white wine in California are unbelievable. There is adventure everywhere. The diversity of the land in the United States is as incredible as the people you meet and the cuisines you savor. It truly is a breathtaking country with charm hidden all over. Here are a few tips I picked up on the road.

BE EARLY

Sounds simple and sounds obvious, but seriously—be early. Why would you risk missing a flight and screwing

up your whole trip? Vacation time is beyond valuable. The average American gets four weeks vacation and doesn't even use two of them. They work too much. And they have too much to fix around the house to leave when it's their actual time off.

You want to show up late to a party, fine, but be early for your vacation. Those days are precious. Considering you have worked so hard and looked forward to this thing for so long, you're going to begin by racing to the airport and screaming at people? For what? So you can lie in bed an extra twenty minutes or watch SportsCenter? Come on. Take it from a pro. I have been known to get to the airport three, sometimes, four hours before my flight. My wife hates it, my friends think I'm nuts. It's relaxing. Some traffic pops up—maybe there is an accident or construction...no problem. I have plenty of time. Big lines at the airport or the tourists in front of me can't find their passport—no worries.

Sometimes flights leave ahead of schedule for a number of reasons. The easiest way to eliminate stress from your life is to be early. I never speed and hardly ever beep. I take my time. I get a magazine, maybe a cocktail, and chill out. I love airports. Sleep on the plane, kid.

BE EARLY 2.0

I have had the fortune of eating at a lot of dope restaurants. I don't make reservations; I go early. The hottest restaurant in town would love to seat you at five-thirty. Every dining room in the country is busy at eight. Every American wants to go for lunch around one. Whether it's Peter Lugers, Eleven Madison Park or Jean-

Jorges...go at eleven forty-five. What's the big deal? It's the same food. You can leave out the time detail when you call your friends.

POINTS AND LOYALTY PROGRAMS ARE OVER-RATED

The financial experts say you're throwing money away if you don't get a credit card with advantage points or rewards. Hotels, rental car companies and airlines vigorously advertise the perks of joining their loyalty programs. Well, I am telling you it's over-rated!

It's all too much. People obsess over it, becoming a slave to these companies. They make choices based on numbers rather than quality and experience. Don't let some fluffy commercial or a catchy deal dictate where you stay or how you get there. Most of the points expire a year from your last activity, which sucks. Subconsciously, that gets people to think more about the company and about using them, so they don't lose them. It also causes stress. That isn't a deal; it's stupidity.

I tell them: "No, I don't want to sign up for anything." I have no problem being rude.

"I don't want to give you my email or phone number. I want to pay for your service and then not think about you."

All the talk and management of miles can cause angst. They are trying to get in your head. If you book flights with credit card points, some boast one and a half to two times the amount. However, there are pages of restrictions about when or where you can go, blackout dates, etc. Oh my goodness, you are screwed if you have to cancel or

change your itinerary. You can't call the airline directly, you have to call the credit card company. Then you wait on hold while some confused clerk finally informs you an hour later that class is no longer available. You then end up in the middle seat and forfeit your precious points. They lure you in by making you think you're getting a deal, but you're really getting a fuck-you sandwich. These companies would never offer this crap unless it makes them more money at the end of the year. Just stop. Don't turn your vacation into a spreadsheet. If I want to go somewhere, I go. If I want to stay somewhere, I stay there. I have points for one airline...Delta. They don't expire. I confess that it's fun to look at the number from time to time, but if there is a better flight...I'm there.

I'll stay at a motel or a boutique spot if it's the right fit for the trip. I pick my hotel based on location or the aesthetics of the pool—not my brand faithfulness. Don't let these smart P.R. people sway you. Pick what you think is the best for you. It's your vacation.

Don't even get me started on credit cards with annual fees. Ninety-five dollars a year to get miles! You're going to pay a company ninety-five dollars a year to get miles? You're out of your mind.

PUT THE CAMERA DOWN

Be present in your experiences. Really enjoy what you see and smell. People who post pictures while they are on vacation are fools. I have no use for them. They take themselves right out of it. Nobody cares either. It's all reciprocal likes and obligatory comments. Get out of the cloud and look at the real world around you. You spend a

lot of time and money to get there, so enjoy it. I see people on vacation spending more time trying to create the illusion of having fun than actually having fun. Don't think about your followers back home. Think about who you are with and what's in front of you. Be in the moment. Enjoy where you are. Everyone says, "Take more pictures."

I say: "Take less."

Are you really going to look at all those pictures of yourself making the same stupid smile? Take it in. Breathe it in. Take a picture with your mind. Revel in your surroundings.

I was on a small boat trip to a private island off the coast of Costa Rica when the captain informed us of some dolphins. What do you think everyone did? They took their cameras out and fought like seagulls to get a pic. You know what I did? I watched the dolphins. When the group sheepishly tried to block the sun to see if they could view the dolphins in the glaring monitor, you know what I did? I watched the dolphins in real life. You're missing out and for what?

All the major landmarks and viewpoints have pictures online from the same angle of people standing in the same place like puppets. Why do you need that picture of you and your annoying friend doing the exact same thing? Is it to prove you were there? I'll believe you. Why don't you try and do something different? That's when you become a more interesting individual.

To the guy holding his phone up and recording the whole event: "Are you really going to watch that entire shaky video in a couple years?" No, but you're ruining the experience for the people behind you. Be a part of the experience; don't dilute it. Don't take away from the

engagement. Don't water down the rush. Experience it with your senses and tell me about it. Oral tradition, man. Come on and tell me about your trip. I want to hear it.

TUESDAY IS THE BEST DAY OF THE WEEK

I love Tuesdays. An abounding number of Americans are working for the weekend. Then, they all show up and crowd the same places for two days. I would work every Saturday if I could have off Tuesday or Wednesday. That's when I like to boat, golf, kayak, see a park, shop and go out to eat. Tuesdays are my favorite day of the week. Tuesdays are the key to life.

BRING LOTS OF TOOTHBRUSHES

I don't get sick often, but if I do, it's quick. I don't wash my hands or take Airborne. I am not one of those knuckleheads wearing a mask. I exercise, I drink juice (yes with sugar) and take naps. But one thing I always do is change my toothbrush. I bring a ton with me when I travel. If you start to get sick, then it will stay on your toothbrush. You keep re-infesting all the little germs from your toothbrush even as you are feeling better.

"Easiest way to prevent getting sick on the road is new toothbrushes."—Linda Ford, Nurse Practitioner.

TALK TO LOCALS, NOT THE INTERNET

I don't go on Yelp or popular travel sites. It's stupid and kinda dweeby. Restaurants and businesses can buy fake reviews and ratings. All these websites take the romance

right out of it for me. You may read a recommendation and think it sounds good, but you have just been steered into a tourist trap—and then you plan your whole day around it. I'll Google a few things before I go just to have some spots to aim for. I may read a travel magazine, making a note if anything tickles my fancy. That's about it. I'd rather call the hotel and ask the front desk for recommendations than go on a travel website. I get that you want to be prepared, but all this information online is becoming too much. You can practically see everything you're going to do before you do it. It leaves little surprises and hardly anything to discover. If you're watching the video, then others are too. What do you think it's going to be like when you show up? Moooo.

One of my favorite things is talking to locals. Whether it's a new country or a new state, I love throwing my bags in the hotel room and immediately running outside. It's my tradition. No shower, no freshening up. I race to the nearest bazaar, farm stand or gin joint and talk to the first person I see. I ask them for suggestions. What's good around here? Any advice? I love finding a hole-in-the-wall place some guy recommends that isn't in the Lonely Planet. If you end up in a place without pictures of the food on the menu, you're doing all right. If you end up in a place with no menu at all, you've found gold.

ASK WHAT'S MOST POPULAR

People tend to be tempted to ask their server what he or she recommends while dining out. I strongly encourage you NOT to do that. They mainly push what the manager needs to sell, which is often the closest item to expiring.

Rather, I suggest you ask: "What is your most popular dish?" I always get good intel from that question.

"Well, we are known for our salmon, but we sell a ton of ceviche."

Works every time.

"Our ribs are pretty popular, but most people come for the bone-in filet."

When in Rome, kid! If you have read *Kitchen Confidential* or *Restaurant Man*, you know to watch out for fish specials. Sometimes it happens to be a special catch and that's what the chef is serving. Most of the time, however, the "special" is the fish that's been sitting the longest and they need to move it. It's a day away from spoiling, so they enhance it with a fancy sauce to mask potential flaw—yet another reason to ask what the restaurant is known for as opposed to what they recommend.

AIRPORT HOTELS AREN'T BAD

It took me a while to stay at an airport hotel. I have grown to love them. I know they seem so corporate and ugly, but I adore them if I have an early flight. They know exactly what they are doing. It's the quickest, smoothest check-in anywhere. I enjoy waking up a few minutes from where I need to be, especially on an early flight. I always try and get a late flight the day I fly back home—four in the afternoon is ideal. That way I am not thinking about it the night before and can still get a little beach time in that morning. It's not always available, though, so, it wrecks the whole last day if I have an early flight out. I love getting an airport hotel if I can't find an afternoon flight. You still

have the whole day and night. I'll get a glass of wine at the hotel bar or order room service and watch the planes take off from my window. They are usually really really cheap and most have complimentary shuttles. You can see the signs for the rental car returns in the lobby. You're already where you need to be.

ALWAYS BRING A BATHING SUIT

This is grade-A Jimmy Ford traveler advice. I don't care if you're going to Buffalo in the winter, bring some board shorts or a bathing suit. The hotel may have a sweet pool or hot tub! Now, I'll go in the jacuzzi in my underwear if I have to, but I'd rather not.

ASK FOR THE CHECK EARLY

We all get antsy from time to time when we sit too long after a meal. You're burning daylight as you wait for the damn check to come.

One of my little pet peeves is the inefficiency of leaving the table when you're done eating. I don't want to sit around for twenty minutes while waiting to pay. The day is a-wasting—lots to do and see.

I hate this: You're done with your meal. Where is the waitress? Ten minutes for her to see you. You tell her that you want the check now, but it takes another five minutes for her to go get it and bring it to you. She drops it off but then she leaves. It only takes two seconds to put your card in it, but it takes her another seven minutes to come back and get it. Then she always tends to another table on her way to run it. Another chunk of time goes by as you wait

for her to bring it back so you can sign it. Come on, people! I want to go. When my entree arrives, I ask for the check before I start eating.

When they bring the food and say: "Can I get you anything else? Hot sauce? Ketchup?"

I say: "Can you please bring the check? I want to run when we are done."

I never thought I'd say this...but Canada is doing it better. They have a card machine that they bring right to the table. You do everything all at once. It's a bit awkward leaving the tip as they watch, but it is lightning fast compared to our flawed method.

Some say, "Jim, what's the rush?"

I say, "No rush."

Sometimes I like to hang out and take all day, but sometimes I want to get going. If you get the outdated check process in motion, then at least you have the option.

AIRPORT SPEED

What is the thing you always have to do before you get on a plane? Go through security. What happens first? You have to show the TSA agent your driver's license and boarding pass. HAVE THEM READY.

All these smiling amateurs: "Hello. We are so excited."

"Can I see your license, please?"

"Oh sure, let me dig through my purse for ten minutes."

I make a game out of it. How quick can I do this?

Whether you have your pass on your phone all sleek, or you have the paper pass, get your license out and ready to go. Put your belt and pocket items in your bag when you

get out of the cab.

All my change, my belt, my phone, tissues, handkerchief and everything else is in my backpack until after I go through the scanner and pick everything out of the bucket. I am the fastest you'll ever see. Don't stand right by the x-ray machine like a tool while trying to put on your fancy boots. Grab your bucket, grab your bags and SLIDE them down—all the way down—so others can move through the line. Take your stuff to a bench, where you can spend all day putting on your accessories again. Come on, guy.

Oh, and I always appreciate shoes without laces, but dude—don't wear flip-flops. Save them for the beach. I don't want to look at your hairy feet.

PACKING

Can't help you here. I have no tricks. I am a mess. I always bring too much and somehow seem to forget something. It's pretty easy to buy whatever you need at a gas station or over-priced convenience store. Don't worry about it.

One thing I've learned to love over the years is mailing stuff back. If I'm taking a two-week vacation, then I usually go to the town's post office after the first week and mail most of my dirty clothes home. This way, I'll have more room for all the crap I buy that I'll never use.

LUGGAGE

You know those light smooth-looking travelers, with their rolling carry-on and personal item on top of it, spinning around the white marble like a fairy? I've been tempted to imitate them, but they are not doing it right. Those burly,

hard-shell suitcases are awful and are responsible for delays nationwide. It takes me five seconds to put my bags where they need to be while sitting down—five seconds! It takes me less time to get up, grab them and start walking down the aisle. These fools that spend minutes trying to shove and fit their heavy suitcases are idiots. Nothing annoys me more. Airlines are trying to do away with carry-on items for this reason. It takes way too long to get everyone on and off a plane, mostly due to the cheap bastards that hold up the aisle because their stuff won't fit. Check your bag—it's not that bad. These suitcases that push the limits of the acceptable size need to go. If the airplane is full, or it's a smaller plane, then it likely won't fit in the overhead compartment. So, they gate check it anyway. You saved a couple bucks by not checking a bag, but now you have to wait twenty minutes after everyone is off the plane for them to go get it. I have a backpack that fits under the seat and a duffle bag that can squish into any overhead compartment. Any trip longer than a couple days, I check my bag.

GROCERY STORES

During check-out, why do women wait until the cashier tells them the total to start ferreting through their pocketbook for their credit card? You can insert your card while they are scanning all your items.

ICE CREAM

Two samples maximum! Come on, people. You know what you're getting when you're walking inside, so try one

funny flavor and then get your Moose Tracks.

Oh, and the prettiest ice-cream stand in the world is Bellvale Creamery. It's on top of a mountain in Warwick, NY.

WINE

The problem with the wine industry is that it's getting way too good at masking imperfections in cheap wine. They have too many tricks: sugars, additives, and/or cheap vanilla barrels. Over 90% of wine bought in this country are $12.99 and under. The majority of wine that cheap was made by machines, not humans. Don't feel guilty about splurging for a good bottle. You don't have to spend $200, but spend over $30 a couple times a year. Drop a HUNDO once, and drink in the difference. Don't be afraid of the price point. You spend $50 on a round of shots at the bar; so, spend $50 on a nice Barbaresco while enjoying it with a friend. When you spend that much, it's almost a guarantee that humans made the wine. Humans picked and selected the best grapes. PEOPLE took out the imperfections like bugs and leaves. It will be aged in proper barrels and made the right away.

Somm: Into the Bottle is a great documentary. It will tell you everything you need to know about wine and food pairings.

I DON'T LIKE GOOD BEER

Okay, there, I said it! I hate IPAs. I'm not into the whole micro-brewery movement. I respect the process. I appreciate the artisan aspect. I even enjoy taking the tours

and sampling a flight. But, wow, do I dislike having a full pint of craft beer. It's too heavy. I simply despise the taste. There is a sort of snobbery that goes along with craft beer that has become increasingly annoying. Big beards and way too much enthusiasm over hop varietals.

I know the alcohol content is much higher. It gets you buzzed up, but it's hard to finish. I drink one pint and my stomach hurts. It feels like I ate Thanksgiving dinner and I don't want to move—it's uncomfortable.

If I have to drink beer, give me a Coors Light or a Miller Lite any day over your small batch porter or limited release pale ale. I enjoy inexpensive, watered-down American beer. I don't care if you want to take away my man-card. It's more pleasurable to drink and doesn't stick to your gut. I know a burger and beer sounds good, but I truly believe beer does not go good with food. A soda or a glass of sweet iced-tea goes so much better with fries and a burger.

WEATHER

I swear it's a conspiracy. The weather channels and websites will never tell you it's sunny if it's going to rain; but, they will absolutely tell you it's going to rain when they know it isn't. They need you to tune in for ratings. Nobody will check if they say it's sunny all the time. You're fine—game on. You don't get to fifty states and over a dozen countries this quick by waiting for perfect weather reports. Assume the weather won't be ideal. Prepare for it, then, if it's nice out...bonus. I never cancel my plans because of weather. I never call an audible because of potential storms. What if they are wrong? The clouds just

cleared, and you're stuck home watching premium cable. I've golfed in the pouring rain, surfed in a hurricane, boated during heavy downpour and went wine tasting in a blizzard. Get some gear. Get dirty, get wet and go play in the elements.

LOVE

An unwilling heart finds a million excuses, while a willing heart finds a million ways.

MAIL POST CARDS

Lots of people want to know what qualifies as "visiting a state." Some think you have to spend a night or see a statue. I spent at least one night in most states, but I say that you have to have an experience. Airports and layovers obviously don't count. You have to get out of the car, touch the ground and partake in some activity. Most people trying to see all fifty states have a thing they try to do in each one. It might be to take a picture, do a hike or see the welcome signs. My thing was to send a postcard.

I wanted to do something special and unique as social media exploded. There is something so romantic about paper and pen. It's more substantial than a tweet or a direct message. For less than fifty cents, all these hands and all these people touch, take and deliver this small piece of paper with a message on it. It's enchanting. Sometimes it only takes a few days, but it travels so far. Still, it always gets to where it needs to be. Do you really think your family and friends give a flying shit about your feet in front of the pool? Well, they don't, they are being polite. We

have all seen a sunset too. I promise the world will be okay without a dozen pictures of you standing in front of it in your new outfit. Mail a postcard and tell them about it. Jot down a quick story. You will make someone's day. Paper is sexy. Postcards are meaningful and aesthetic.

If I could, I would also try to have an authentic meal in each state. All the same, mailing a postcard was my thing. It was entertaining to see some post offices, too, because they're often located off the beaten path. You get to see the true colors of the town. You get a better feel for the area than just strolling down Main Street. Come on; who doesn't like getting mail?

TRAVEL

Do it. Get off the couch and go! You have to make the effort and pull the trigger. You can't sit around thinking about seeing the places you want to see. You have to go there. Why do folks have this notion that you have to be sixty-five before you can start to live your life? You could get hit by a bus. Whether it's Europe, Asia, a tropical island or a national park—go now. People talk about doing that road trip or special vacation, but only when they retire. Why do you have to wait? Stop making excuses and go. Don't be afraid to wing it and surprise your significant other with something last-minute. Just go. Go now!

Your goal may be to simply escape the office. Bask in the warm weather with a fruity drink by the pool. That's all right, but I find the all-inclusive resorts a bit mundane. Travel, man! Get away from the buffet. Leave the hotel. Get out to the streets, ride public transportation and do what the Romans do, baby. Don't be afraid of emb-

arrassing situations...steer into them. That is when things get interesting. Take a risk and talk to some locals. Make out with a stranger. Eat something that you have never heard of before. Don't plan every minute of every day but be spontaneous. Get out of your comfort zone. Don't play it safe—get food poisoning. Try something new. Get scared. Get lost. Look around, laugh a lot and live.

Go out and get some stories!

ABOUT ATMOSPHERE PRESS

Atmosphere Press is an independent, full-service publisher for excellent books in all genres and for all audiences. Learn more about what we do at atmospherepress.com.

We encourage you to check out some of Atmosphere's latest releases, which are available at Amazon.com and via order from your local bookstore:

Tree One, a novel by Fred Caron
Connie Undone, a novel by Kristine Brown
The Enemy of Everything, poetry by Michael Jones
A Cage Called Freedom, a novel by Paul P.S. Berg
Giving Up the Ghost, essays by Tina Cabrera
Family Legends, Family Lies, nonfiction by Wendy Hoke
Shining in Infinity, a novel by Charles McIntyre
Buildings Without Murders, a novel by Dan Gutstein
Katastrophe: The Dramatic Actions of Kat Morgan, a young adult novel by Sylvia M. DeSantis
Peaceful Meridian: Sailing into War, Protesting at Home, nonfiction by David Rogers Jr.
The Stargazers, poetry by James McKee
SEED: A Jack and Lake Creek Book, a novel by Chris S. McGee
The Pretend Life, poetry by Michelle Brooks
The Testament, a novel by S. Lee Glick
Minnesota and Other Poems, poetry by Daniel N. Nelson
Southern. Gay. Teacher., nonfiction by Randy Fair

ABOUT THE AUTHOR

Jim Ford is an award-winning actor, stuntman, and filmmaker in New York City. Ford grew up in Massachusetts and began making his first short film when he was only 11. He was athletic as a kid and played every sport from traditional to extreme. He was always videotaping his snowboard and BMX sessions with a camcorder. When he started to add humorous sketches to them, interest and production value soared. Soon public access stations and local TV shows started airing his videos. Towards the end of high school, he still played sports but decided to try theatre. After being cast as Romeo in his high school's production of *Romeo & Juliet*, he dodged the typical business school route and announced he would study theatre in college. Jim received a B. F. A. in drama from the renowned acting conservatory, The Hartt School in West Hartford, Connecticut. He got an agent quickly and combined his classical training with his athletic background to amass a large amount of diverse roles. He has nearly 200 combined film and television credits, which include primetime shows, Oscar-winning movies, and major summer blockbusters. Jim recently received his first Screen Actors Guild Nomination for his work on the film, *The Irishman*.

Though he still moves a lot, he currently calls New Jersey home. He continues to travel to random parts of the US and the world. You cannot follow him on Twitter but you can have fun visiting him on his website: www.jimford.com

CPSIA information can be obtained
at www.ICGtesting.com
Printed in the USA
LVHW091026061020
668080LV00001B/305

9 781648 260919